ANTARCTICA: A Year at the Bottom of the World

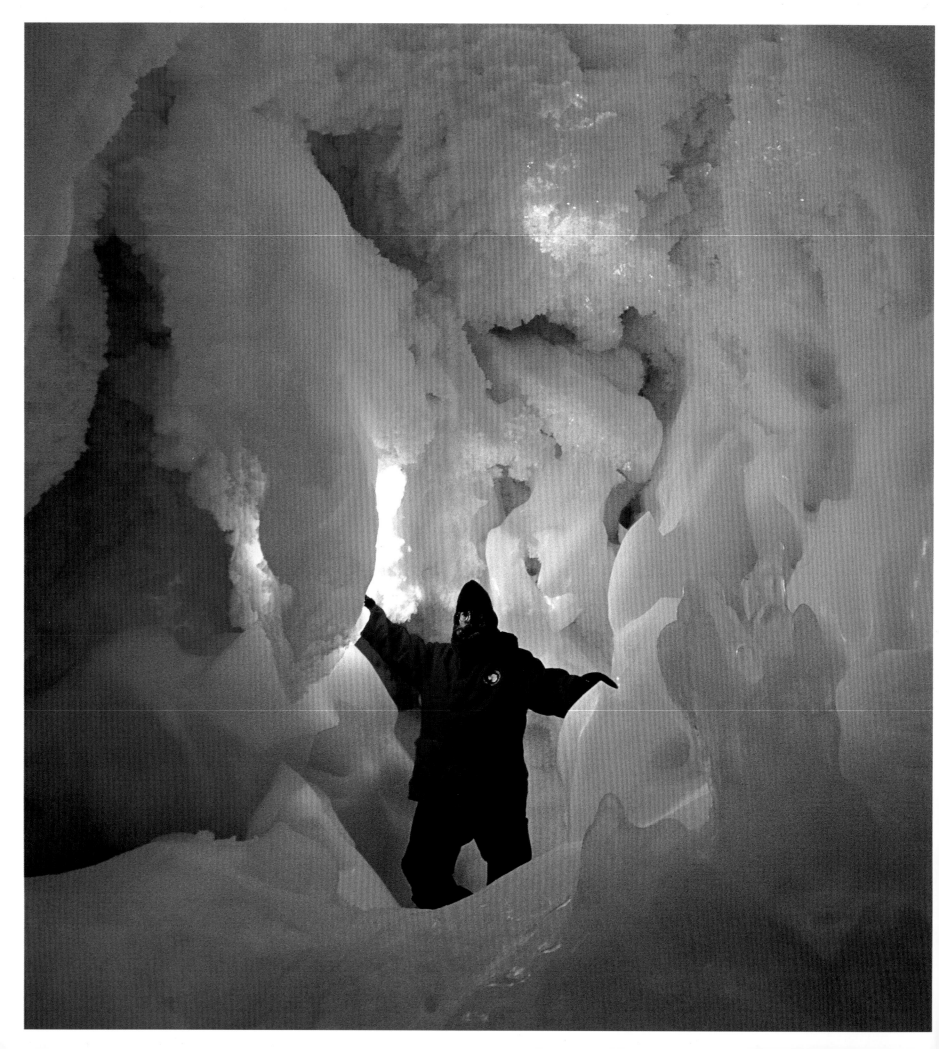

ANTARCTICA

A Year at the Bottom of the World

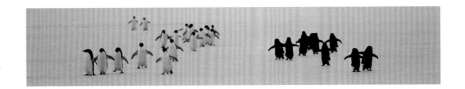

JIM MASTRO

A Bulfinch Press Book

Little, Brown and Company

Boston • New York • London

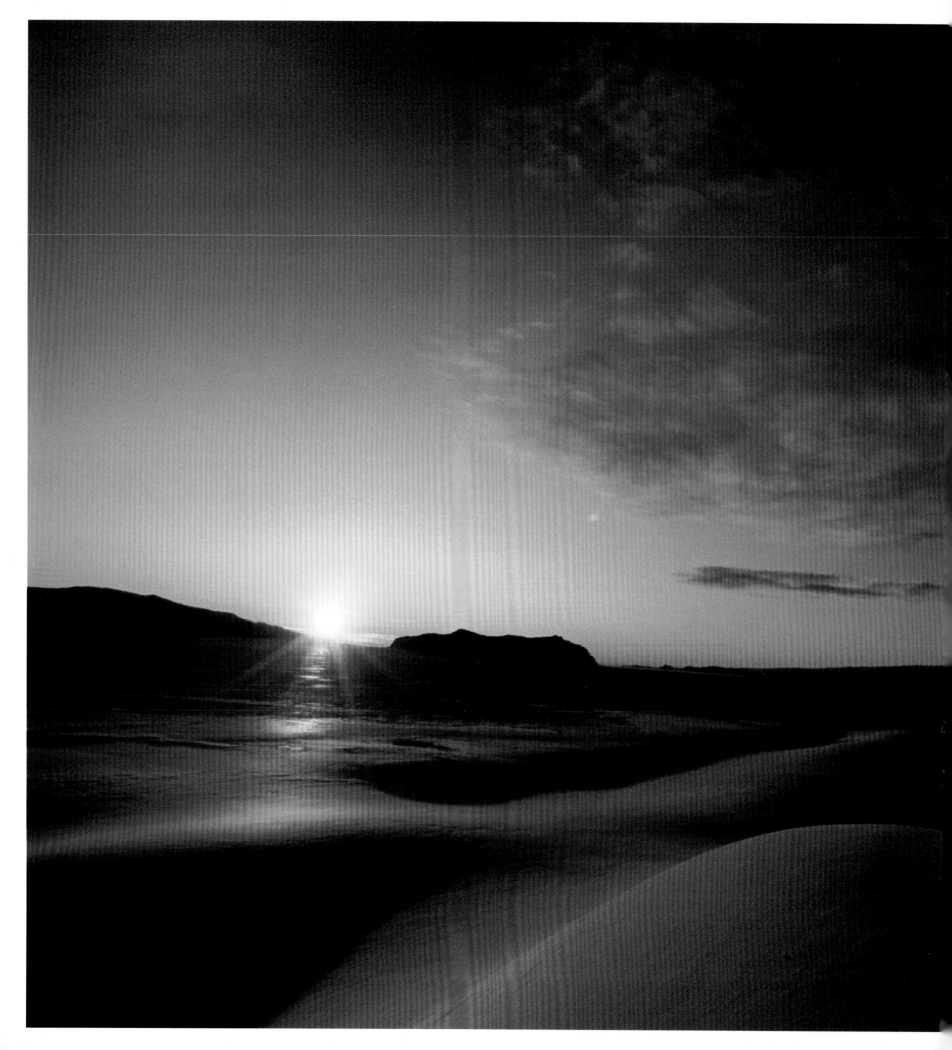

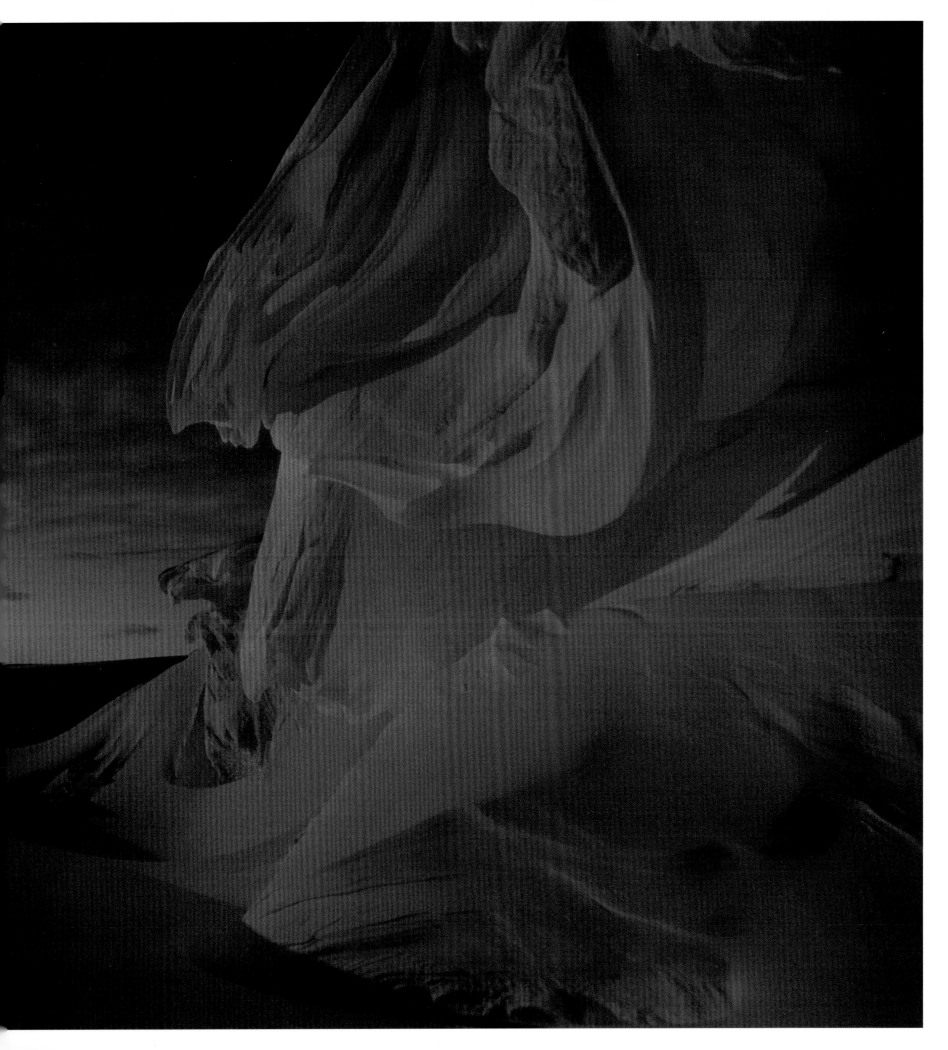

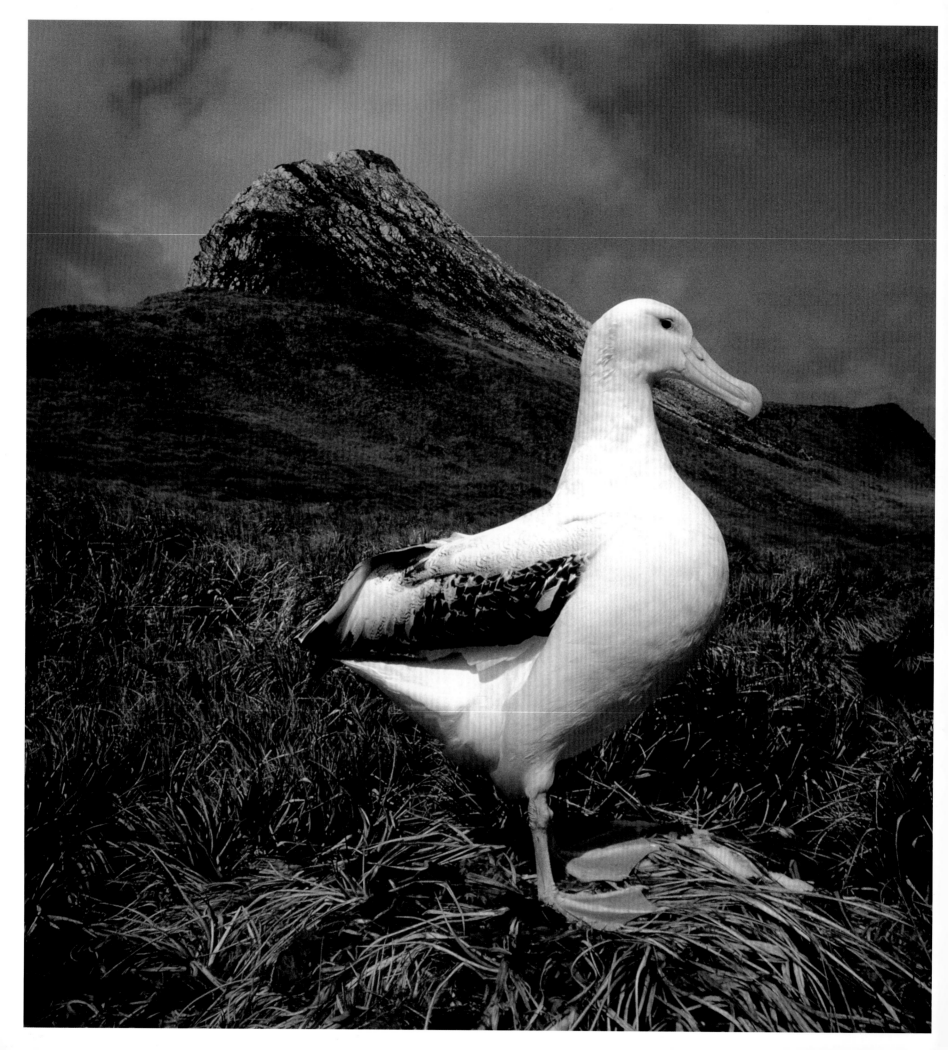

CONTENTS

All maps designed and adapted by Lisa Mastro.
Original Ross Island and Vicinity map courtesy U.S. Geological Survey, National Mapping Discipline, Polar Program.

First Edition
Library of Congress Cataloging-in-Publication Data
Mastro, Jim.
Antarctica: a year at the bottom of the world / Jim Mastro. — 1st ed. p. cm.
ISBN 0-8212-2754-8
1. Mastro, Jim — — Journeys — Antarctica. 2. Antarctica — Description and travel. I. Title.
G860 .M334 2002
919.8'904 — dc21 2001038932

Bulfinch Press is an imprint and trademark of Little, Brown and Company (Inc.)

Book and jacket design by Blue Design, Portland, Maine

PRINTED IN SINGAPORE

Captions

Page 2: The interior of a multifaceted, convoluted ice cave in the Erebus Ice Tongue. Buck held a camera strobe against the ice and fired it off when I opened the shutter.

Page 3: Rush hour on the penguin highway. These Adélie penguins are traveling to and from their rookery at Cape Royds, in McMurdo Sound. Each member of a mated pair goes to sea to feed for a few days, then returns to the nest to take care of the chick while the other parent leaves. The penguins may have to walk several miles over ice to reach open water.

Pages 4–5: Another spectacular September sunset at the Erebus Ice Tongue, with wind-sculpted snow on the glacier and Tent and Inaccessible Islands silhouetted in the background. The temperature was minus 40° F and the air was absolutely calm.

Page 6: Wandering albatross (*Diomedea exulans*) standing on a nest, perhaps waiting for its mate to appear. Wandering albatrosses mate for life, and they live for a very long time. Ages of fifty years have been recorded. For most of the year, these birds stay aloft, circling Antarctica on the prevailing westerly winds and scooping up their food (squid and fish) from the ocean's surface. Their almost twelve-foot wingspan is the largest of any bird, and it allows them to soar indefinitely on the slightest breeze. They return to land only to mate.

Pages 10–11: Climbing a twenty-foot snowdrift at the tip of the Erebus Ice Tongue to watch a sunset over the sea ice.

Page 12: Three Adélie penguins on the sea ice of McMurdo Sound.

ACKNOWLEDGMENTS

The list of people I could thank, and should thank, for their role in this project would make a book in itself. None of them could have known that the adventures we shared would end up in a book someday. Even I didn't know that until recently. Nonetheless, without these people, my time in Antarctica would have been impoverished, and this book would have been impossible. I thank them all.

Some, however, deserve special mention. For their forbearance, and for the fact that there is a U.S. Antarctic Program at all, I thank the folks at the National Science Foundation's Office of Polar Programs, especially Dave Bresnahan, Erick Chiang, and Dwight Fisher. I'm indebted to Jerry Kooyman for introducing me to the idea of Antarctica, John "H" Wood for talking me into it and giving me that first opportunity, Steve Kottmeier and Kristin Larson for bringing me back time and again, Bill Green for Taylor Valley, Dan Costa for Bird Island, and Bill Baker for that one last chance to get in the water. I thank Rob Robbins and Sandra Ackley for their guidance, Kerry Fitzharris for making the winter meaningful and magic, and the Scott Base "labbies," Gary Brown, Andrew Harrall, and Doug Martin, for making it fun.

I am deeply indebted to Steve Waszak for his help with the book proposal, and to my agent Sandra Dijkstra for her hard work on my behalf. For their invaluable help with the manuscript, I am grateful to Pam Barksdale, Kerry Fitzharris, Chuck McGrosky, Dwight Fisher, and especially Karen Dane, my editor at Bulfinch. I thank Jerry Mullins and Angel Gonzales at the U.S. Geological Survey for their assistance with maps. I also owe a special thanks to Kristin Larson, for her incisive comments on the manuscript, for her support and encouragement, and for being the best of friends.

Finally, and most important, I thank Lisa Mastro, my wife and soul mate, for her support, her hard work on the maps, her patience, and her understanding. I surely could not have done it without her.

AUTHOR'S NOTE

I first went to Antarctica in 1982. Over the next fourteen years, I returned time and time again, until I had racked up two winters and nine summer seasons — a total of sixty-eight months at the bottom of the world. Of all that time, the first year left the deepest impression on me. Everything about Antarctica was new, every experience novel. Consequently, most of the stories here and all of my descriptions of life in McMurdo come from that first year. I've also included a few stories from later seasons, and at times I've combined events or details from two years into a single narrative. Thus this work is a compilation of all my experiences. My purpose is less to describe a particular year exactly than to give the reader a sense of what it was like to spend an entire year in Antarctica.

All of the events are true, though I have changed a few of the names. Memory is a mutable and sometimes untrustworthy thing, however. I lived through these times and incidents with many other people, and their memory may differ slightly from mine. Nonetheless, to the best of my recollection, this is the way things happened.

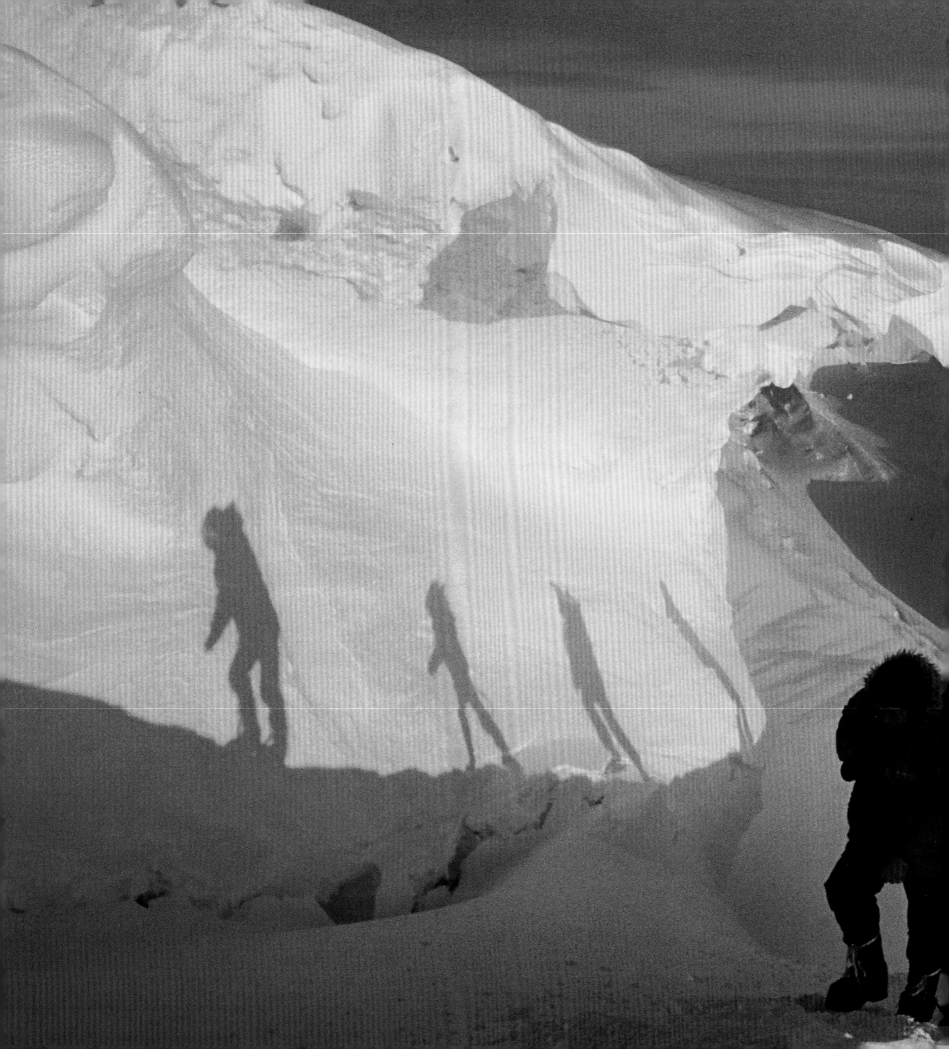

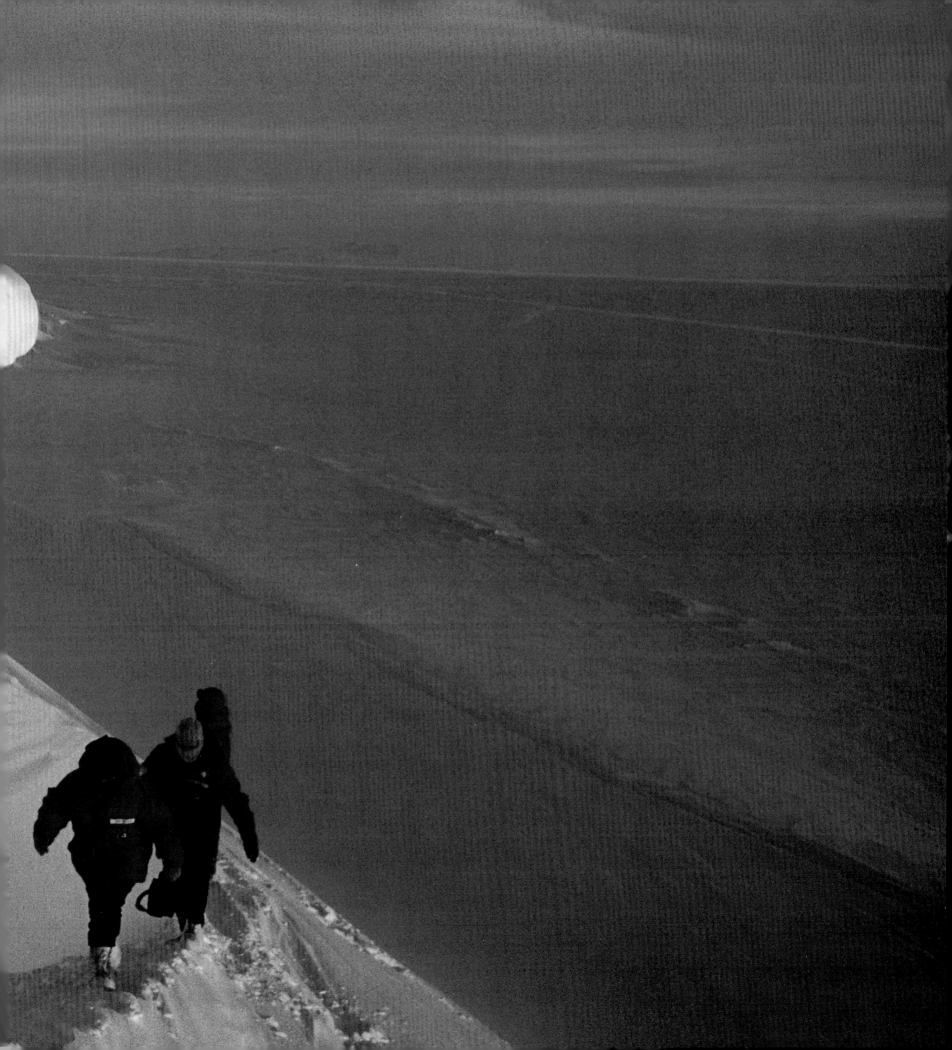

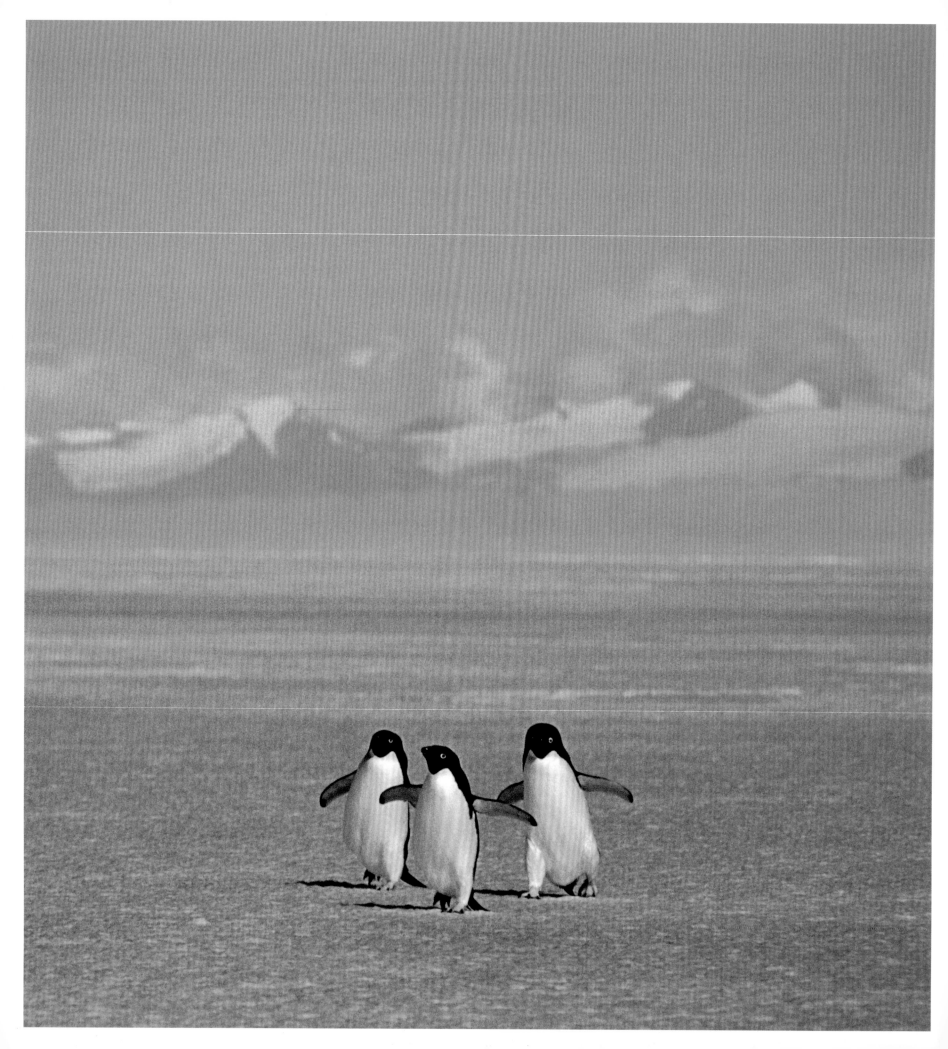

DEDICATION

To the people of the U.S. Antarctic Program, to the friends who will always be a part of my life,
and especially to Kirk Kiyota, a good friend who left us too soon.

———————————————

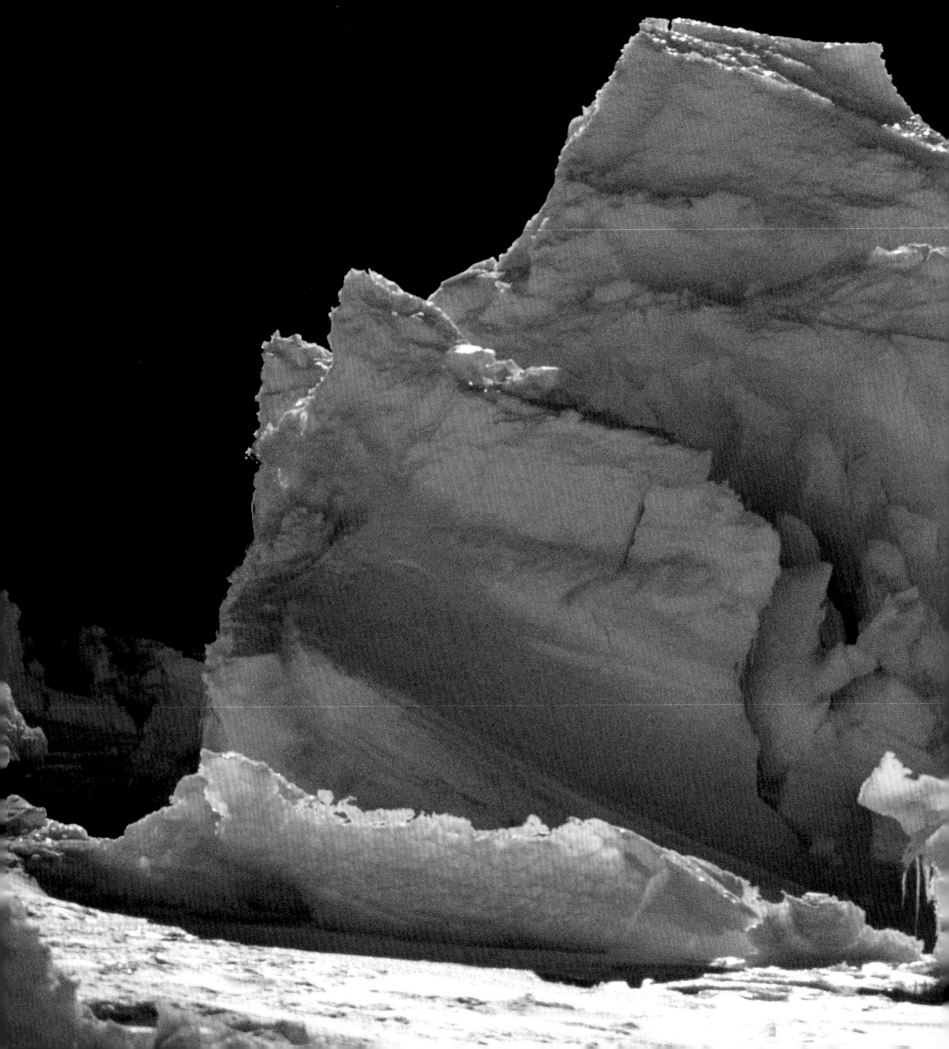

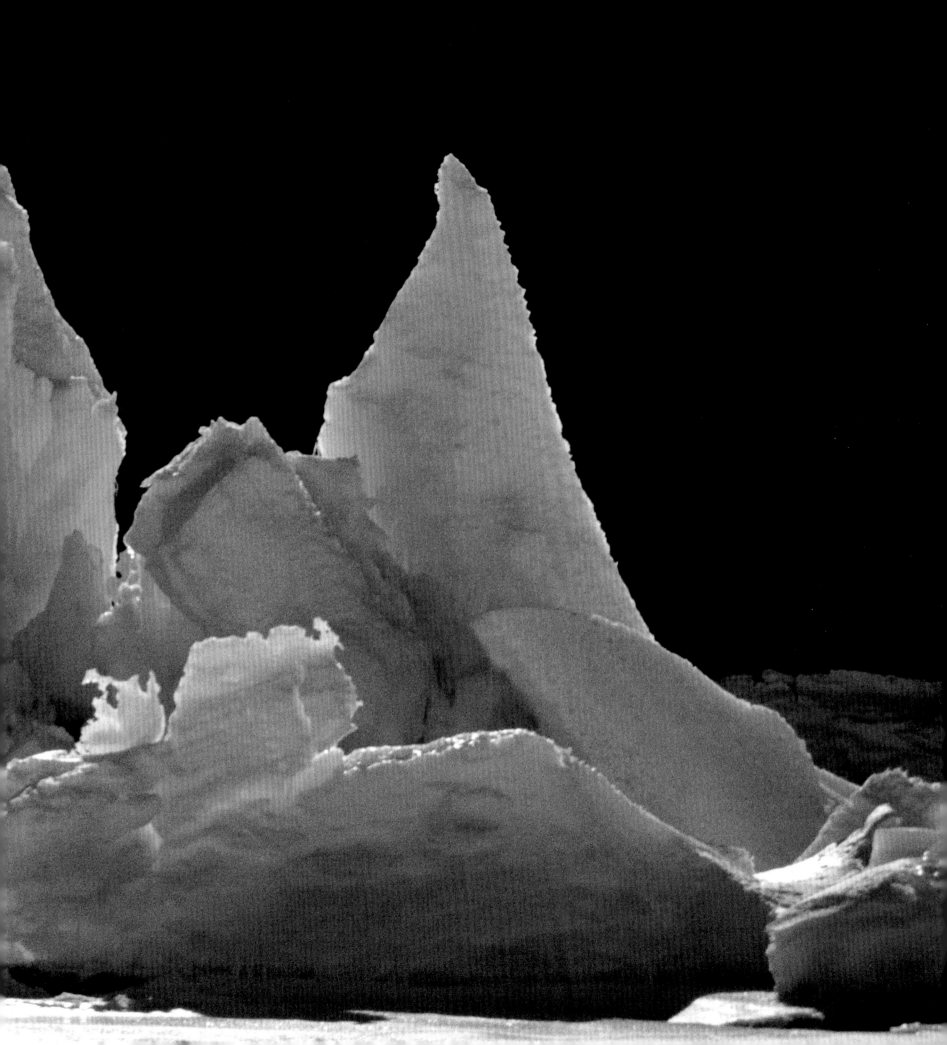

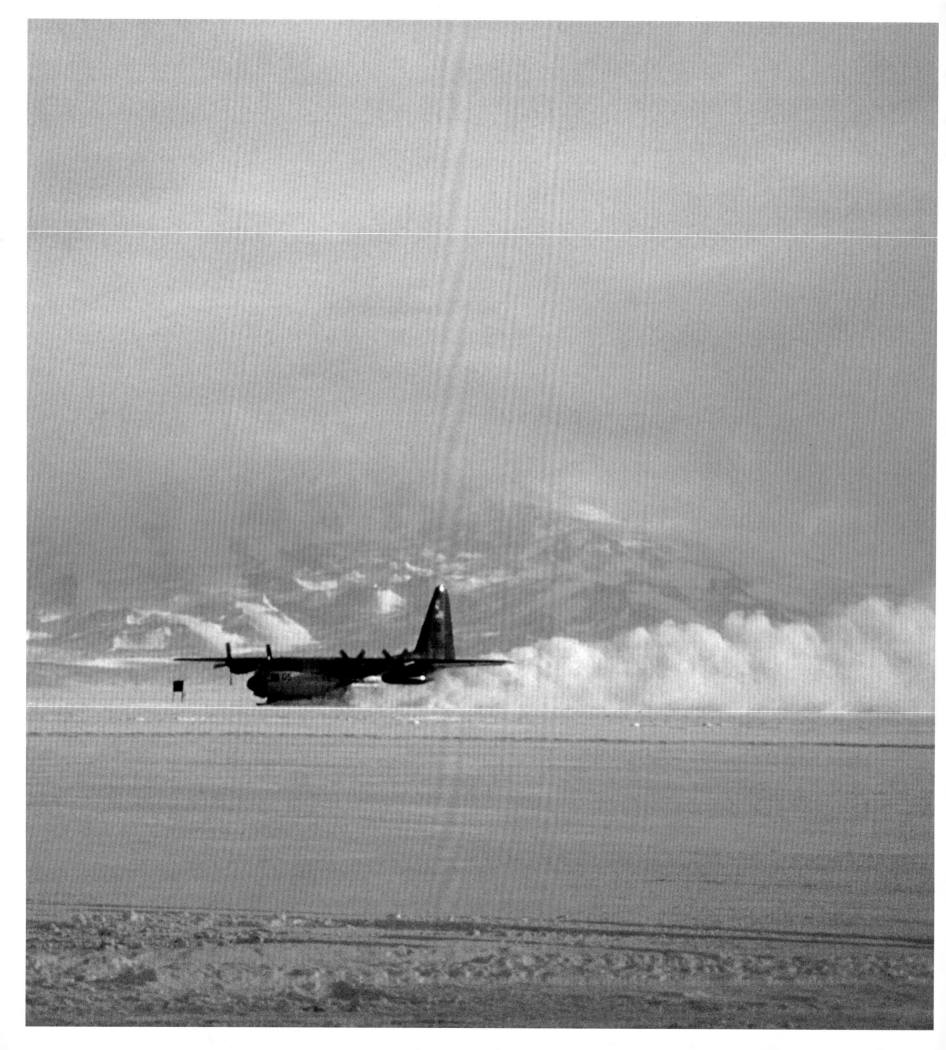

Spring

ARRIVAL

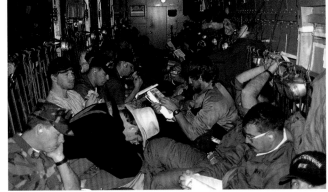

We gathered in the warehouse of the Antarctic Clothing Distribution Center at the Christchurch, New Zealand airport just after midnight on a cold August morning. There were about thirty-five of us. We were to be on the first flight, the first plane to land in Antarctica in six months.

Earlier that day we had tried on our extreme cold weather (ECW) clothing for fit. Now we were to don everything for real. The warehouse director, Alan Renwick, stood next to a giant bulletin board that was covered with tacked-up articles of clothing. Looking like an elementary-school teacher, he used a long wooden pointer to indicate those items we were required to wear.

"Everyone," he said in his proper New Zealand accent, "must wear the waffle weaves."

A few people groaned.

Alan waggled his stick and gave them a meaningful glance. "Everyone," he repeated.

Previous pages: The Ross Ice Shelf, at the south end of McMurdo Sound, is slowly but constantly moving northward. It pushes against the sea-ice sheet, shoving it into islands and creating pressure ridges of tortured ice, like frozen waves breaking against a rocky shore. **Opposite:** An LC-130 Hercules aircraft taking off from the ice runway in front of McMurdo Station. **Above:** Coach class on Penguin Airways. Passengers relax in the comfort of an Air Force C-141 Starlifter, on its way to McMurdo Station. The interior of an LC-130 Hercules aircraft looks much the same and provides the same level of comfort, though the 130 is a shorter aircraft and carries fewer people.

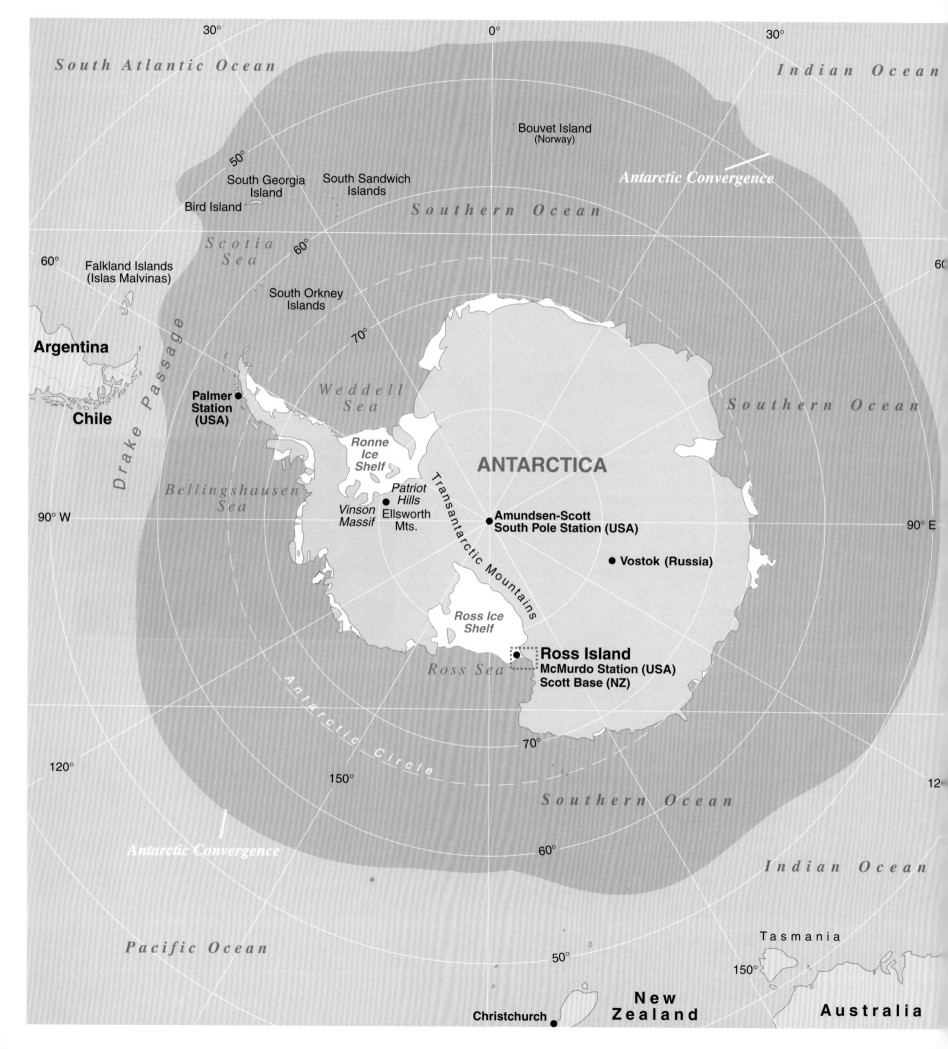

I understood the griping when I pulled on the long white cotton underwear. The scratchy fabric really did look like a waffle, and it was tight and uncomfortable against my skin. Is this the best they've got for the coldest place on Earth? I wondered. Next, I pulled on insulated pant liners and tightly woven black wind pants, followed by a heavy red-checkered wool shirt. I tucked in the shirt and cinched up my belt. Gloves, fur-covered "bear-claw" mitts, woolen balaclava, and scarf I tucked into the pockets of my heavy red parka. Finally, I pulled heavy, insulated white rubber "bunny" boots over thick wool socks. I stared at my feet in amazement. The boots were huge! And round! My feet looked like they belonged to a cartoon character.

After throwing my luggage onto the back of a truck that would transport it to baggage check-in, I shouldered one of the orange canvas bags we'd all been issued with our ECW clothing and left the warehouse to trudge to the flight terminal. The night was calm and clear, but the air was moist. Patches of grass next to the sidewalk were wet with dew. I felt like I was part of a parade. We had each arrived in our own distinctive clothes. Now we all looked the same, bundled-up soldiers marching around the Christchurch airport in big white boots, black wind pants, and red parkas. The roar of aircraft engines echoed off the buildings around us.

"That's our Herc," someone said. I knew he was talking about the special ski-equipped LC-130 Hercules cargo plane that would be taking us south. The turboprop engines made a distinctive sound, throaty and powerful, that filled the night air. I started walking faster.

Below: The Barne Glacier, like the Erebus Ice Tongue, rolls off the flank of Mount Erebus and into McMurdo Sound. The Barne is a shorter glacier, but much taller. Its face is an impressive hundred-foot wall of sheer blue ice.

At the terminal, we collected our luggage again and stood in line to be weighed. Most of the people handling the passengers and cargo were members of the New Zealand Army. I had been in the country only two days and hadn't yet tuned my ear to their accent, so I had a hard time understanding what they were telling us to do. Check-in bags were "chicken" bags, and "Form a line" became "Queue up." Following the lead of people who had done this before, I stood in the queue until it was my turn to be weighed, placed my "chicken" bags on the scale, then stepped up on the scale myself. One uniformed New Zealander took my name and jotted down my weight, then another hustled me into the boarding lounge, a spartan room with few chairs and a thin carpet. Photos of old Antarctic aircraft adorned the walls, and a coffeemaker sat on a table in the corner. After announcing that the preflight briefing would begin soon, the New Zealander hurried away. Our flight was scheduled to take off in an hour, and it was now 1:30 A.M.

An hour later, we were still waiting. Those who had been through this process before were lying on the floor, their heads buried under their parkas, trying to get some sleep. I was far too excited for that. Two days ago, I'd been sweltering in a San Diego summer. Now I was halfway around the world where the seasons were reversed, where it was the middle of winter, and where I was waiting to go to Antarctica. For a year. There were moments when I found it hard to believe. I paced the room, studying the photos and peering impatiently through a window.

Finally, two clean-cut, flight-suited U.S. naval officers came in. One stepped up to the podium while the other stood just behind him and slightly to one side, in perfect military formation. I was surprised at how young they looked. The one at the podium introduced himself as our pilot and

launched into his briefing. The plane would be ready shortly, he said. There was a slight headwind, the flight would take about eight and a half hours, and if we were to go down for any reason, there was an exposure suit on board for everyone, which the loadmaster would hand out. Follow his instructions. Thank you. They left, and we waited some more.

I hadn't given much thought to the risk I was taking, but the briefing gave me pause. We would be flying over the coldest, stormiest sea in the world, in a plane that probably had been built before I was born. I wondered how reliable the aircraft was, and how experienced those young pilots were. If we went down, would there be any hope of survival, exposure suits notwithstanding? I tried to imagine thirty-five terrified passengers struggling into the bulky suits while their plane was plummeting, then trying to extract themselves from the sinking aircraft once it hit the water. And if we got that far, would anyone be able to rescue us? It seemed doubtful.

To top everything off, McMurdo Station lay two thousand miles from Christchurch, at the very limit of the Herc's range. As I understood it, by the time we arrived we'd be running pretty much on empty. Because of this, the pilots had established a point along the route, called the point of safe return (PSR), where they could still safely abort the flight and have enough fuel to return to Christchurch. If the weather at McMurdo were to suddenly turn foul after we had passed PSR, we'd have no choice but to keep heading south, to land in the teeth of a storm. There was nowhere else to go.

It seemed obvious that this was a one-shot deal. If we went down, we were dead. Simple as that. I wondered if anyone, including the pilots, seriously thought otherwise.

I shrugged. It didn't matter. It couldn't matter. I was committed. I was going to the Ice (as the people who'd been there were fond of saying), and there was no turning back.

Anyway, the risk added to the excitement. I remembered my few moments with Joe Greco, the man in charge of paperwork for contract employees like me. He'd sat me down and told me what my pay would be, then without giving me a chance to say a word, launched into a lecture designed to assuage any potential dismay at the amount. "But you're going for the adventure, right?" he said in his rapid-fire New Jersey accent. "It's not the money, it's the adventure, right?"

What kind of sales pitch is that? I remember thinking. But now, standing in that passenger lounge, with the walls vibrating from the sound of powerful engines, I had to admit he was right.

I had signed on with a private company that provided support to scientists in Antarctica. As a biologist and a scuba diver, I'd been hired to help manage a biology laboratory and a scientific diving locker. Beyond that, the details weren't clear, but I knew I would be in the thick of the action, interacting directly with researchers at the leading edge of science, at the very end of the earth. I was filled with anticipation.

After another hour, the passenger coordinator rousted snoring people off the floor. We were herded out to the street, where a bus was waiting. Wearing all my gear, including my parka so I wouldn't have to carry it, I crammed myself through the narrow door and down the aisle to an empty seat. The seats were those of a school bus, made to accommodate two children. It was all I could do to jam myself and my bulky carry-on bag into one, and there was no room for anyone else. When the bus was stuffed front to back with red parkas, bunny boots, orange canvas bags, and sweating bodies, the driver closed the door, said something incomprehensible, and put the vehicle into gear.

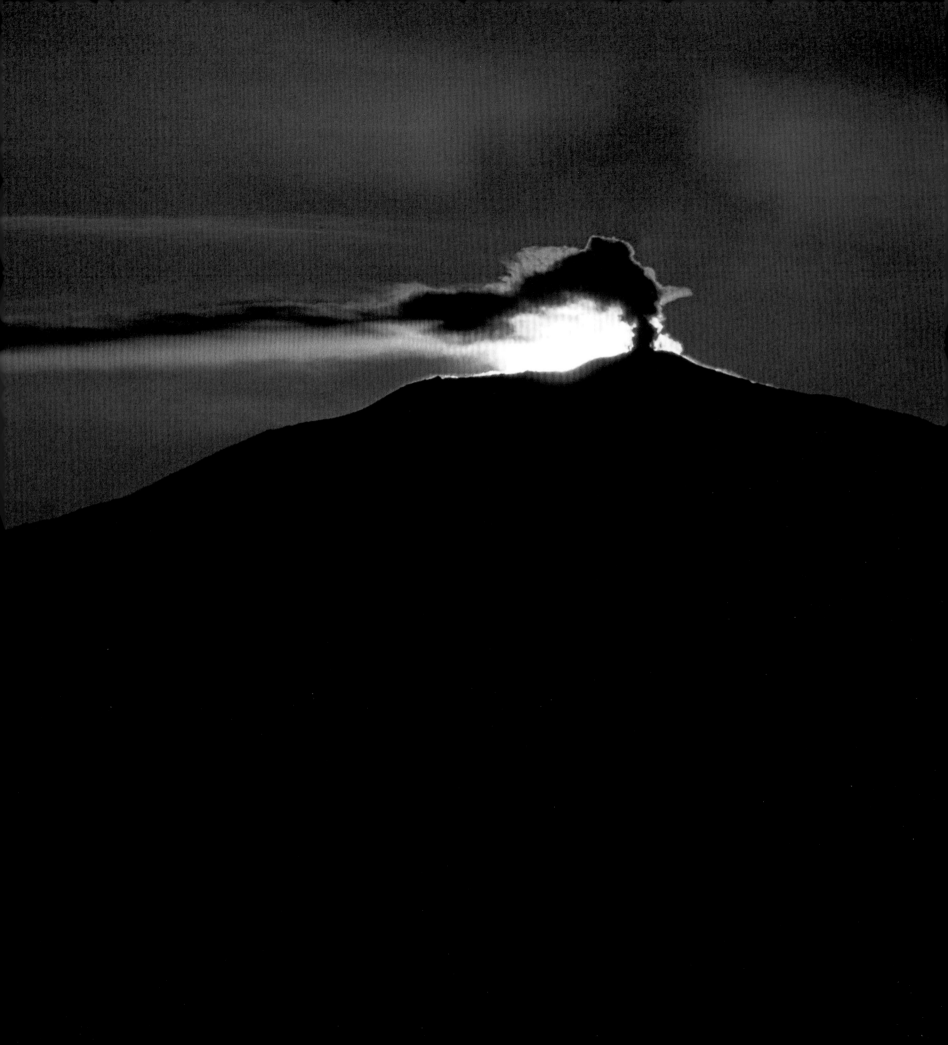

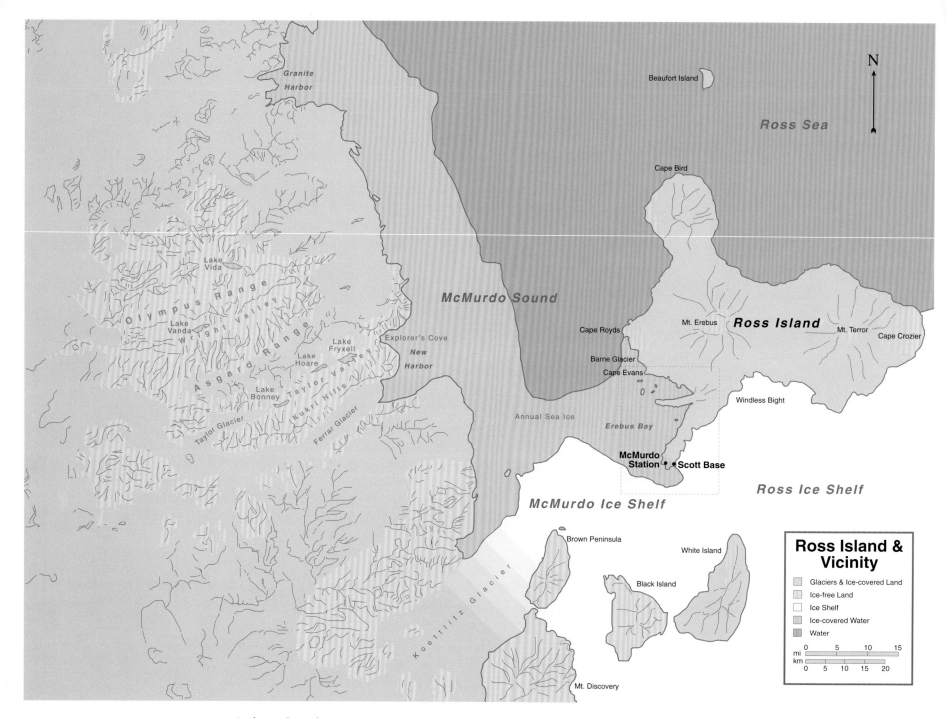

A short drive later, we were ushered out of the bus and into an aircraft hangar, where we were told it would be a few more minutes before we could board. Even though there was only a concrete floor to lie on, a few people managed to fall asleep again. Another forty or fifty minutes passed. Finally, we were roused by another flight suit and told to file out to the tarmac.

Compared with the jumbo jet I'd flown on from Los Angeles to Auckland, the Hercules was not a big plane. Still, it looked plenty impressive to me. It sat on the taxiway, illuminated by powerful tarmac lights in the predawn darkness. With its pudgy gray body and snub nose, it looked like a flying hippo — a hippo with a giant vertical tail and four massive engines. Those engines were quiet now, their giant propellor blades still. Retracted against its fuselage were the skis that would allow us to land on the snow.

A member of the ground crew handed me a bag lunch just before I climbed a short set of stairs and squeezed through a tiny door behind the cockpit. I found myself in a tightly enclosed, dimly lit

**Erebus Bay &
Hut Point Peninsula**

cabin. The loadmaster took my hand-carry bag and placed it in a pile with everyone else's, on the floor in front of a large pallet of boxes and luggage. He directed me down one aisle and around to the other side of a flimsy wall of red nylon netting. I sat down next to the guy who had been in front of me in line. The seats were benches made of nylon. There were four rows filling up the front half of the plane. A row ran down each side of the fuse-lage and a back-to-back row ran down the center. The backs were nylon netting, and each bench was supported by aluminum braces. They were obviously designed to be quick to install and disassemble, but they were not comfortable.

When all the passengers were finally jammed in, we were sitting thigh to thigh, shoulder to shoulder, and our legs were intertwined with those of the person sitting in the row opposite. There was literally no room to move. Coach class on even the stingiest airline would have felt like luxury in comparison. The loadmaster then passed out compressible foam earplugs. The rea-son for them became clear when the first engine roared to life. Hercs are cargo planes not insulated for passenger comfort. I hurriedly stuffed the plugs into my ears.

Four hours after we had arrived at the Christchurch airport, our plane rolled down the runway and lurched into the air. We were heading south at last.

Time passed slowly in the deafening, crowded cabin. Conversation was impossible. Everyone seemed lost in his own private thoughts. I tried to sleep but couldn't get comfortable. Each time I started to doze, one of the other passengers walked over me to get to the rest room, jarring me awake. I gave up and dug through the sack lunch I'd been given. There was a bologna sandwich, a peanut butter and jelly sandwich, an apple, a small container of fruit cocktail, a can of soda, and a candy bar. None of it was enticing, but it would have to do. I munched on the peanut butter and jelly sandwich and thought about where I was headed.

Hours into the flight, I unbuckled myself and clambered over other passengers to get to the back of the plane. It was colder there, but I didn't mind. The narrow space between cargo pallets seemed luxurious compared with my seat, and there was no one else nearby.

I leaned against the cold metal of the aft passenger door and pressed my face close to a tiny round window. Outside in the night, I could see only the wing, engines, and extra fuel tank, all illuminated by the plane's navigation lights. The rest of the world was a dark and formless void. I stared at the outboard engine, hanging suspended beneath a motionless wing, and at its racing propellor. I could

Below: During August and September, the cold is so intense that even thick, double-pane windows can't keep it out. The moisture contained in my exhaled breath condensed on the inside of my win-dow and formed these ice crystals, which were then lit by the low spring sun.

feel its thrumming power, pulling me toward the unknown, toward a destination of great mystery. I felt like I was on a spaceship, on my way to another planet.

When the horizon finally lightened to blue, then deep red and orange, I searched the dimness below, looking for my first glimpse of Antarctica. I saw an uneven, monotone landscape, but I couldn't be sure if it was a vast field of ice or just a layer of low clouds.

I glanced at my watch, holding it up to catch the dim light in the cabin. It had been over six hours since we left Christchurch. I'd heard stories of planes getting as far as PSR, then turning around and heading back to Christchurch. Nine hours of flying just to end up where you started, and then having to do it all over again the next night! Some people had made two or three attempts before finally getting through. It looked like I was in luck, though. We were well past PSR and hadn't turned around.

A short time later, the loadmaster crawled past the cargo pallet and motioned me forward. The other passengers were already buckling in, and I had to climb over them to get to my seat. Crammed in again, shoulder to shoulder and knee to knee, we waited. I was dying to look outside, but there was only a handful of tiny round windows in the side of the plane, and none within neck-craning distance. I listened for any change in engine pitch and tried to interpret every bank of the airplane. When I thought we were close to landing, I pulled on my balaclava and my gloves and mittens. A moment later, I felt the plane bounce onto the snow. The engines roared into reverse thrust, then throttled back. The large cargo hatch at the back of the aircraft opened, and a cold rush of air swept through the cabin. The pallet containing our luggage slid out onto the snow.

The plane lurched to a stop with the engines still running. I knew the pilot wouldn't shut them down, for fear the cold would keep them from starting again. The tiny hatch through which we had entered was kicked open and the loadmaster directed us out of the plane. As I started down the stairs, he shouted in my ear to stay to the right, away from the propellors. I nodded, pulled up the hood of my parka, and stepped down onto the packed snow of the Ross Ice Shelf.

Outside the aircraft, the roar of the plane's four massive engines was beyond deafening, and they kicked up the snow behind them into a violent man-made blizzard. I moved away, following the lead of my fellow passengers who, like me, were anonymously bundled up, our faces hidden by hoods and masks. My balaclava and parka hood obscured my vision in every direction but forward. I felt like I was moving through a tunnel. My nose stung. I could feel the tissue in my nostrils freezing and thawing with each breath of bitterly cold, dry air. My exhalations formed a cloud in front of my eyes, making it hard to see.

When I got far enough from the plane, I could hear the tinder-dry snow squeaking beneath my thermal boots. I looked up and held my breath. Everything around me was blue. The sky, the vast field of snow on which I was standing, even the ice crystals flickering in the air — all of it was blue. Blue in a million hues. In the distance, jagged, snow-covered mountains glowed pink and purple from a still-hidden sun. The sky was cloudless, the air dead calm, and the whole world encased in ice.

It was more strange and more beautiful than I could have imagined.

❅ ❅ ❅

Opposite: Cracks that form in the sea ice may sometimes be shoved back together with such force that the ice is deformed and driven skyward to form a pressure ridge. Sometimes, strange shapes are the result, like these "Jaws of Ice."

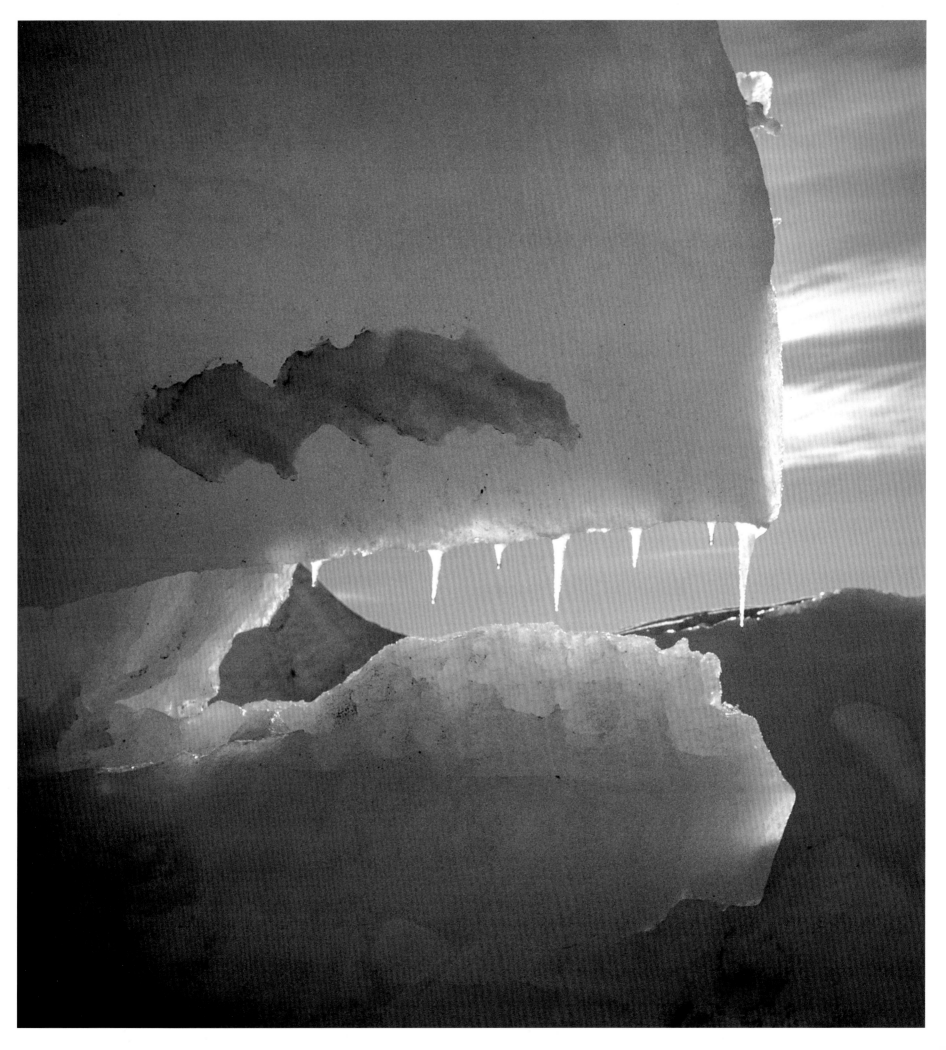

The name *Antarctica* ("opposite of the Arctic") is appropriate, and not just for the obvious geographical reason. The Arctic region is an ocean surrounded by continents; Antarctica is a continent surrounded by ocean. The difference makes Antarctica colder, higher, icier, and more inhospitable. Winds and ocean currents race unimpeded around the continent, thermally isolating it, keeping it colder than it would otherwise be. Most of Antarctica, which is about the size of the United States and Mexico combined, is covered by a 10,000-foot-thick cap of ice called the Polar Plateau. The few ice-free regions are located near the coast and comprise only 2 percent of Antarctica's area.

Ross Island sits at the southernmost end of the Ross Sea,

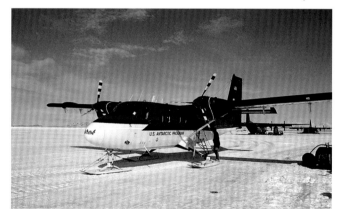

about 800 miles north of the South Pole. The massive Ross Ice Shelf, essentially a glacier the size of France, abuts Ross Island, joining the island to the Antarctic continent about thirty miles away, across McMurdo Sound.

The Sound is contained on the east by Ross Island, on the west by Western Antarctica, and on the south by the Ice Shelf.

McMurdo Station is on Ross Island, at the tip of a volcanic peninsula that juts out into McMurdo Sound from the flanks of Mount Erebus, the taller of two mountains on the island and one of only two active volcanoes in Antarctica. A dirt road leads from the station through a pass and down a hill to New Zealand's Scott Base, a little over a mile away. From there, the road transitions to the packed snow of the Ross Ice Shelf and runs another several miles to Williams ("Willy") Field, McMurdo's permanent airfield for ski-equipped aircraft.

McMurdo Station serves as the hub of the U.S. Antarctic Program (USAP). Hercules and smaller Twin Otter aircraft serve as supply and passenger links from McMurdo to Amundsen-Scott South Pole Station and to an ever-changing collection of temporary inland research camps. U.S. planes also fly to the stations of other countries, such as Russia's Vostok Station.

In 1961, twelve nations signed the Antarctica Treaty, agreeing to set aside the continent of Antarctica for peaceful purposes, primarily scientific research. Since then, several more countries have signed on. Though many of these countries

have established research bases in Antarctica (at any given time, there are between forty and fifty active ones scattered around the continent), McMurdo Station is by far the largest. It is the Gotham City of Antarctica. Most of the other bases are quite small by comparison, and most are along the coast, accessible only by ship. A large number of these are on the Antarctic Peninsula, that finger of Antarctica that reaches north to almost touch South America.

The USAP is administered by the National Science Foundation (NSF) through its Office of Polar Programs. The NSF provides funds to researchers who want to study some aspect of Antarctica. Through an independent contractor, and to some extent through the Department of Defense, the NSF also provides travel and logistical support: clothing, lab space, supplies, vehicles, field equipment, food, and housing.

Different buildings are dedicated to each of these support functions. The Berg Field Center (BFC), for example, supplies scientists with the camping and mountaineering gear they need to live and work in the field. During my first year, geologists worked out of the Thiel Earth Sciences Laboratory (TESL), located at the top of the slope McMurdo occupies, just above the BFC. The Eklund

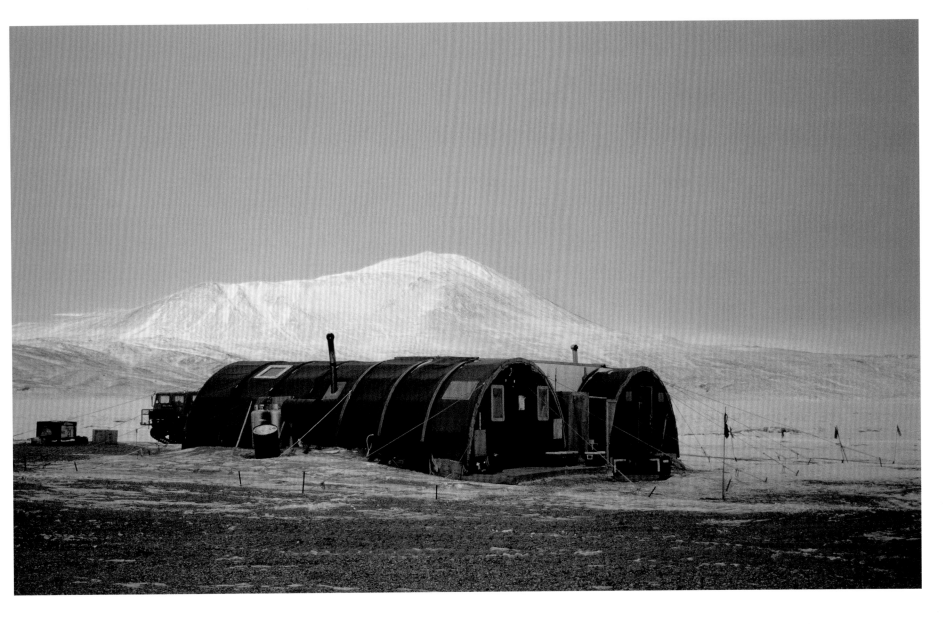

Biological Center (EBC), or just "Biolab," provided lab space and equipment for biologists. Both of these lab buildings were pre-fabricated, boxlike, insulated wooden structures called T-5s. Like the military-surplus, green, half-cylinder-shaped tents called jamesways, T-5s were common and were among the oldest buildings in McMurdo, functional but not pretty. (The laboratories have now been replaced by the state-of-the-art Crary Science and Engineering Center [CSEC]. The EBC has been demolished, but

TESL now serves as a base for the snowcraft school instructors who, each year, teach McMurdo residents how to survive in the wilds of Antarctica.)

A variety of berthing structures were scattered around town. Near the Biolab were two dormitories, the large, metal-skinned Hotel California and the smaller, wood-sided Mammoth Mountain Inn, as well as a few T-5s and jamesways. Additional large dorms, T-5s, and jamesways were located on the other side of McMurdo, near the power plant. Most Navy personnel

were housed in Building 155, the largest building in McMurdo. Situated in the center of town, 155 also held the galley, the ship's store, the laundry, the library, and the liquor store.

Above: The New Harbor field camp, a semipermanent scientific camp built with jamesways, sits on the edge of the sea at the mouth of Taylor Valley. Jamesways are portable, expandable shelters constructed of wood frames, wood floors, and insulated cloth coverings. Another jamesway was built on the ice over a dive hole to serve as a dive hut.

On my first full day at McMurdo Station, I walked around, trying to get my bearings. Buildings were scattered across the slope of a hill without any sense of order to their placement. Neither was there any color scheme or architectural pattern. Some buildings were blue, others gray, still others green or brown. Most were shaped like boxes, though a few seemed to have had additions hastily tacked on. Jamesways were plunked down here and there, anywhere there was a spare patch of flat earth. Trucks and strange tracked vehicles, all of them painted red or orange, were parked next to many buildings, and electrical cables ran from the buildings to oil heaters in each vehicle. Telephone poles sprouted randomly all over town. Power and phone lines snaked across the McMurdo sky like a web spun by a drunken spider. I was stunned. McMurdo Station, the flagship of the U.S. Antarctic Program, looked like a shantytown. I'm not sure what I expected, but this wasn't it.

The shabbiness was especially apparent in contrast to Antarctica's austere natural beauty. I stood in front of the Chalet, a wooden A-frame that served as administration center for the National Science Foundation, and looked out across the vast expanse of McMurdo Sound toward the distant mountains. These were the Royal Societies, part of the Transantarctic Mountains, the same ones I had admired from Williams Field just the day before. Their peaks again glowed bright pink, in contrast to the twilight blue of the frozen sea and the cold blue of the sky. The air was crystal clear, so crisp that there was no distance effect. The edges of the peaks were as sharp as if they were only a few feet away instead of forty miles.

That panorama was never the same two days in a row. I had arrived when the sun was just returning from its long winter absence. Since McMurdo Station lies in the shadow of Mount Erebus, my only clue that the sun had cleared the northern horizon was the light on those mountains. Days consisted of a few hours of twilight on either side of noon, though each day the sun rose higher and the period of light lengthened. Every day that went by without a storm, the mountains displayed a different light and color pattern. Some days the clear air acted like a magnifying glass, making the peaks seem as though they were nearly on top of me.

Light was a constantly shifting and changing phenomenon. As the days grew longer, the horizon blazed with color. Sunsets lasted for hours, with both the sky and the ice on fire. Yellows and oranges shifted to pinks and deep reds, and finally, almost imperceptibly, to deep purples and violet. Frequent nacreous (mother-of-pearl) clouds added to the spectacle. These carnival-colored clouds refracted the light of the setting sun in a way that made them seem to glow with their own internal light. Roiled into wisps or pillows by violent high-altitude winds, they shone eerily red or green, covering the twilight sky with a Picasso–Van Gogh merging of bold strokes and unlikely color schemes. I stood one afternoon, awestruck by this display of color in the heavens, wondering how a place so inimical to human life could be so utterly beautiful.

McMurdo confounded my other senses as well. The only sounds I heard, except for the whistling of wind through overhead wires, were man-made — growling diesel engines, vehicles rumbling and clattering across rock-strewn roads, snow being shoveled, doors slamming, voices. There was no natural odor. There were no plants or flowers to create smells, nothing but ice, snow, rock, buildings, vehicles, boxes, piles of construction material, and piles of debris. The air smelled cold, and it was redolent with diesel fumes. Plumes of exhaust wafted upward from every building.

The extreme cold made the air dry, too. Bone dry. Desiccated desert dry. Suck-the-moisture-right-out-of-your-body dry. Dehydration was a constant threat. I'd heard of people being hospital-

ized and placed on IV fluids because of it, but most people simply operated at a chronic level of dehydration. It was insidious. It also exacerbated the infamous "McMurdo crud," a particularly virulent and long-lasting form of the flu that seemed to strike almost everyone.

Even worse was the static electricity the dryness caused. Sliding across a truck seat or simply walking across a floor was enough to build up a substantial charge. When I touched a truck handle or a doorknob, I received a nasty shock. Bolts of blue lightning bright enough to light up a dark room arced through the air and left burns on my skin. Pulling dry clothes out of a dryer made my hair stand on end, and it was impossible to avoid being shocked by the metal of the dryer itself. Shaking hands was electrifying. Once, while leaning close to whisper in someone's ear, I took a very painful static lightning bolt up a nostril.

The air sometimes seemed like a living thing, a diaphanous beast that disliked people. The cold and dryness were bad enough, but it was the wind that gave the beast its bite. The wind was a constant companion, aided and abetted by the local geography. Two hills guarded the south end of McMurdo Station, Crater Hill and an old cinder cone called Observation Hill. Between them was a pass and the road to Scott Base. The prevailing southerly wind rushed unimpeded over the Ross Ice Shelf, accelerated through the pass, and swept down over McMurdo, stinging my eyes and cutting through seams in my clothing. It probed me relentlessly, pushing at me, fighting me every moment I was outside.

Storms were frequent. The people around me called them "Herbies," though I could not figure out why. Clouds would roil up over a narrow bluff barely visible to the south, then descend over McMurdo with a rush of howling wind and blowing snow. The weathermen had a terminology for these conditions. Condition I was the worst, with either extremely limited visibility, extreme cold temperatures, hurricane-force winds, or all three. During Condition 1, we were prohibited from leaving a building. During Condition 2, we were allowed to move between buildings, but travel on the sea ice was restricted. Condition 3 meant the weather was fine and no storms were imminent. Of course, "fine weather" was often still cold and miserable.

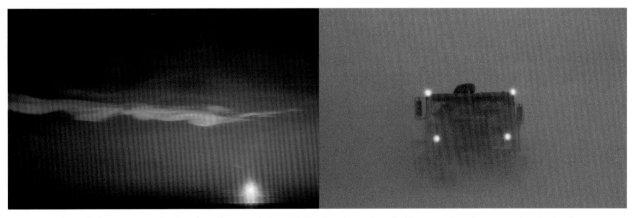

Above left: Nacreous cloud and setting sun during Winfly, the six-week period between late August and early October. Temperatures during this time are among the coldest of the year. Only when the stratosphere drops to minus 112° F or below can these nacreous clouds form from tiny ice crystals and condensed nitric acid. **Above right:** We had gone out to drill a hole through the ice when a sudden storm kicked up, reducing visibility. Though the flags are not easily discernible in this photo, we were on a flagged road that led us safely back to McMurdo Station.

Most of the year, the sea in front of McMurdo is completely frozen over with annual ice. It begins to freeze early in the winter, in March or April, but storms often keep it from solidifying until May or June. It continues to freeze and thicken until early summer, around the end of October, reaching six feet or more. Then, as summer temperatures climb, the ice begins to degrade. The Ross Ice Shelf is permanent and much thicker, from forty-five feet thick at the front edge near Scott Base to hundreds of yards thick nearer the center.

The sea ice on McMurdo Sound is also called "fast ice" because it is solid, or fast, to each shore. Cracks form in this ice, largely because the relentless northward motion of the Ross Ice Shelf shoves the sea ice ahead of it, bending it around islands in the Sound. Sometimes the ice sheet simply splits cleanly apart, then freezes again with a gap between the two sheer sides. As long as they aren't too wide, these "straight edge" cracks are not hazardous and can be crossed by a vehicle. The ice is thick right up to the edge. A crack that is "working" is continually moving, opening up a little at a time. It does so slowly enough for the newly exposed seawater to freeze, forming a thin skin that spans the opening between the thicker edges of the crack. This makes it dangerous. The ice in the center is often too thin to support a vehicle, but a light dusting of snow can make it blend into the thicker ice. Despite these dangers, biologists and oceanographers use the ice as a research platform and as a highway to their study sites.

The sea ice is also the location of the annual ice runway, on which the wheeled C-141 Starlifter and C-5 Galaxy jets land. A new runway is fashioned every season by blowing off built-up snow, checking for cracks, and grooming the ice. The ice runway is closed and the rest of the sea ice placed off-limits to vehicular travel by mid-December, when warm summer temperatures have made it unsafe. In January, the ice begins to melt and break up. Generally, by the middle of February the sea ice has disintegrated and blown north out of the Sound, leaving open water where planes once landed.

A variety of vehicles are used in Antarctica, from trucks to bulldozers, forklifts to snowmobiles. Most of these operate on the dirt roads of McMurdo Station and Scott Base, but some of the vehicles are specifically designed for snow and ice. One of these is the Spryte, which is little more than a metal box placed over an engine and chassis. Instead of wheels, the Spryte has metal and rubber tracks that allow it to travel over soft snow. The vehicle is controlled by a pair of levers that stick out of the floor between the driver's legs. Pulling on either lever applies a brake to the track on that side. Since the other track continues to turn, the vehicle turns in the direction of the pulled lever.

Below: A C-5 Galaxy, one of the largest planes in the world, on the ice runway in front of McMurdo Station. This was the first time a plane this large had landed on the sea ice at McMurdo.

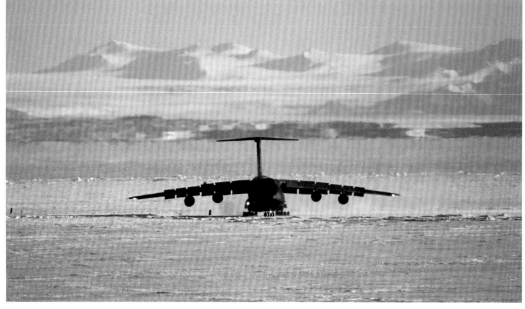

ON THE FROZEN SEA

It was my first time out on the sea ice, and I didn't know what I was seeing. I knew we were driving over two thousand feet of very dark, very cold ocean. That had me unnerved enough. But then, through the foggy windshield of our noisy tracked vehicle, I saw steam venting out of the ice in front of us. I took my foot off the accelerator and let the Spryte coast to a halt. With a leather mitt, I wiped frozen breath off the windshield and looked hard. There were four or five vertical columns of steam, arrayed in a straight line.

Fumaroles? McMurdo Sound was a volcanic area, after all, I thought. I'd already watched plumes of sulfurous smoke streaming out of Mount Erebus, and it was no secret to me that McMurdo Station sits on an old lava flow. So was there volcanic activity out in the middle of McMurdo Sound? And what did that mean for the integrity of the sea ice?

I glanced at Sandra Ackley in the passenger seat, who just smiled knowingly and climbed out of the Spryte. I followed her onto the hard ice. My nose stung briefly as I inhaled the much colder air outside, freezing the mucous membrane in my nostrils. Still, it was a relief to get away from the engine noise inside the cab. John Wood and Rob Robbins, the other two in our flagging party, joined us and we walked toward the miniature geysers. I noticed that, rather than venting constantly, these fumaroles were pulsing; blasts of steam were punctuated by still air. I also noticed that my confusion was amusing my more experienced companions. As we got closer, it became clear why. Away from the rumble of the Spryte's engine, I could hear the rush of forced exhalations. Instead of some strange volcanic phenomenon, these spouts of steam were the breaths of Weddell seals trapped under the ice.

I got on my knees to look at one more closely. The hole in the ice, surrounded by a cone of condensed and frozen breath, was barely large enough for the seal's nose. I could see only two large nostrils and a few whiskers. Then the seal exhaled and I got a faceful of fishy breath. I was dumbfounded. This mammal's only link to the surface and to the air he had to breathe was through a hole barely large enough for his nose, a hole that he had probably gouged with his own teeth. It seemed like an incredibly tenuous existence.

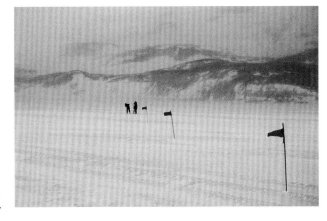

Below: Flagging a road to a dive site on the sea ice. These flags were a lifeline back to McMurdo Station in case a storm came up and reduced visibility.

Rob walked ahead to inspect the other seal breathing holes. A series of seal holes usually indicates the presence of a crack in the ice, and cracks are dangerous. Dangerous for humans, anyway. A few years earlier, four men had been driving their vehicle very near this spot when it plunged through the ice. Three of them were able to get out in time, but the fourth, a biologist like me, was pulled to his death by the sinking vehicle. I tried to imagine what that would be like, to be trapped in a Spryte that was sinking into the lightless depths of McMurdo Sound. Drowning anywhere would be bad enough, I thought, but drowning in the icy black water beneath my feet seemed particularly horrible.

Antarctica was full of hidden hazards. Cracks and thin areas lurked under a masking layer of snow on the sea ice, and deceptively solid snow bridges hid crevasses on glaciers. Each was a deadly trap masquerading as safe ground. Our job today, and one of my new responsibilities as assistant lab manager, was to reconnoiter the ice and establish safe, flagged routes for the scientists who would follow

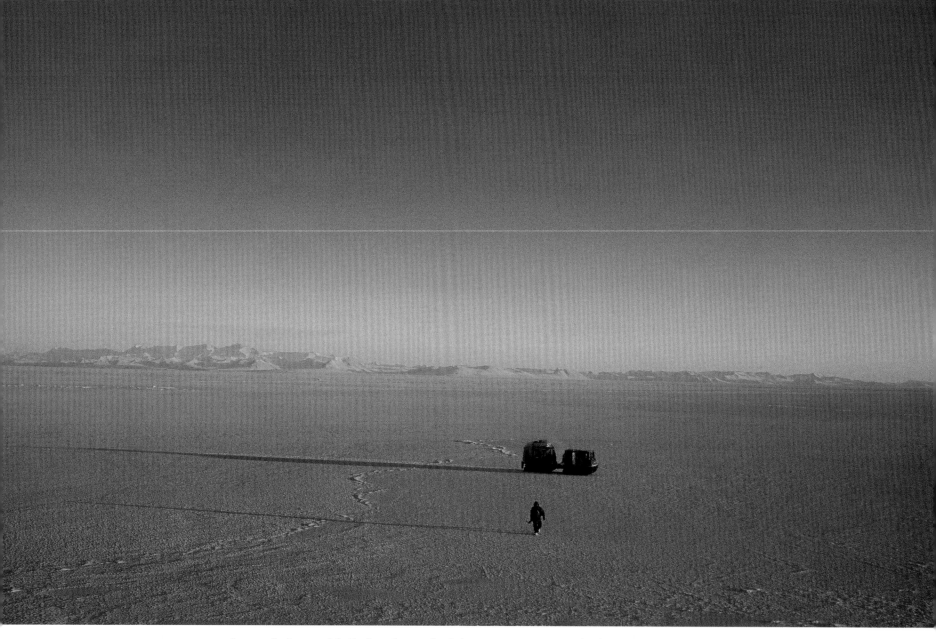

Above: The vast expanse of the sea ice in September, with shadows that stretched for a hundred feet.

us. I tagged along with Rob as he probed the snow. Sure enough, the breathing holes were arrayed along a crack, and it seemed to be a working crack. We'd shift our direction slightly to avoid it.

The road we were making consisted of red cloth flags tied to the ends of bamboo poles. We used a large, generator-powered drill to make shallow holes in the ice, then jammed the bare end of the bamboo pole into the hole. We placed them twenty-five yards apart, in as straight a line as possible. I glanced back the way we had come. The flags stretched back in a diminishing line, a secure and comforting trail of red dots all the way to McMurdo Station. This would be the lifeline for people working on the ice. If a sudden blizzard came up, they could find their way safely home. At least, that was the theory.

To my right, the massive hulk of Mount Erebus loomed, dominating the landscape. A plume of volcanic smoke boiled above the summit, its edges blazing from the sun directly behind it. Purple shadows arced across the sky. To my left, the Royal Society Mountains were a distant ridge, their jagged peaks encased in white. The sea I was standing on was a solid sheet of milky blue that spread out to the horizon in every direction. The air was still and cold — minus 40° F today — and the world was frozen in time. There was ice everywhere I looked — mountains cloaked in ice, massive cliffs of ice, tumbling ice falls, ice covering the sea, ice frosting my beard, and ice freezing my eyelids shut when I blinked.

I sensed magic in the crystalline stillness around us. The only sounds were those of the Spryte motor and the generator, and of our boots crunching on the thin crust of snow coating the ice. If not for the bitter cold — and the fact that we still had work to do — I could have stared at this extraordinary world for hours.

We switched positions, with Rob taking the driver's seat and me manning the drill. I preferred being out on the ice. The walking kept me warm, and with a little distance between me and the Spryte's engine, it was much quieter and more peaceful. The sun popped out from behind Erebus's plume, lighting up the icescape and creating shadows that stretched for a hundred feet. After a while, ice began to build up on my scarf and balaclava. My moisture-laden breath, like that of the seals, was condensing and freezing almost immediately, forming my own cone of ice. Icicles drooped from my mustache.

After what seemed like a very long spell of stop-and-go travel, Rob braked the Spryte and jumped out. We'd done enough flagging for the first day, he announced, and he wanted to make sure we had enough time to investigate the ice caves before dark. I climbed back into the driver's seat of the Spryte and put it in gear.

The surface of the ice had changed. Instead of a slick blue plain, it was now covered with a layer of drifted snow that the wind had scoured into ridges and odd sculptures called sastrugi, which made the driving more difficult and less comfortable. The Spryte bucked and bounced across the uneven ice. To make matters worse, this particular Spryte had a tendency to pull to the right and I had to keep correcting. Because the brakes didn't pull evenly, my attempts to keep the vehicle moving in a straight line resulted in a queasy seesaw motion that had my passengers, all of them more experienced drivers, rolling their eyes. I hit a snow mound and the nose of the Spryte pitched up sharply, then came down with a jarring crash.

After a few more minutes of rough travel, the sastrugi became less pronounced. Snow had drifted up thickly around the Erebus Ice Tongue, a floating glacier that rose out of the ice in front of us. I pulled up close and stopped the Spryte. We grabbed our ice axes and jumped out. The Ice Tongue was a thirty-foot vertical wall of ice, a frozen Great Wall of China trapped in an equally

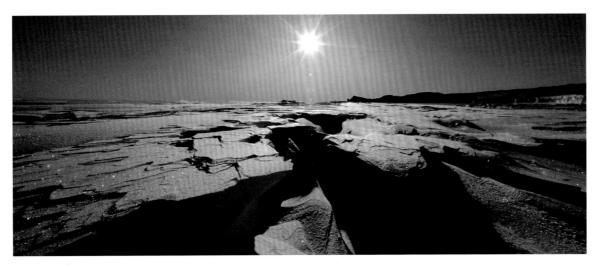

Above: Sastrugi — wind-sculpted snow formations — on the sea ice of McMurdo Sound. They were beautiful, but driving over them made for a bumpy ride.

frozen sea. Rob spotted a dark opening halfway up the wall and we headed for it. Using ice axes to carve steps in the hard snow of the drift, we worked our way up to the hole. Rob stuck his head in, broke away some snow to enlarge the opening, then disappeared inside. Without waiting for a report, I followed.

I slipped down a small hill of ice and snow and sat up in my first ice cave. When my eyes adjusted to the dim light, I could see I was in a small antechamber. On hands and knees, I worked my way around massive columns of ice. They seemed to erupt from the slippery floor and thrust themselves toward the low ceiling, itself a maze of multifaceted ice crystals. The only color was blue, blue everywhere, an intense, deep, bottomless blue.

The passageway of columns gave way to a narrow tunnel sloping downward. Ahead of me, Rob had rigged a rope with ice screws. I grabbed hold and shinnied down. Fifty feet into the heart of the glacier, this tunnel opened suddenly into a great, frozen cavern.

It was a room from the Lost Temple of the Ice Gods. Impossibly smooth walls rose from an equally smooth floor. Enormous, crystal-encrusted stalactites hung down from the ceiling high above. Fantastical shapes sprang from the walls, the result of vast forces that had twisted and bent the ice as the glacier inched along. The only sounds were those I brought with me: my breathing and the roar of blood in my ears. When I moved, the fabric of my one-piece thermal suit crackled in the

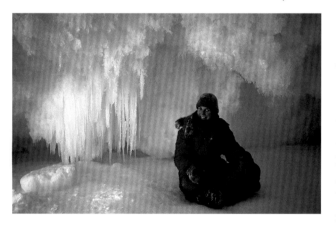

cold. My bunny boots shooshed on the slick floor. I felt as though I had entered a sacred place, and was struck by the sure knowledge that this icy cathedral had never before been seen by human eyes. It was utterly pristine — untouched and unsullied by human presence.

John and Sandra joined Rob and me, and the four of us spent over an hour climbing into lofts and probing dark holes in the ice. There seemed to be no end to this cave. The main cavern was riddled with openings to side chambers, and many of these chambers had passages that led to still other chambers. After squeezing through a narrow tunnel, I discovered a balcony overlooking a giant chamber of twisted and deformed ice. Dozens of stalagmites, some like icy needles and others like blunt columns, jutted up from the floor. It

was chaos, as though the chamber had been flash-frozen in the middle of an explosion.

Finally, the four of us decided it was time to return, and we reluctantly headed back to the entrance of the cave. Night would fall soon, and we wanted to get back to McMurdo before then.

The wind had come up while we were in the cave. I crawled out of the entry hole and into the full force of it. The skin on my face felt like it was being sprayed with liquid nitrogen. I yanked up the hood of my thermal suit and made a beeline for the Spryte. We rode back to McMurdo Station in silence, with spindrifts of snow skittering across the ice in front of us and our newly planted flags straining against their poles.

❉ ❉ ❉

Above: Sandra Ackley sitting in the subdued light of an ice cave. **Opposite:** One of the many ice caves I explored in the Erebus Ice Tongue. This one was a carnival of fantastic shapes and strange formations.

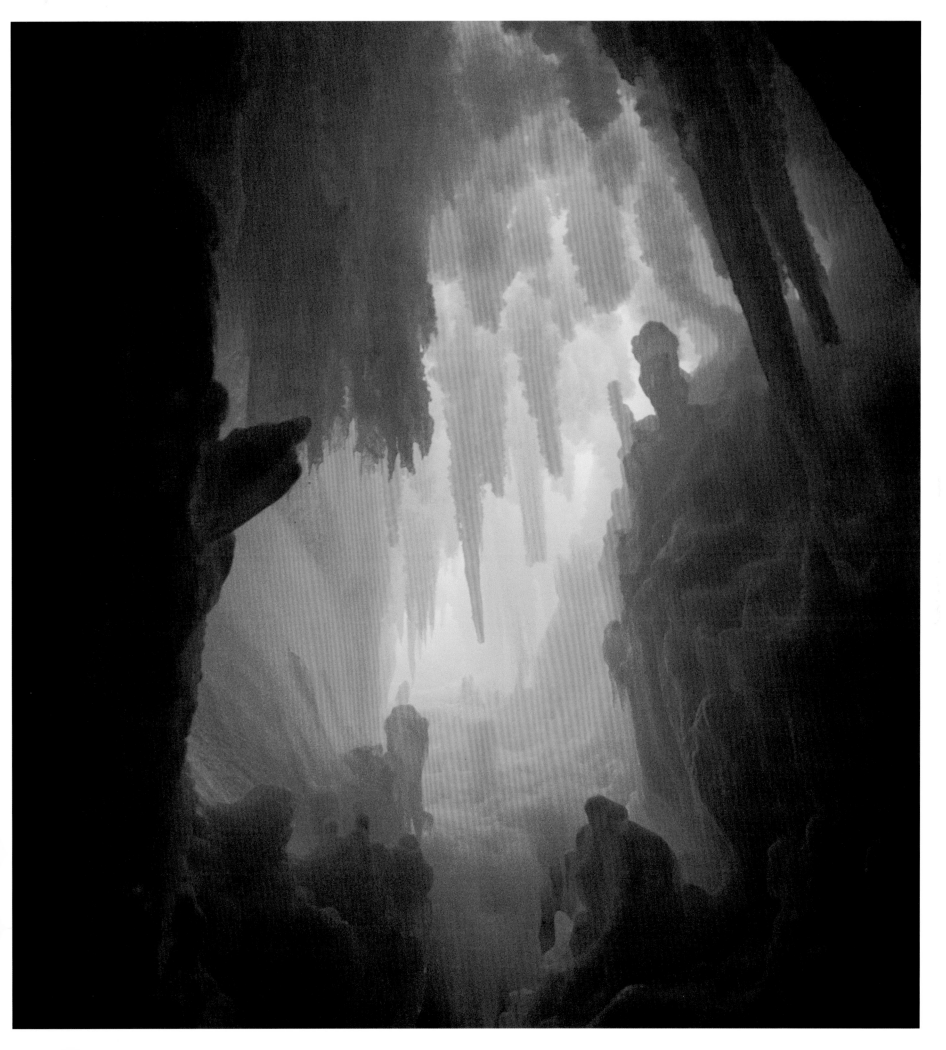

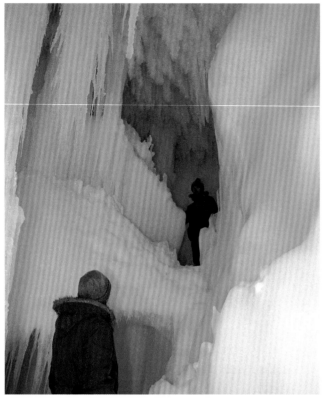

On another flagging trip a few days later, we extended the road to Cape Evans. There was nothing remarkable about Cape Evans itself, except that it was the location of Captain Robert F. Scott's 1910–12 expedition hut, from which he departed for his fatal journey to the South Pole. The boxlike wooden structure sat as it did when Scott's men left it, perfectly preserved by the cold and the dryness. We climbed up from the sea ice and ducked as we entered through the low-hanging door.

A faint musky odor with a hint of fishiness stung my nostrils. I saw the source almost immediately. Seal hides, with the blubber still attached, lay stacked inside the vestibule. We passed through and into the main room of the hut. It was dim inside, illuminated only by sunlight through a couple of ice-encrusted windows. Seventy-year-old food supplies were neatly stacked on shelves near the entrance. Beyond those were bunks, with bedding still crumpled on top and boots hanging from posts. It looked as though the occupants had left just that morning. In a separate room, I found Robert Scott's and Edward Wilson's bunks. Shelves over the beds were still laden with their personal effects. A mummified emperor penguin lay on its back on a table between the two bunks. I wondered if Wilson had intended to dissect it upon his return. Of course, he never did return. He died on his way back from the South Pole, along with Scott, Birdy Bowers, Edgar Evans, and Lawrence Oates in March 1912.

Running down the center of the main room was the long dining table I'd seen in the 1911 photo showing Scott and his men gathered around for his birthday meal. Standing where the camera had been placed, I almost thought I could see their ghosts, passing plates back and forth, engaging in quiet conversation, hunkered down for that winter almost a century ago.

<p style="text-align:center">❄ ❄ ❄</p>

Of all the strange things I discovered during my first few weeks, McMurdo's social and cultural life was the strangest of all. Part military base, part wildcat camp, part research station, McMurdo was a bizarre, hybrid, frontier town, with its own unique language, laws, and social structure.

At the beginning of Winfly, many winter-overs were clearly pleased to see new faces. I noticed this most clearly in the galley, where everyone went for meals at the same time. The winter-overs sat eagerly with the incoming people, reestablishing friendships and making new acquaintances. For the first few days, every meal seemed like a party. There were a few winter-overs, however, who seemed unable to deal with the new population. They avoided the galley, or came in only long enough to grab some food and quickly leave. As time wore on, many of the initially exuberant winter-overs moved back into their well-established winter social circles, while some of the more reticent folks broke out of their shells and became more social with the new people.

Above: Sandra looking up at John, who was exploring the "loft" in a multilevel ice cave.

The person I was replacing was a good example. At first she was eager to sit and eat with me, and to talk about our boss and our work, but this behavior quickly evaporated. Soon she was back spending all her time with her winter friends.

I'd been warned during my orientation back in the States that I should tread lightly around the winter-overs. I was given the impression that we could encounter almost any reaction from them, and that they might exhibit a certain emotional fragility. When I arrived, I did sense a territoriality, as if McMurdo was their home and we were rudely barging in. One woman barely acknowledged the existence of anyone other than her fellow winter-overs. At first I thought she was being aloof, but then I realized she was just overwhelmed and ill-prepared to deal with the onslaught.

It didn't help that the sex ratio was grossly unbalanced. Out of almost three hundred people, only about fifteen were women. This made for a very odd social dynamic. The newly arrived women were immediately the center of attention, all the time and everywhere. This was brought home to me very graphically soon after I arrived. I happened to walk into the galley at almost the same time as an attractive woman who had come down on the flight after mine. The entry door was at one end of the room, and the food-serving area at the other. People entering the galley had to walk the entire length of the room, past all the tables, to get to the serving line. As soon as that woman walked in, every male head in the room turned to look at her, a hundred guys all swiveling their heads as one. Even though I was walking behind her and I knew it wasn't me they were looking at, it was still very unnerving. I slowed down to put some distance between us. It was just too weird to have all those faces tracking my progress across the floor. The woman marched stiffly forward, keeping her gaze straight ahead.

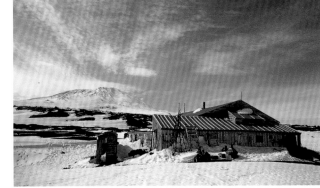

Another woman told me of being in the Chief's Club on her first night. She sat on a bar stool and was immediately surrounded by a cluster of eager young men. Each of them did his best to engage her in conversation, while she felt both flattered and flustered by all the attention. The questions came fast and furious.

"What's your name?"

"Where are you from?"

"What do you do?"

"Is this your first time to Antarctica?"

Every one of them bought her a drink. Ten or twelve cans of beer were lined up like an aluminum train on the bar next to her seat.

Each of the women dealt with this intense pressure differently. A couple of them erased their femininity and tried to blend in as "one of the guys." Alice, who had been to McMurdo before, seemed

Above: Robert Scott's 1910 hut at Cape Evans, preserved by the cold and the dryness. It is considered a museum and a historical site and is protected by treaty. **Following pages:** This geodesic dome and buried tunnel are part of Amundsen-Scott South Pole Station, named in honor of the first men to reach the southern geographic pole. Norwegian Roald Amundsen was first, arriving at the pole by dogsled in December 1911. A month later, in January 1912, Englishman Robert F. Scott and his men reached the same spot by foot and ski. This South Pole station was erected above the snow in the 1970s. Over the years, it has been slowly buried. Currently, a new South Pole Station is being built to replace the one shown here.

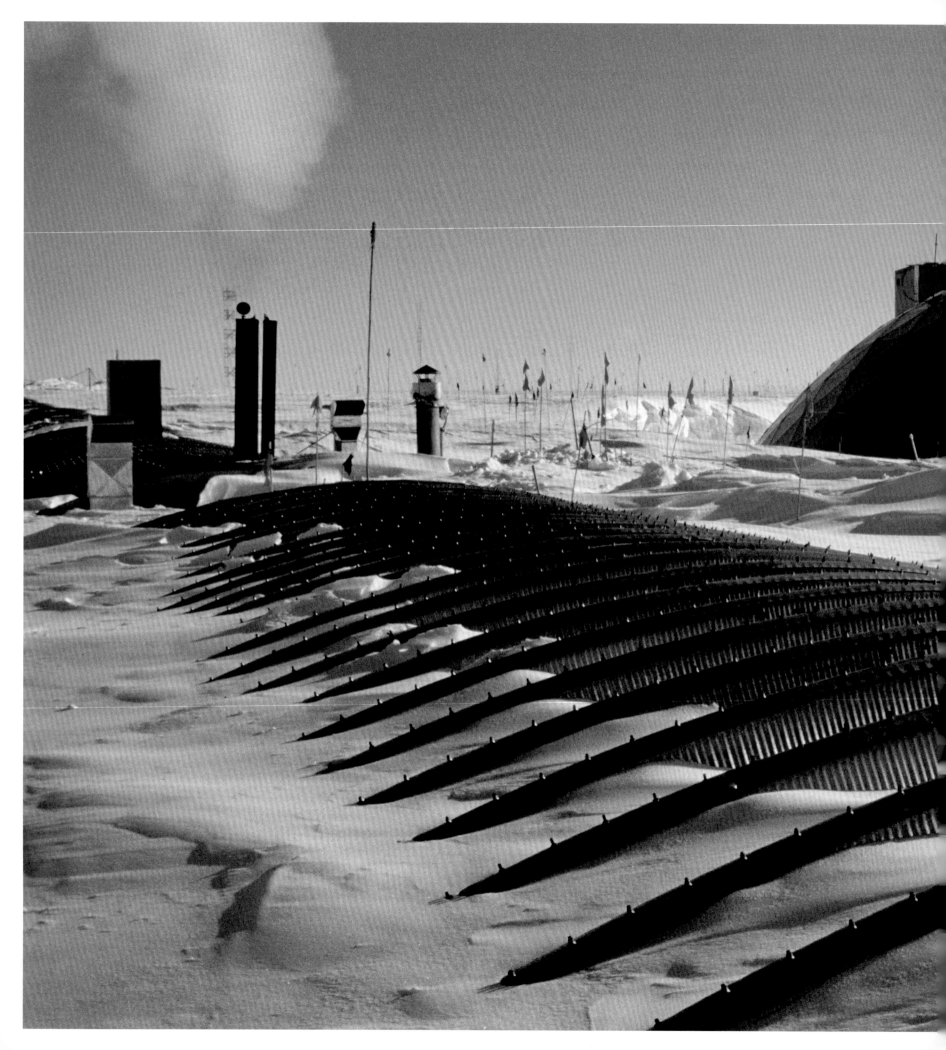

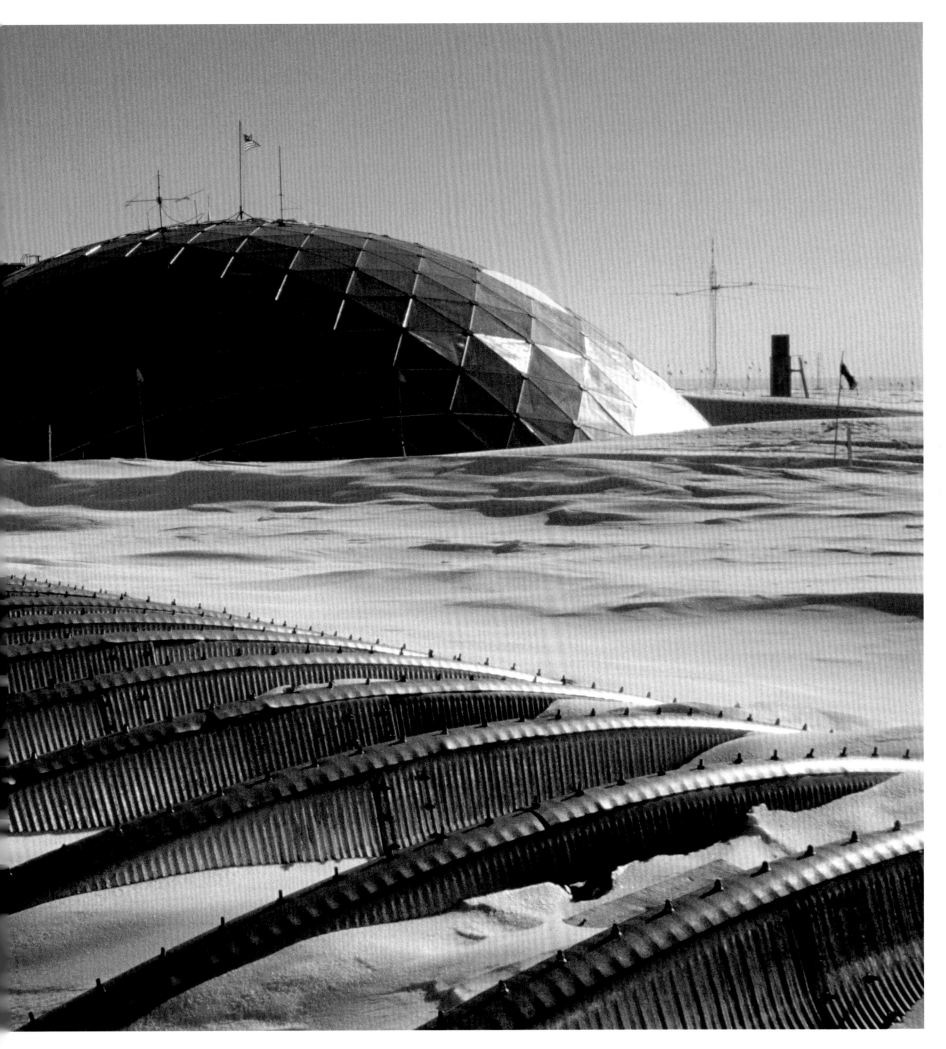

In those parts of the earth where plants grow, it is the solar cycle that determines seasons. Spring means the return of warmer weather. Leaves sprout from winter's bare branches, flowers pop out of the ground, birds flutter and sing. The world opens up to new life.

The solar cycle determines seasons in Antarctica as well, but only insofar as it affects the movement of people. The arrival of people at "Winfly" (short for "winter fly-in," even though it takes place at the very end of winter) signifies a kind of spring. This is the advance guard, the people who will help prepare the station for the influx of people ("Main Body") at the beginning of October. Thus the entire period from late August to the beginning of October is called Winfly, even though the flights end in August. During this time, the sun is slowly returning to the Antarctic after the long winter darkness. There is a day/night cycle, with the days growing steadily longer and the nights shorter.

Flights to McMurdo resume at the beginning of October. Those flights, which signify the start of Main Body, arrive packed with support staff and scientists eager to get to work. The Main Body period, from October to the end of February, is the summer (also called the "austral summer season"). During this time, nights disappear completely. Daylight lasts for twenty-four hours, and it's as bright at midnight as it is at noon. The sun circles the heavens, dipping slightly lower in the west and rising higher in the east.

Just when it seems as though day will last forever, the sun starts to sink again. The weather turns stormy and the world gets darker. People rush to leave McMurdo. The moment the last plane lifts off from Williams Field and heads toward New Zealand at the end of February, winter has begun.

The coldest time of the year is often at Winfly, when temperatures hover around minus 30° F and windchill temperatures of minus 100° F are common. This is often the stormiest time of year as well, as the returning sun creates wide temperature differentials. It stays cold throughout October, but by the middle of November things have begun to warm up a bit. Storm activity eases and, if it weren't for the almost constant wind, McMurdo could almost be considered pleasantly comfortable. At the height of the summer, in late December and early January, temperatures can actually rise above freezing, to as much as 36° F. They fall quickly, though. By the middle of February, temperatures are back down to the teens and twenties.

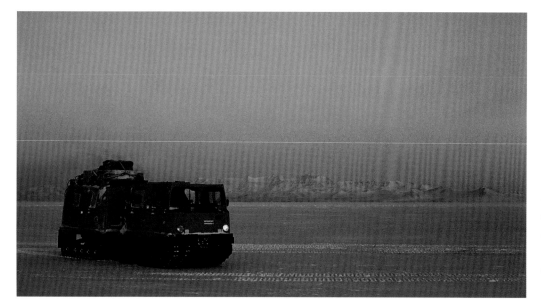

Above: This Haaglund is one of the many tracked vehicles we took out to reconnoiter the sea ice. This is a day in early September, when the sun remained very low on the northern horizon. In the distance are the Royal Society Mountains.

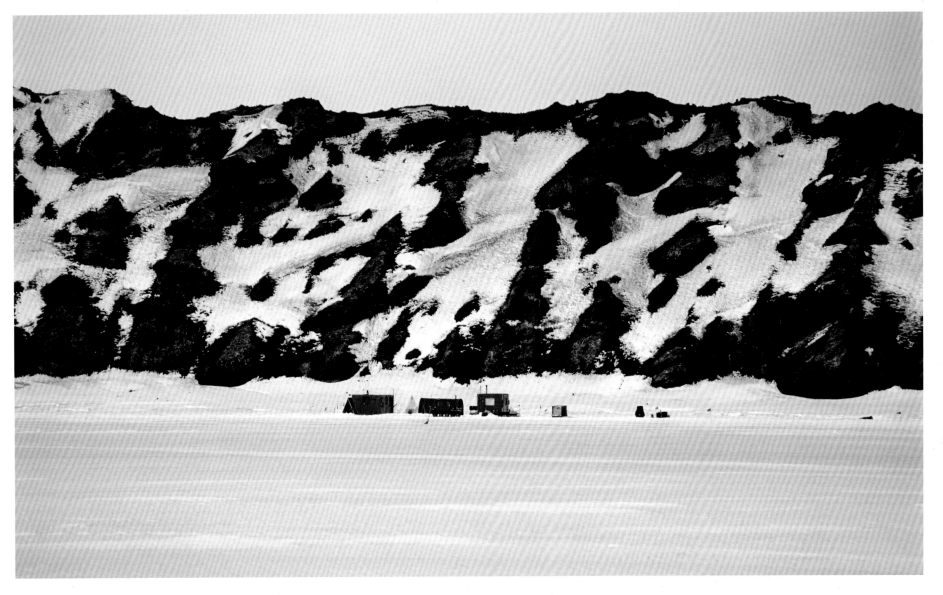

not only to relish the attention, but to expect it. Her dorm room was a very popular place, as far as I could tell. Tina, who was new to McMurdo, also basked in the attention. For the first couple of weeks, she had a party in her room every night, five or six guys and Tina, having a great time. It didn't take long, though, for things to get weird. When the pressure became overt and intense, Tina suddenly shut down the party and withdrew. It was just too much.

Tina, like me, was an FNG (f------ new guy [or gal]). As "fingies," we were fair game for "packing" by our more experienced colleagues, OAEs (old Antarctic explorers). This involved being dragged outside and having one's clothing packed with snow and ice. It didn't sound like fun, and once I learned that packing generally required a certain level of drunkenness on the part of the participants, I made it a point to avoid the clubs.

Heavy drinking was a regular McMurdo pastime. Alcohol was subsidized and cheap, and consumption was high. After all, the U.S. Navy had established McMurdo Station in the mid-1950s, and drinking, as I understood it, was a long-standing Navy tradition. Even though the percentage of civilians in McMurdo was increasing every year, the tradition had persisted. All the bars closed at 11:00 P.M. during the week, and every night at five minutes after the hour I heard men staggering back to their rooms. I was staying in the Mammoth Mountain Inn, and the whole building would shake when the drunks slammed doors and stumbled into walls. Half the time

Above: A typical science field camp on the ice. This one was placed next to Big Razorback Island, one of the remnants of an enormous, ancient caldera.

they'd shout something slurred and incomprehensible at one another. One night I was awakened by the sound of some poor slob gagging and vomiting right outside my window. A few guys worked all day, spent every night in the bars, woke up the next morning with screaming hangovers, then did it all again. I couldn't understand how they managed to function.

The days grew longer, but not appreciably warmer. Storms and blizzards roared through town on a regular basis, burying everything in snow. At times it seemed all I did was shovel snow, just in time to have it build up again. Between storms, though, the returning sun began to light the world around me. By the end of September, sunlight was falling on McMurdo for a few hours each day. It was still bitterly cold, but summer was coming.

The turmoil of early Winfly had settled into a new equilibrium. The winter-overs and Winfly people had become integrated into a single community instead of two separate ones. But that equilibrium was about to be disrupted.

I could see it in the way people were acting. As the first of October and the arrival of the first flights of Main Body grew closer, the Winfly people who would be staying through the summer became more frantic about work that needed to be completed. The winter-overs, on the other hand, grew more relaxed. In a few days, they'd be winging north to trees and beaches and warmth. At this point, anything they hadn't accomplished no longer mattered.

Soon McMurdo would be overrun with even more new people. The Air Force C-141 Starlifters about to land on the ice runway in front of the station would deliver a hundred a day. Barring weather delays, four hundred people would arrive within a week. McMurdo's population would more than double.

It was going to get nuts.

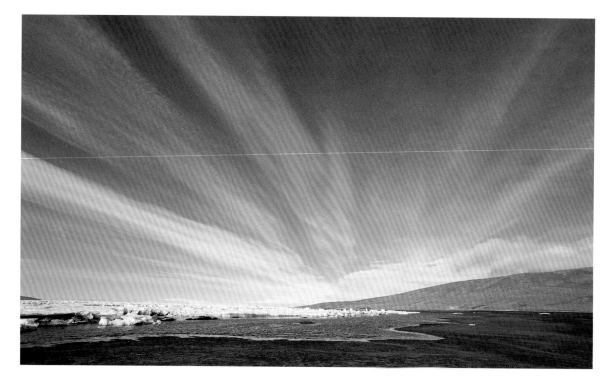

Right: Looking toward Ross Island and Mount Erebus from the shores of New Harbor, at the eastern end of Taylor Valley.

There were four clubs in McMurdo when I arrived, reflecting the Navy culture that had established them: the Officers' Club, the Chief's Club, the Erebus, and the Acey Deucy, which was the enlisted-men's club. Only the Chief's Club and the Acey Deucy were open during Winfly. When all four clubs were open, the Navy had strict rules about who could go to which ones, based on rank. Civilians were allowed to go to any club, but tended to segregate themselves, with scientists and managers gravitating to the "O" Club and blue-collar occupations spending their time at the Acey Deucy and the Erebus.

The galley was also organized along Navy rank lines. The enlisted side was larger. It was a rectangular room with rows of rectangular tables. On the other side of a wall was the officers' side, a smaller room with round tables and a more intimate atmosphere. During the winter and all through Winfly, only the enlisted side was open. Everyone ate from multipartitioned metal trays that I was certain were identical to the kind used in prisons.

Galley food was not impressive. To be fair, the cooks had just come out of a long winter, and they were burned out. Suddenly they had three times the number of people to cook for — with no additional staff. In addition, the ingredients they had to work with were less than spectacular. Although fresh fruits and vegetables had been delivered along with us passengers, most of the available food supplies were either frozen, canned, or dried. All of it was at the very least eight months old, since it had been delivered on the previous season's resupply vessel. I was convinced some of the meat was much older. (At one point, I spied the date on a box of lobster tails: 1969. They were thirteen years old!)

The food was heavy on meat, fat, and starch, high in calories and low on flavor. Meats were usually overcooked, rendering them tough and dry. The vegetables were also overcooked, resulting in mush. Most offerings were bland, except for an occasional excess of salt. The cooks worked through a rotating menu of the same dishes, repeated every couple of weeks. It wasn't all bad, of course. Between the chicken yakisoba and fried rabbit, there were special dinners, like "Mexican night," but these were infrequent. I ate a lot of salad, until the fresh vegetables ran out, and then I ate way too many New Zealand ice cream cups. The baker, unfortunately for me, made exceptional donuts. Between the high-fat food and the abundant desserts, I sensed trouble.

The galley was one of the few places where there were smells other than that of diesel. But they were the smells of an institutional kitchen, with all the food aromas mixed into one blended smorgasbord that usually had little appeal. Just like randomly mixing a bunch of different paints together will produce a muddy brown, the random blend of food smells in the galley produced a "brown" odor.

Left: McMurdo Station's Halloween party. This was the wildest party of the year, with everyone blowing off steam from a stressful month. I was amazed by the creativity and resourcefulness it took to come up with some of the costumes.

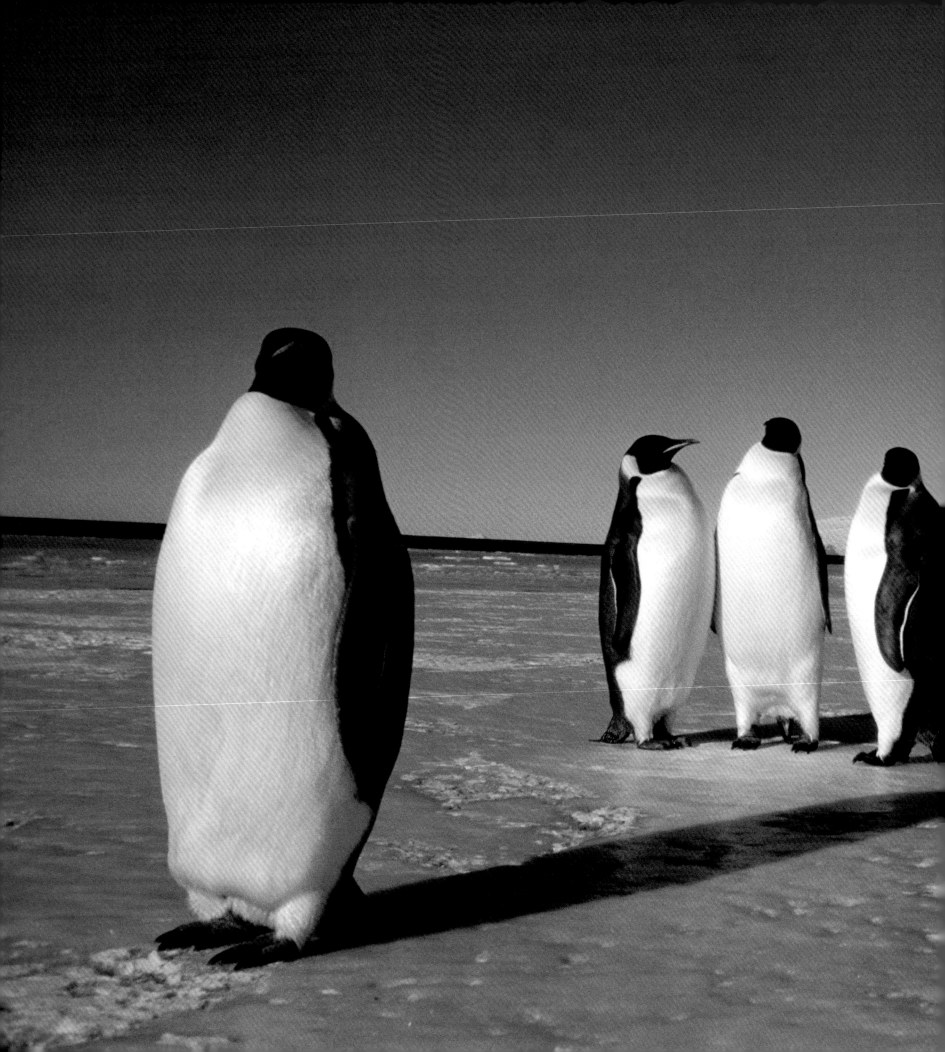

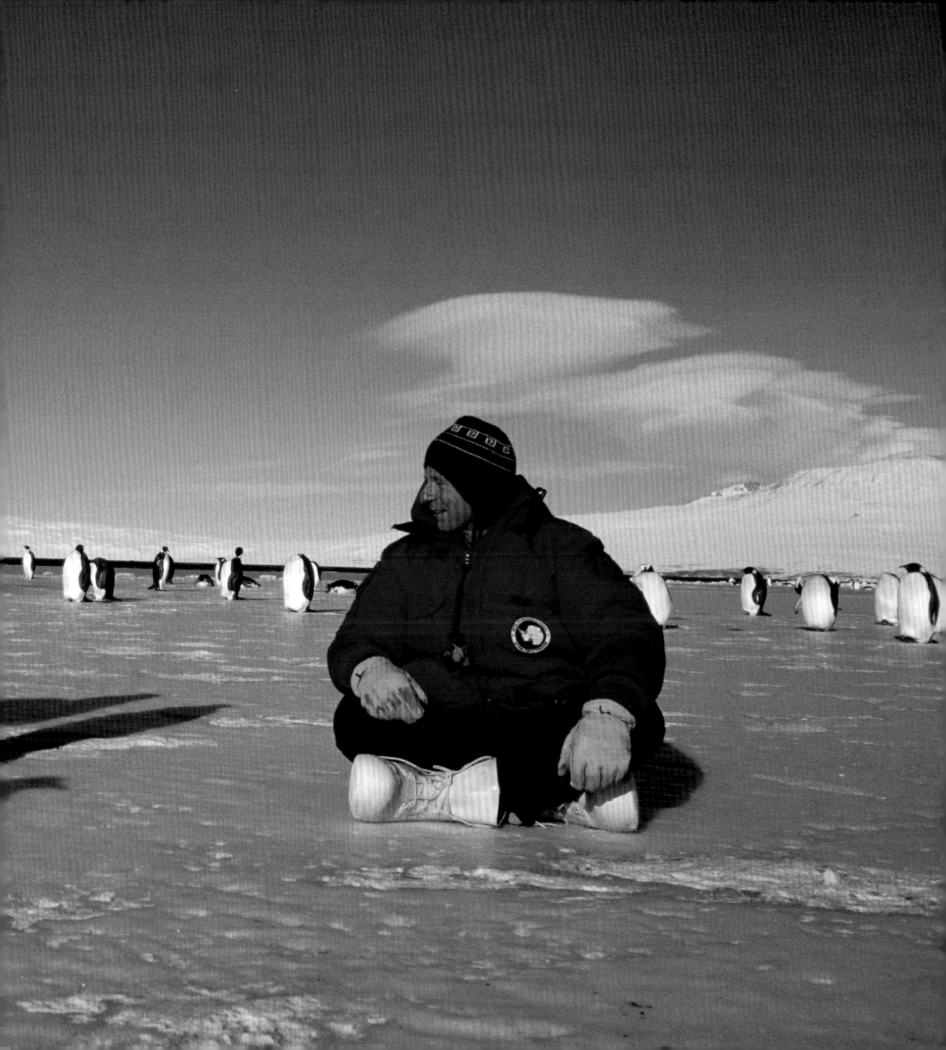

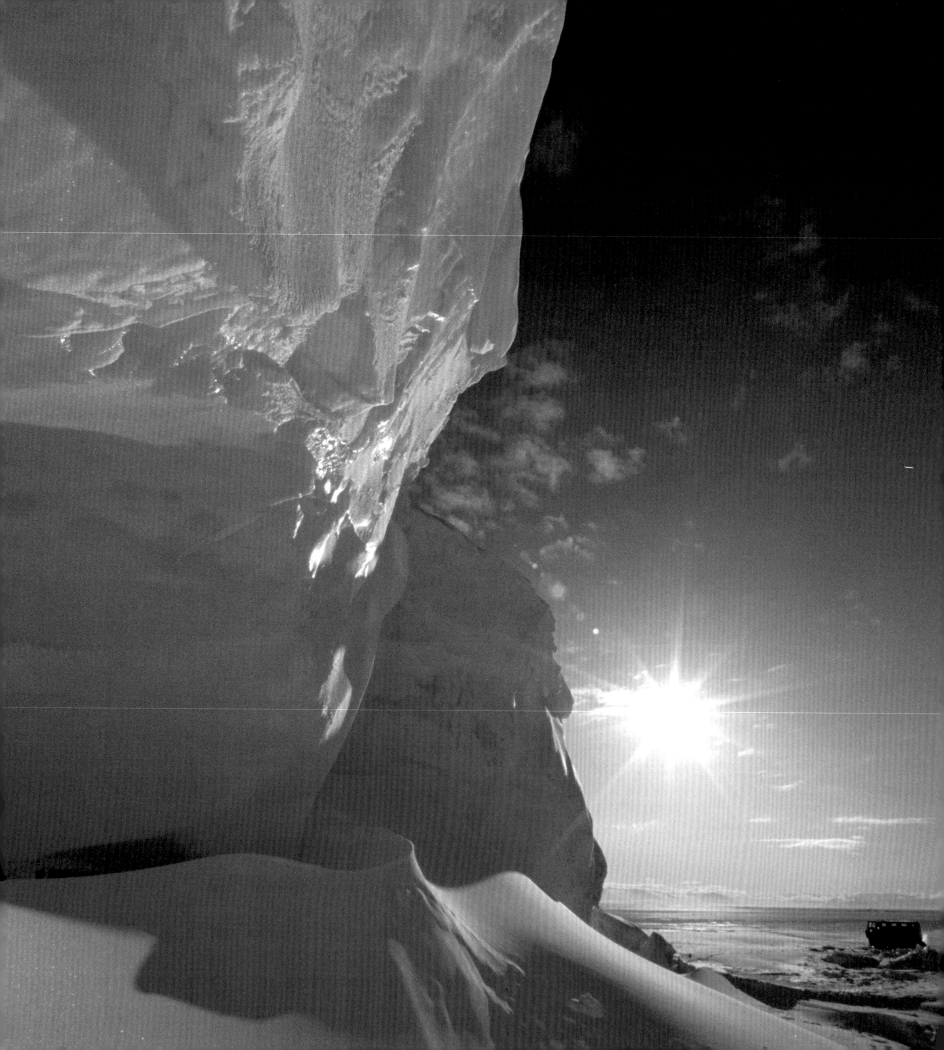

Summer

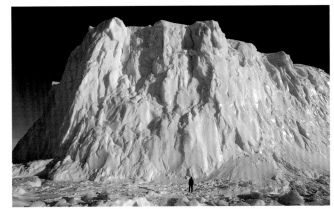

I stood in front of the Biolab and watched with mixed feelings as the first C-141 descended over the Royal Societies and slid gingerly onto the frozen sea, kicking up a cloud of snow with its reverse thrust. Moments later the muffled roar of the jet engines rolled over me. Winfly had been a time to explore and learn about this new world, and the pace of life had been slow. As soon as the people on that plane motored into town, that would change.

There had already been a few changes. I'd had to give up my single room in the Mammoth Mountain Inn and move into another dorm across town. Berthing was very tight during the summer, and almost no one got a room to himself. Some had to sleep in bunkrooms with ten or more people. I was one of the lucky few who had to share a space with only one other. In my case, that one other was a fellow named Bob Simms.

Bob was an interesting character, tall, lanky, laconic, with a large mouth, enormous lips, and the pallid skin of a man raised in long winters. We'd shared the same hotel room in Christchurch. He seemed intelligent and easygoing, and we had become friends. Like me, he was going to Antarctica for the first time. When we were told we had to choose a roommate for McMurdo, we had agreed to extend the Christchurch arrangement. It seemed to me that it would work out perfectly.

Previous pages: Curious emperor penguins (*Aptenodytes forsteri*) check me out at the ice edge. Emperor penguins are irresistibly drawn to objects on the ice. Since the sea ice is a relatively featureless plain, almost any object stands out in dark contrast, easily spotted from far away. When I arrived at the ice edge, there were no penguins to be seen. Moments later, penguin heads began bobbing up in the water, and soon the birds were popping up onto the ice. They waddled over, almost to within arm's reach, then stood there with feigned nonchalance, all the while stealing glances at me from the corners of their eyes.
Opposite: The northern side of the Erebus Ice Tongue, reflecting the summer sun. **Above:** A towering mountain of ice. The face of the Barne Glacier in the harsh summer sun.

There was only one problem: He snored. No, that's the wrong word. Bob *roared* in his sleep. He growled and grated and sawed and gurgled and popped. He was *loud*. When I mentioned it to him in passing, he said it was only because he had a cold and normally he didn't snore at all. I was a bit dubious, but I accepted his explanation. Nonetheless, during those nights in Christchurch, sleep for me was elusive. One night, after tossing and turning for hours amid the rumble from Bob's side of the room, sleep-deprived and perhaps not thinking altogether too clearly, I devised a plan. I didn't feel like I knew Bob well enough at that point to yell at him or throw a shoe, but I figured if I just made some sort of loud, nondescript noise I might wake him enough to make him roll onto his side and stop snoring long enough for me to get to sleep. So I sat up in bed and grunted, a deep, loud, drawn-out, guttural growl. Sure enough, Bob stirred in his bed and stopped snoring. I lay back down and closed my eyes. A few minutes later, however, he was at it again. So I repeated my performance. Once again, he stirred and stopped snoring. I lay back down. This time he didn't start again immediately, and I was able to fall asleep.

The next morning Bob seemed somewhat reticent. Over breakfast, I mentioned what had transpired the previous night. Immediately, a look of relief came over his face. Apparently, he had heard my growls in the night and, each time, had sat up just in time to see me lie back down again. The reason he had not started snoring again the second time was because he was scared to death. Here he was, he told me, stuck in a small room in a strange town with some guy who was sitting up and growling like an animal in the night. Bob didn't know if I was doing it in my sleep (bad enough) or if I was truly a nighttime nutcase. He lay with his eyes wide open, expecting me to jump out of my bed at any moment and attack him.

Now that we were roommates once again, I did feel like attacking him. If anything, Bob's snoring was worse *after* his cold. In fact, he had sleep apnea, a condition in which a person suddenly stops breathing during sleep and then, moments later, struggles to semiwakefulness, gasping for air. I felt like I was sleeping with a rattling old generator that kept cycling on and off and was in serious need of repair.

One night I was lying in bed, my pillow over my head, desperately trying to get some sleep, while Bob was in his bed across the room, blissfully vibrating the walls. Suddenly, the snoring stopped. I breathed a sigh of relief and rolled to my side, thankful for the respite. A moment passed without a sound. Then another. I opened my eyes and held my breath, listening intently. Could a person with sleep apnea actually stop breathing altogether and die in his sleep? I wasn't sure. Still no sound from Bob. I took the pillow off my head and leaned up on my elbows. Even with the curtain drawn over our single window, the endless day of the Antarctic summer was lighting the room. Bob lay perfectly still, his mouth agape. At least a full minute had passed since I had heard him breathe. *My God,* I thought, *he's going to die in his sleep!* I had flung back the covers and was ready to jump out of bed and start CPR when Bob exploded into a spasm of gasping inhalations, gurgles, and grunts. I fell back onto my pillow, buzzing with adrenaline, wide awake, and ready to throw a shoe at him.

It was going to be a long summer.

I started sleeping with earplugs. They didn't completely mask the din, but they helped.

❈ ❈ ❈

An hour after the first C-141 landed, there were a hundred new people in McMurdo. A few days and several flights later, the place was overrun. Lines in the galley were fifteen minutes long. Crowds of strangers were everywhere. The dorms were suddenly noisy, as old friends met after months of separation. Every night there was a party in someone's room. At the Biolab, dozens of people I'd never seen before were suddenly demanding my time and attention. I finally had a sense of how the winter-overs had felt when we'd arrived at Winfly. It was exhausting.

The winter-overs took this second invasion with complete equanimity. It amazed me how completely undisturbed they were, until I realized that there was no pressure for them to integrate themselves into the new dynamic. They had finally come to grips with relinquishing their possession of McMurdo to the Winfly people and no longer felt the same responsibility. McMurdo wasn't their home anymore. It wasn't their job anymore. They were on their way out.

The days became a blur of new faces and nonstop activity. My job was to get the scientists (also called "grantees" because they were in Antarctica on a grant from the NSF) everything they needed to do their work. This included pulling portable wooden shelters called fish huts onto the sea ice, filling scuba cylinders, unpacking cargo boxes, and fetching beakers and other lab equipment from a warehouse. The pace of work was insane. Grantees, I discovered, didn't sleep. It was not unusual for me to walk through the Biolab at midnight and find one or two filtering seawater samples or running analyses. These people often had only a couple of months to do their work before deteriorating sea ice conditions made it impossible. So they hit the ice running and they didn't slow down until they were on the plane heading north again. And I had to keep up with them.

By the end of October, planes and helicopters were coming and going at all hours. The Hercs had returned to McMurdo for the summer to ferry people and cargo to field camps and inland stations. It was twenty-four-hour daylight now, so the only restrictions on activity were weather and some people's occasional need for sleep.

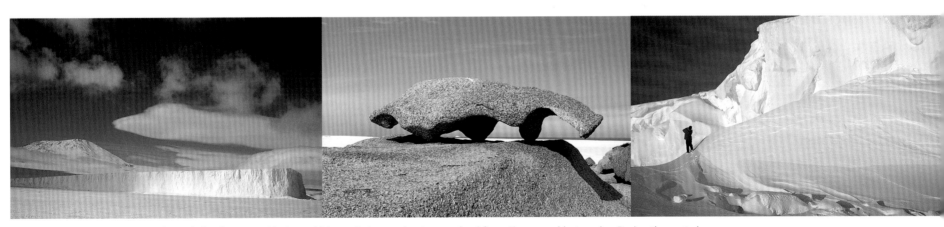

Above left: The Barne Glacier and Mount Erebus under strange cloud formations on a blustery day. During the austral summer, it often seemed as though white and blue were the only colors in the entire world. **Above middle:** The relentless wind, blowing at hurricane force for millennia and driving sand and dust before it, has created some incredible natural sculptures called ventifacts. This piece of granite, near Italy's Terra Nova Base, resembled a turtle. **Above right:** The Erebus Ice Tongue, probably the most photographed glacier in Antarctica.

Sleep for me had become something of a problem, and not just because of my roommate. The bright sun made it hard to go to bed at ten or eleven, even though we had a curtain drawn over the window. I wound up staying up until midnight or one, then getting up early for another stressful day at work. The result was that I was always fatigued, and my one partial day off, Sunday, wasn't nearly enough to catch up. I had only that one day to take care of everything that needed to be done and couldn't be done during the hectic week — like laundry and letter writing. I found myself in constant conflict over how best to spend those precious few free hours.

"Water hours" added to the stress. McMurdo's water was produced by means of three flash-evaporators located in a large building dubbed Water Distillation (WD), located halfway up Observation Hill. Seawater was pumped out of the ocean and up to WD, where it was flash-evaporated to release water vapor, which was condensed for our water supply. It was good water, but there was never enough of it. The three evaporators were theoretically capable of producing 10,000 gallons a day each, but they rarely did. With all three evaporators working, we were permitted one short shower every other day and laundry once a week. When one or more of them broke down, as they did on a regular basis, showers were reduced to one per week, and no laundry was permitted. When all three evaporators broke at once, all water use apart from drinking was banned.

It was a good thing the cold air kept things from smelling.

The extreme dryness also kept everyone from becoming too greasy and disgusting, but even so, after a week I was in desperate need of a shower. Even on good weeks, all we were ever permitted was the so-called Navy shower, for which instructions were prominently posted in all bathrooms: (1) Wet down for one minute. (2) Secure water. (3) Soap up. (4) Rinse off for one minute. (5) Secure water. The whole process was supposed to take no more than two minutes, but I'll confess, I rarely made it that short.

By early November, McMurdo's population had reached about 1,200, all of us living and working at a frantic pace under conditions of dense crowding. The galley was always jammed. Prime food items, such as fresh fruit, disappeared quickly. The winter cooking staff had been replaced, but the cuisine did not improve. Except for the occasional shipment of fresh vegetables flown in from Christchurch, the menu remained essentially unchanged from Winfly. There were times when those "freshies" were the only thing that saved me. I was gaining weight. The donuts in the morning and the multiple servings of ice cream in the evening were taking a toll, and there was no time for regular exercise.

In the middle of November, Hercs flew in to South Pole Station to open it up. The winter-overs there had endured nine and a half months of total isolation. When they arrived in McMurdo, on their way to Christchurch, they were a strange sight to behold. Most of the people in McMurdo at this point were recently arrived and so still had a little color in their skin. The bone-white "polies" stood out conspicuously. Many of them walked around in a daze, seemingly befuddled by the buildings, the mountains, and the people. Their hair was long, in some cases unkempt, and their faces were covered in beards. One or two fellows had wild, vaguely frightening looks in their eyes. I was told that it was policy to give them a few days in McMurdo to acclimate before sending them out to real civilization in Christchurch, and I immediately saw

Below: Cold? What cold? To avoid polluting McMurdo Sound with hundreds of bamboo poles and road flags when the ice broke out, a team would go out to remove them before the ice was closed to travel. And if the sun was warm and there was no wind . . .

Opposite: The wind carves the built-up snow on the sea ice into many amazing and bizarre shapes. I called this one "Mick Jagger's Tongue." It was about three feet long and a foot and a half wide.

Diving under the ice in Antarctica is neither simple nor routine. The ocean temperature in McMurdo Sound is stable at about 28° F, the freezing point of seawater. The surface of the ocean would actually remain liquid at that temperature if not for the much colder air temperatures in the winter and spring that freeze the surface water into a six-foot-thick skin of ice.

The logistics of diving in this environment are complex, and the amount of gear necessary to do it safely is daunting. Each diver must wear sufficient thermal protection against the deadly cold, which generally means a dry suit over several layers of insulation. Hands are the most important part of the body to protect, yet they are the most difficult to keep warm.

Divers often wear thick, bulky mitts that severely restrict dexterity.

All this gear is extremely heavy. Between the dry suit and undergarments, air cylinder,

weight belt with enough lead (up to fifty pounds) to counteract the huge amount of air contained in the undergarments, regulator, fins, and other gear, a diver might enter the water carrying 120 pounds. It all becomes essentially weightless in the water, but getting in and out can be a chore. Also, because of the bulkiness of the dry suits and the undergarment insulation, it is difficult, if not impossible, to put on all the gear without help. Assistants (or "dive tenders") are required to help divers with their cylinders, weight belts, watertight gloves, and other equipment.

The severe cold is hard on scuba gear, especially the all-important air regulator. Divers have to be careful to keep their gear warm and dry before the dive. During the dive, the process of compressed air expanding through the regulator supercools the mechanism. Any water inside will freeze and jam the regulator open. Although the diver still has air, it's like trying to breathe from a fire hose. Even more dangerous, a free-flowing regulator can completely drain a dive cylinder in seconds. On one dive to eighty feet, both of my buddy's regulators began to free-flow. I handed him my spare regulator and we headed for the surface. By the time we reached our dive hole, about thirty seconds

later, his set of twin cylinders was completely empty.

Just getting through the ice to the water is a major chore. Around Ross Island, a diesel-powered drill is towed by bulldozer to a prospective dive site. The four-foot-diameter bit is then drilled through the six-foot-thick ice to create a dive hole. Since the sea ice is actually floating on the surface of the water, the water immediately fills the hole so that only about seven inches of ice actually sits above the surface of the water. The hole through the remaining five and a half feet of ice is like a tube through which the diver must descend in order to enter the world below.

Early in the season, divers place a hut over a newly drilled hole to give them a warm place to suit up. Additional "safety" holes are also drilled nearby to provide divers alternate access to the surface in case of emergency. Once the hut is placed, snow must be shoveled up around the

sides to keep wind from blowing underneath and refreezing the dive hole. Safety holes must be covered with insulated caps to slow their freezing. Despite all these efforts, during the early part of the season (September through early November) the holes will continue to freeze over and freeze in. The top layer of new ice can usually be chipped away to reopen the hole. However, the process of freezing in from the sides cannot be remedied, and holes often become too narrow to use.

Diving outside a hut before mid-November is extremely uncomfortable, if not impossible. Equipment and body parts become too cold even before the diver can enter the water, making for a very unpleasant and perhaps dangerous dive. The possibility of gear failure increases dramatically. Sometimes, regulators or other equipment will freeze and fail before the dive even begins. After mid-November, though, diving is often done outside the confines of a hut, which expands the choice of dive locations. Some of this diving is done through natural openings, such as cracks and seal holes.

the wisdom in that course of action. I wondered what it was about the South Pole that could do that to a person. Even the spaciest of McMurdo winter-overs hadn't looked so grim.

Then again, the pace of life and the crowding in McMurdo were beginning to get to me. It was nuts, utterly nuts. Some evenings I arrived back at my dorm room so exhausted that I didn't care that we were on water hours. I was too tired to take a shower anyway. I looked for any opportunity to get out of town and away from the craziness. The real Antarctica, I realized, was out on the sea ice, or on the Polar Plateau, or in the Dry Valleys. Anywhere but McMurdo.

UNDER THE ICE

I sat on the ice at the edge of a crack with my flippered feet dangling in the water, as my dive tender fitted the scuba cylinder onto my back. I took the straps he handed me and buckled them together at my waist, then breathed into my cupped hands to warm them. It was difficult to manipulate the straps and buckles of my gear with thick gloves on, so my hands were bare, and they were freezing. The tender reached under my left arm to hand me the dry suit's inflator hose, which would allow me to add air to the suit as I descended. Otherwise the increasing water pressure would squeeze the suit against me to the point I wouldn't be able to move. Adding air to the suit would also help to keep me warm.

I attached the hose to my inflator valve and tested it with a push. With a whoosh, air flowed into the suit. Next I positioned my spare regulator to a loop on my chest, within easy reach. My buddy Rob, sitting next to me on the ice, was going through the same process. We were at Hutton Cliffs, on the shore of Ross Island, deep into the notch created by the Erebus Ice Tongue and Hut Point Peninsula. A robust breeding colony of Weddell seals had established itself here, and our intent was to get a firsthand look at what their lives were like underwater.

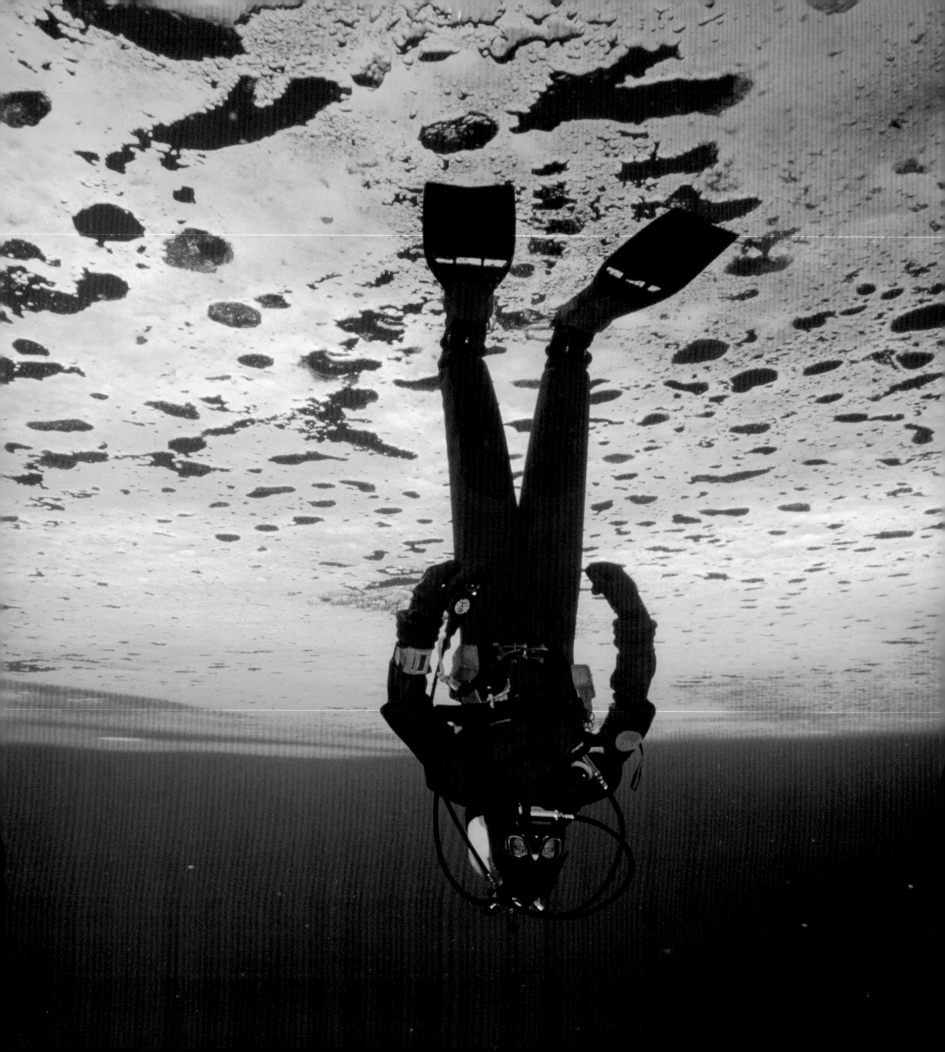

At other dive sites, seals had kept their distance from us. Every once in a while, I'd catch a glimpse of a shadowy form skulking along, eyeing me from a hundred feet away. Today my hope was that, preoccupied with breeding, they'd allow me a closer look. As if to confirm my wishes, a big male surfaced in the crack only a few feet away. Breathing heavily from having held his breath on a long dive, he stared at us for a few moments, then slipped back below the water. The fast and powerful males were brutal to each other during the mating season, often aiming vicious bites at both flippers and groin. If they decided *we* were intruding on their territories, we wouldn't have a chance. I was banking on the assumption that they were smart enough to know the difference between an awkward human and a competing seal and would leave us alone.

The crack we were using was big, stretching along the shore and out into deeper water. It was riddled with holes and open water areas, some of them formed by the natural movement of the ice and others by the seals. Directly across from where we sat, no more than thirty feet away, the sheer rock wall of Hutton Cliffs rose vertically from the water. A cornice of snow hung over the top, sticking out several feet. Though the air was cold, the sun was bright. I wondered if solar warming might loosen the wind-packed snow, causing it to fall. I silently hoped it would hold for the duration of the dive and not come down on our heads.

I grabbed my mask, cleared out the ice, and slipped it over my face. Using my fingers, I checked that it was securely sealed against my face. Once my mitts covered my hands, I wouldn't have the dexterity to reposition it if it was leaking. Satisfied it was on tight, I helped the tender attach my bulky three-fingered mitts to my suit, sealing out the water. I was now almost completely protected from the 28° F ocean. The only exposed part of my body would be my lips, wrapped around the regulator mouthpiece.

I knew from past experience that the water hitting them would be a shock, and then they'd quickly go numb. There was no danger of frostbite, though. The salt content of my blood and the heat generated by the rest of my body and carried to my face by my circulation was enough to prevent the flesh from being permanently damaged. It might be a different story if my suit, or some part of it, were to flood. On a previous dive, one of my mitts had flooded. In the ten minutes it took me to get out of the water, my hand had gone completely numb. In the dive hut, I plunged it into a vat of warm water, but instead of feeling relief I was rewarded with blinding, excruciating pain. During the entire twenty minutes it took for my hand to rewarm, I felt like it was being held in a metal vise with a professional wrestler clamping down on it with all his might.

Opposite: Most of our dives were down to a hundred feet or deeper, since that's where a majority of the seafloor life is found. On our way back to the surface, we'd pause in shallow water for what is called a "safety stop" to rid our bodies of some of the extra nitrogen we'd absorbed during the dive. To relieve the boredom of these fifteen- or twenty-minute stops, we'd sometimes hyperinflate our dry suits and invert ourselves to stand upside down on the ice. **Above:** These lamellarian gastropods, or "tennis ball mollusks" (*Marseniopsis mollis*), are, in fact, almost the same size and color as tennis balls. They are snails with a tough outer covering and an internal shell. The one on the right is laying eggs.

That experience taught me to double- and triple-check the seals on my mitts before each dive. I did that now, rotating my arm so I could see every inch of the connection between the mitt and the arm of my suit. Satisfied, I looked to see if Rob was ready, then pushed myself off the ice and into the water. The tender handed me my camera. I opened the exhaust valve on my suit and, as the air hissed out, began to sink.

In a moment, I was suspended in the water fifteen feet under the ice. I glanced around. The black, rocky bottom lay fifty feet below, and it sloped steeply into the depths. Immediately beneath the cliff, against the shore, was an underwater wall of ice. Above me, the crack ran along the shore in both directions, a sliver of bright light splitting a dark cover. Where the sun shone through, it created shafts of light that shimmered in the water and swept across the bottom like searchlights. Far below, a seal coasting through the gloom was briefly illuminated as he swam through one of these beams.

Rob joined me and we headed along the shore to the east, keeping directly under the crack. Just ahead, a massive jumble of broken ice blocked our path. I was about to descend below the block when I noticed a tunnel of sorts through the jumble. I swam in, navigating over and under slabs of upended sea ice. Tidal forces had crumpled the normally flat sea ice, breaking it and twisting it into a pile, then forcing it down into the water. I passed a side chamber where a seal was sleeping, then I emerged on the other side. The seafloor had disappeared, and I was now suspended in blue space.

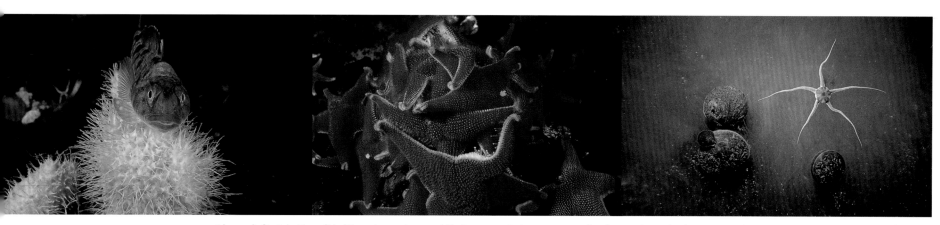

Above left: A bottom fish (*Trematomus bernacchii*) sits on a polychaete sponge (*Isodictya erinacea*). The seawater in McMurdo Sound is about 28° F year-round, but it doesn't freeze solid because of the salt content. Fish cannot survive with that level of salt in their blood, however, so to keep from freezing, they produce special antifreeze molecules. The system doesn't always work perfectly. At times, I found fish on the bottom, curled up and stiff, barely alive. **Above middle:** Cluster of sea stars (*Odontaster validus*). These ubiquitous stars, besides being voracious predators, are the janitors of the sea floor, cleaning up everything from dead animals to seal feces. **Above right:** Antarctic scallops (*Adamussium colbecki*) and a lone brittle star (*Ophionotus victoriae*) crawl up an underwater ice wall at New Harbor. The relatively shallow New Harbor environment, extremely dark under fourteen feet of ice and low on nutrients, mimics the deep, abyssal ocean floor. In that respect, it may be unique in the world. How the submerged ice wall formed is unknown. My own personal theory is that it is a remnant of the last ice age. When the ice age ended and sea levels rose, the cliff was inundated. Since the seawater is colder than the melting point of freshwater ice, the ice has never had a chance to melt. **Opposite:** A diver swims through a small tunnel in a grounded iceberg at New Harbor. There seemed to be no end to strange shapes of ice, both above water and below.

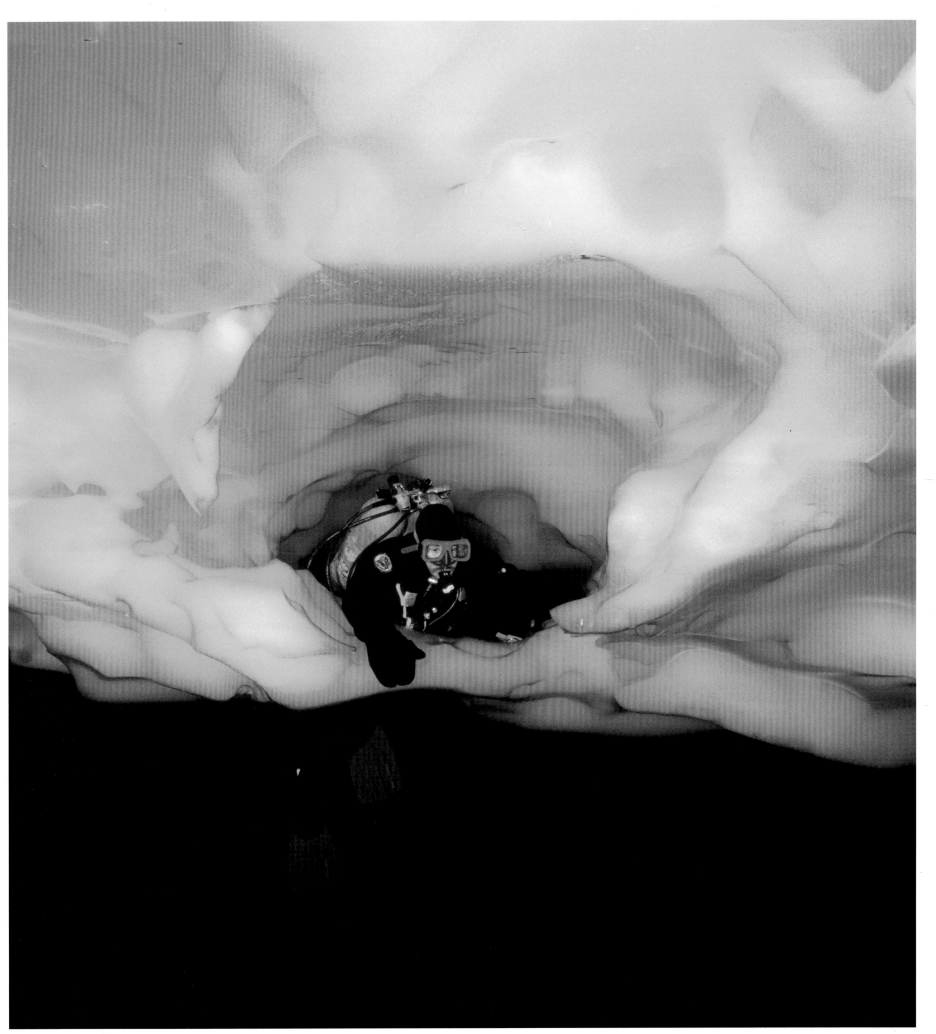

Right: On the seafloor in shallow water, ice crystallizes on rocks and sometimes even on slow animals. Here a single large crystal sits on the bottom in nine feet of water. Because of this "anchor ice," few animals live in this region, mostly just mobile creatures like sea stars, urchins, worms, and science-fiction-ugly crustaceans called giant isopods. Sedentary animals like anemones and sponges are found much deeper.

Below right: Rob Robbins under a safety hole at Little Razorback Island. We drilled safety holes to provide us with alternative means of reaching the surface in case of emergency, and they shone like spotlights through the darker sea ice.

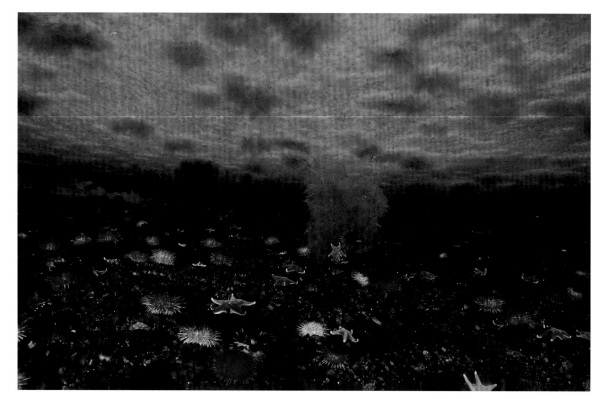

Above me, the bright crack stretched on ahead. On either side, massive blocks of ice jutted in every direction, including thirty feet down into the water. It was as though some careless god had dumped his cosmic ice cube tray into the water at Hutton Cliffs.

Everywhere there were seals. Several were suspended vertically below the crack at regular intervals. I knew these must be males guarding their territories. Each kept one eye on his neighbors and another looking down into the water, vigilant for challengers who might try to sneak up and nip at flippers. Subadults and females coasted through, appearing and disappearing from unseen caves and tunnels like ghosts in an ancient castle. The water was filled with their haunting, alien cries. The male closest to us suddenly left his breathing hole and descended to a position directly in front of us. Directing his gaze into a tunnel that another seal had just entered, he began to vocalize. Starting as a high-pitched whine, the call descended through the scale, then transformed into a cicada-like buzz. It was an otherworldly sound, eerie and beautiful at the same time. It filled the water and vibrated through my body. When the seal was done, he glanced briefly in our direction, then drifted back up to his territorial hole.

I looked at Rob. Both of us had heard that sound before, faint and muted, as we stood on the sea ice above. Here in the water, I was astonished at its power.

We kept swimming. I saw another seal descend from near the surface with several powerful strokes of its flippers, then straighten its body and coast into the depths. A moment later, it had disappeared into the darkness. I marveled at the grace and power of

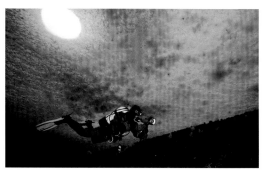

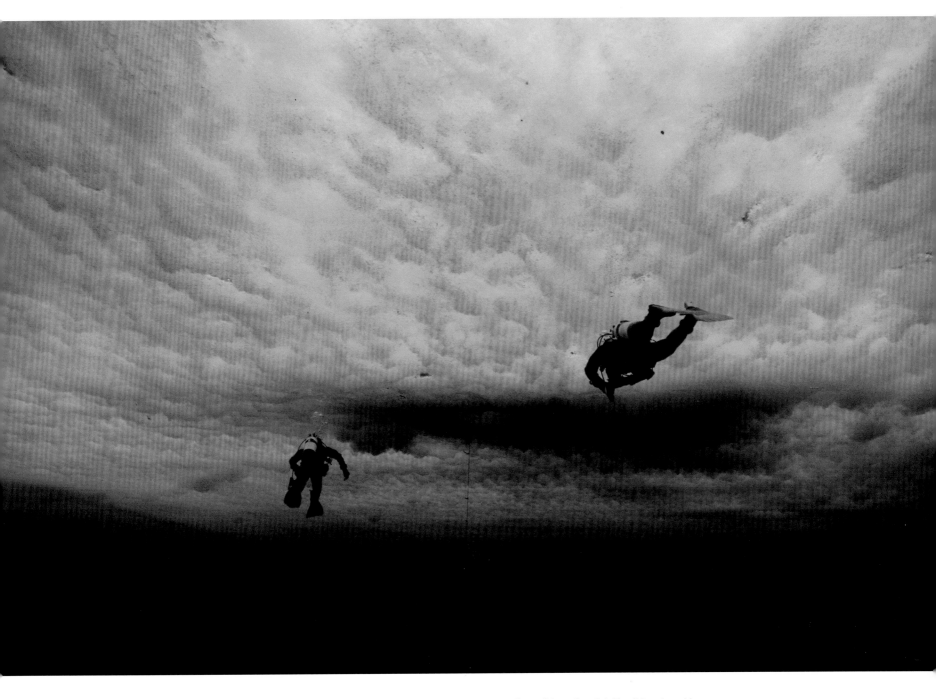

Above: Divers "flying" under the ice. With underwater visibility as much as 900 feet, diving often felt like flying. I could see the lay of the land in every direction below me and the sea ice stretching into the distance above. These divers are returning to their dive hut, marked by the large shadow in the center of the photo.

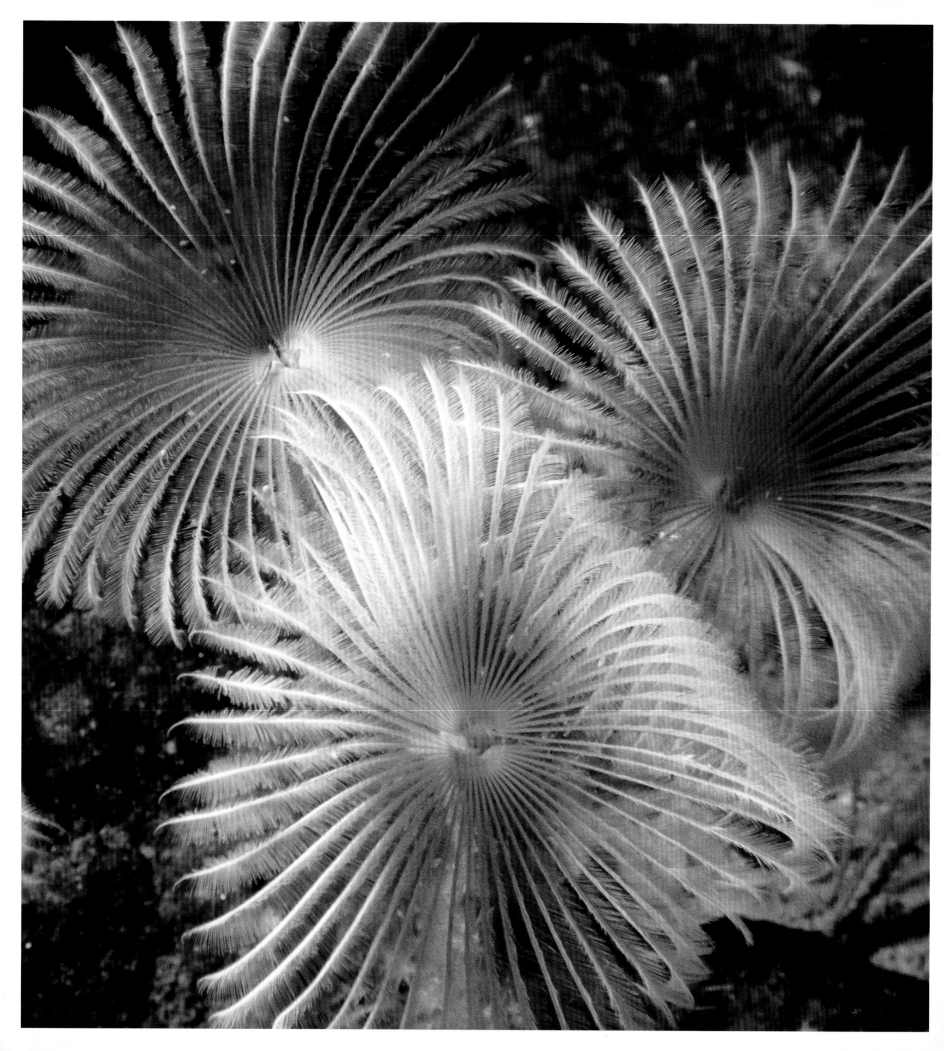

these animals, so clumsy on land but so elegant and supremely adapted to the strange world below the ice. I wondered what they thought of us, two gangly, awkward, bubbling oddities floundering around in their midst. I turned to look back the way we had come. The ice blockade seemed far away. With visibility at least 500 feet, it seemed as though I could see forever in every direction. The crack stretched on into the dim distance. On either side, the flat undersurface of the sea ice was pockmarked with seal holes and spiderwebbed with hairline cracks. These features stood out starkly against the myriad blues and purples of the ice itself.

Deciding to explore beyond the crack, we descended to thirty feet and ducked under an ice ridge. On the other side, we found a vast cavern, completely closed at the surface and surrounded on all sides by deep ice ridges. There were fewer seals here, but something in the center of the cavern caught my eye. We swam closer to discover a large Weddell seal, upside down and frozen into the ice. His eyes were open in the glassy stare of death. Apparently the seals, as supremely adapted as they were, were not invulnerable to the caprices of their environment. I wondered what had killed him. Had the other males prevented him from entering a breathing hole? Had he gotten lost under the ice? Or was this simply an example of old age or disease?

The sight was sobering. Rob and I decided to head back. We were a long way from our access hole and our air was getting low. We retraced our path to the ridge, dropped down to pass under, and came up . . . in another sealed cavern. The crack was nowhere to be seen, and the surface was an unbroken sheet of blue ice. For a brief but horrible moment, I felt the first twinges of panic. Were we lost under the ice? I thought of the dead seal and saw myself similarly plastered up against the ice, my cylinder empty, my face frozen. I glanced at Rob and he must have seen the worry in my eyes. He shrugged his shoulders. He didn't know the way out either.

I mentally grabbed myself. The danger was not being lost, but descending into panic. That's what killed divers. I looked around. Deciding we must have strayed to the left and ducked under the wrong ridge, I signaled to Rob to swim toward the next ridge. Coming up on the other side, I saw the crack overhead and the familiar channel full of seals.

Some of the magic had been jolted out of me. We ascended to fifteen feet and headed straight back to the jumble of ice blocks that divided the channel. As we entered the tunnel, an adult male

Opposite: These featherduster worms (*Potamilla antarctica*) live in a calcareous tube and extend their featherlike feeding appendages out of the top. At the slightest sign of danger, the appendages are rapidly withdrawn. At Discovery Bluff, in Granite Harbor, I swam over a giant field of these creatures. It looked like a garden of flowers — until the worms felt the pressure wave from my flippers. In an instant, the garden disappeared and all that remained was a seafloor full of vertical sticks. **Above:** This brown vase sponge (*Rosella fibulata*) I discovered at Granite Harbor was only the second one seen in thirty-five years of Antarctic diving. Since then, others have been found.

entered from the other side. We passed within inches of each other in the tight space, the seal glaring at us out of the corner of his eye.

Rob and I emerged on the other side into a more familiar waterscape. Once again, there was a seafloor below us, and just ahead our down line, with its checkered flags and flashing strobe lights, marked our entry hole. Nearly an hour had passed since we entered the water. I hovered just below the surface as Rob took off his cylinder and weight belt and passed them up to the tender. Then he pulled himself out of the water and onto the ice.

I looked around one last time, trying to soak up every nuance of this undersea world. When I glanced up, I could see Rob and my dive tender looking down through the crystal clear water at me, waiting for me to surface. That was always the hardest part. Despite our close call, I loved the feeling of weightless flight, and the ability to see so far underwater. Finally, though, I sighed into my regulator and rose slowly to the surface.

❊　　　　❊　　　　❊

Every dive site was different, every dive an adventure into the unknown. One time Rob and I went diving at the Erebus Ice Tongue, with nothing below us but black, fathomless depth. The glacier tongue sat motionless in the water, an inconceivably massive monolith of blue ice. It stretched away in both directions as far as I could see, and down at least 200 feet. I finally grasped the true nature of the Ice Tongue. The part of the glacier that sat above the surface of the sea ice, that thirty-foot wall with ice caves that I'd been scrambling through, was but an insignificant fraction of the gargantuan whole. The real glacier was here underwater.

It was hard to comprehend such a gigantic block of ice, hanging suspended in endless space. This, I thought, must be what it would be like to approach an asteroid between the planets. I felt like an astronaut, suspended in the void, weightlessly drifting toward a newly discovered object.

At other dive sites we explored seafloors covered with unusual and colorful animals. Most people think of Antarctica as a barren and desolate wasteland. That had certainly been my first impression. Below the ice, though, Antarctica was vibrant with life. Hundreds of species of sponges, in myriad shapes and colors, supported rich communities that included sea stars, urchins, snails, nudibranchs, sea spiders, anemones, soft corals, fishes, and dozens of other organisms. In some places, the seafloor was as diverse and thick with life as some tropical coral reefs I'd seen. At New Harbor, on the western side of McMurdo Sound, I found giant beds of scallops and tall, majestic soft corals that actually crawled along the silty bottom.

Many times I dived where no one else had ever been and saw things no human being had ever seen. Granite Harbor was such a place. There, I discovered a white

Above: Turtle Rock, a small island north of the Erebus Ice Tongue, is home to a large number of Weddell seals, much like Hutton Cliffs. The seals move through a world of broken ice, convoluted tunnels, and hidden caves. This seal is displaying a threat posture, and producing a low-frequency *thump-thump-thump* vocalization, to signal that this is his territory.
Opposite: An A-Star helicopter lifts off from New Harbor camp after delivering divers and equipment.

volcano sponge big enough to swallow a diver. Because they grow so slowly, a sponge that large could be thousands of years old. I also found a bed of featherduster worms. These delicate creatures live in a tube sticking up from the bottom. From the top of the tube they splay out lacy, featherlike appendages to sift food from the water. At the slightest sign of danger, they instantly suck their appendages back into the safety of the tube. When I swam over them, the worms must have felt the pressure wave from my kicking, for in a heartbeat they all disappeared. What had looked in one instant like a lush underwater garden became suddenly a bare field covered with vertical sticks.

Returning from the depths at Discovery Bluff, another buddy, Pat, and I were shadowed by a young Weddell seal who pressed his nose into our masks and swam next to us, belly to belly, while we stroked his fur. Near the surface, the seal made a playful, open-mouthed charge toward Pat. Pat's eyes widened and he went from amused complacency to horror. His clumsy efforts to pull away and protect his vital parts looked so ludicrous that I burst out laughing — and flooded my mask as a result. It felt like I had jammed my face into a bowl of liquid nitrogen. I cleared the frigid water out of the mask

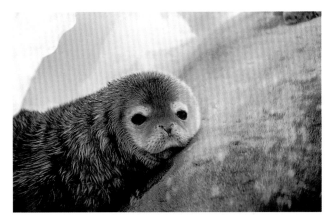

in time to see Pat beating a hasty retreat toward our dive hole. I knew the seal had no intention of actually biting, but I also understood Pat's reaction and probably would have done the same. That seal's teeth could turn a thousand-dollar dry suit into a rag in seconds, and after my brief experience with the flooded mask I could imagine the extreme discomfort of a flooded suit.

Dives like this were the essence of true exploration. I thought about all the other places in the McMurdo Sound area that had never been dived, and of all the other wondrous things left to uncover. There wasn't enough time in several lifetimes to do it all.

THE EDGE OF THE ICE

On the way back to McMurdo from a dive at New Harbor, we took a detour to the ice edge. This was the northern border of McMurdo Sound's ice cover, the line that divided frozen from liquid, stillness from motion, dark from light, and predator from prey. On one side of the edge was a seemingly endless plain of cracked and tortured ice. On the other was clear blue ocean.

Adélie penguins scurried away as the helicopter settled down onto the white plain a hundred yards from the edge. The pilot maintained lift, essentially hovering on the ground, while a crewman clambered out and drilled the ice, checking for thickness. With the door open, the wind from the rotors swirled around me and the scream of the turbine blasted through my ear protectors. Three feet down, the crewman's ice auger broke through into water. He signaled to the pilot, who nodded and powered down the engine. The roar and whine of technology dwindled into silence.

Six of us gathered our ice axes, ice drills, and cameras and set off toward the edge, our heavy boots crunching through a thin layer of snow. I scanned the ice field as I walked, searching for hazards. Thinner ice would appear gray, its translucence revealing the dark water below, but this ice was milk-white and streaked with hard patches of cobalt blue that marked it as solid and stable. Fifty feet from the edge I probed a crack, gauging its activity and length. It ran parallel to the ice

Opposite: Perspective. Our tiny dive hut dwarfed by the vastness of Antarctica, a speck of warmth in a universe of cold. The black rock in the foreground is Little Razorback Island. Behind it is Ross Island and the imposing bulk of Mount Erebus. **Above:** Weddell seal pup (*Leptonychotes weddellii*) leaning on its mother's belly at Hutton Cliffs. Weddell seals give birth on the ice, then spend the next few weeks nursing their pups into rotundity. When the mother leaves, the pups need all that stored fat to live on while they figure out how to fish.

edge and showed sign of recent movement. If a wind picked up from the south, we'd have to watch it closely. The slightest wind pressure could force it apart, turning the block of ice we were standing on into a floe, drifting north.

The edge of the ice was sharp, a clean break, a perfect demarcation between solid and liquid sea. I stood on the cusp and stared down into the pellucid water. The crisp air was still. Without wind to ruffle it, the surface of the ocean was a plate of the purest blue glass. Sunbeams stabbed into the depths, fading into the distance. I could see the ice itself underwater, a straight-edged white wall that ended abruptly three feet below me, with only dark emptiness below that. We stood alone for the moment, but small black figures in the distance and flurries of motion in the water told me it wouldn't be for long. Emperor penguins were approaching.

Emperor penguins were the most curious animals I'd ever encountered. Any upright object, dark against the glaring white of the ice, attracted them like kids to a department store Santa. I saw their heads bobbing up out of the water nearby, skewering me with a quick glance, then plunging down again. I looked into the clear water below me and saw them darting and spinning like swallows, performing a complex and intricate three-dimensional dance. Trails of bubbles streamed out behind each penguin like the contrails of jets. The bubbles drifted slowly upward, forming shimmering silver curtains in the blue water.

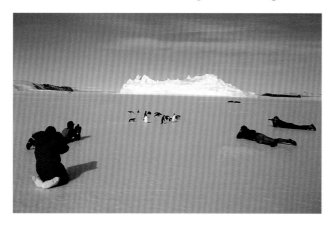

Soon the penguins began rocketing out of the water, literally flying (as birds are supposed to do) from the sea to plop onto their bellies on the ice. They used their beaks and flippers to push themselves upright, shook the water off their faces, and began to trundle toward us. I sat down to wait. They walked purposefully to within arm's reach, then stood there nonchalantly, grooming and preening and sneaking glances in my direction, as if that was the most natural thing in the world to do, and what the heck kind of red-coated, hairy, grinning, ugly penguin is *that?*

In a few moments I was surrounded by them, and beyond this group that had called dibs on checking out the funny-looking animal there were now over a hundred penguins on the ice. The recently empty edge had become Penguin City. Even a few of the smaller Adélie penguins had joined the congregation, fluttering nervously whenever one of their more massive cousins waddled by. A few emperors in the distance trumpeted majestically. Their voice was like an out-of-tune brass instrument, a distorted salute to a medieval king, a Louis Armstrong on drugs. Each call vanished as quickly as it was uttered into the thin, vast air.

Above: A small group of Adélie penguins, like Antarctic celebrities, surrounded by parka-clad paparazzi. **Opposite:** Adélie penguins, lost on the sea ice. When an Adélie sees a dark, upright form on the ice, he naturally assumes it's another penguin and moves toward it. What else could it be? In the hundreds of thousands of years Adélies have lived in McMurdo Sound, there has been nothing else. One time, three Adélies spotted me from far away and made a beeline in my direction. About fifty feet away, they put on the brakes and stared at me in alarm. "Hey," I could almost hear them exclaim, "that's not a penguin! Let's get outta here!" And they immediately turned around and scooted off.

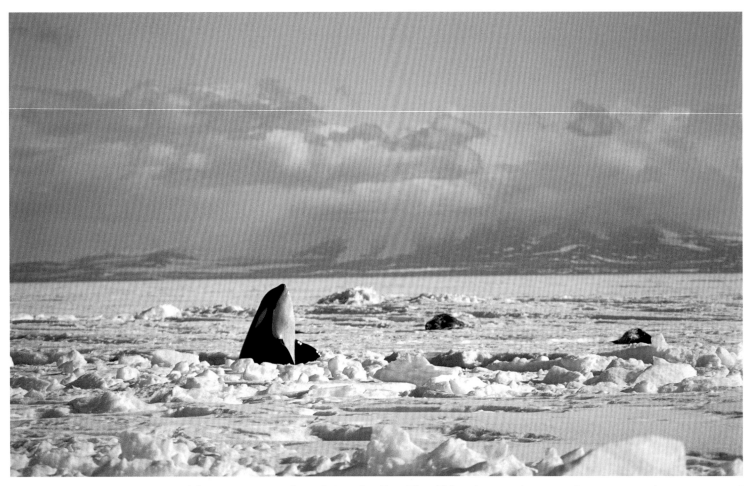

The group around me began jostling. They'd lost interest in me and my yammering camera and were thinking about getting back in the water. But this took some time. It's not something done rashly. This was the edge, after all, and everything eats at the edge, including the leopard seal.

The leopard seal is a fearsome and fearless predator, master of its domain, with jaws more like those of a tyrannosaurus than a marine mammal. Silent and cunning and as invisible as alligators in a murky river, leopard seals will hide beneath the ice, or under an overhanging lip, with only their nostrils exposed, waiting for unsuspecting birds to plunge into their jaws. The emperors knew this instinctually, and no one wanted to be the first in the water. They jostled and pushed, looked at me, looked at the water, flapped their wings, shifted their feet. "You first," they seemed to say. "No, you first." "No, really, after you."

Above: Every January, a U.S. Coast Guard icebreaker cuts a channel through the sea ice to McMurdo Station, clearing a path for the resupply tanker and cargo ship. And every year, a resident pod of killer whales (*Orcinus orca*) follows the ship in, taking advantage of the newly created channel to exploit otherwise inaccessible hunting grounds. These orca are fish eaters, and they are after the fat, juicy, 150-pound Antarctic cod (*Dissostichus mawsoni*) that live under the ice. But the channel tends to close up over time, cutting the whales off from open water. When this happens, they "spy-hop" to look for open holes and a safe path out of the ice.

Finally, acting on an impulse I could not detect, they all plunged in together, a flurry of motion, thrashing flippers and scrabbling feet, all elbows and cloacae. It was curious to me that they would be this cautious and this frenetic when there were other penguins in the water nearby, and an unsuspecting human would never imagine there to be a leopard seal around. But perhaps the seals do not chase emperors in the water. The birds are far faster and more maneuverable than the seals, after all. It could be that it is only at the interface of ice and water, and the boundary between sea and air, that the seal can successfully hunt.

Also curious to me was that the penguins were in the water at all, because I could hear killer whales approaching. Their sound was unmistakable, that explosive *whoosh!* of air forced at gunpoint out of the whales' lungs. I jumped to my feet and looked for the source. Puffs of vapor shot into the air a few hundred feet from where I stood, and the distinctive, black dagger of a male's dorsal fin cleaved the smooth surface of the water. The spouts and arcing fins stretched into the distance along the ice edge, and they were moving toward me.

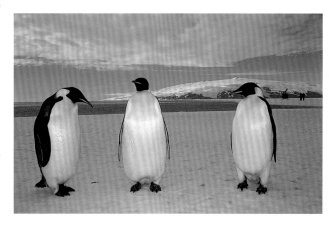

Several years ago a team of Soviet scientists, in the endless pursuit of knowledge, captured and killed 906 Antarctic killer whales. They took morphometric measurements — length, girth, weight — and they carefully examined the stomach contents of each whale. They found that there were two distinct groups of killer whales in the Antarctic. In one group the individuals tended to be smaller and have an orange cast to their skin. These whales traveled in large pods of up to 200 animals, and 99 percent of their diet — that is, 99 percent of the smelly glop the scientists extracted from their stomachs — was fish and squid.

Whales in the other group were generally larger, their skin carried no hint of discoloration, they traveled in small groups of ten to fifteen individuals, and in their stomachs were almost exclusively the remains of seals and penguins.

The big group approaching me was clearly the former type, and as they drew closer I could indeed see an orange cast to the white parts of their skin. I marveled at how the penguins could know the difference between dangerous whales and these fish-eaters that posed no threat.

The killer whales, like leopard seals, cruised the ice edge. Unlike the seals that wait for their meals to drop into the water, the whales seek their food below the ice, and this food is most likely the 100- to 150-pound Antarctic cod. These cod, like all fish in McMurdo Sound, are full of natural antifreeze to keep them from turning into ice blocks in the frigid water. Because they have no swim bladder, their tissues are loaded with oil to aid in buoyancy. This oil, and all the caloric energy it carries, makes them a tempting target for predators.

In November, these cod congregate beneath the sea ice in McMurdo Sound. Where they come from, no one knows. Why they come is also a mystery, but I had my own theory. November is when the killer whales return to the deep south, and the one place the killer whales cannot go is beneath the ice in McMurdo Sound. The ice is a nearly solid lid over the ocean, and the Weddell seal breathing holes that exist are too small and too widely scattered to benefit whales. Do the fish somehow know they are safe? I saw them in my mind's eye, silent wraiths coursing through the lightless depths 1,500 feet below the ice, giant schools of large-mouthed, oiled-up, Prestone-treated protein.

Above: One that flies and three that don't. Three emperor penguins and a helicopter at the ice edge, with Ross Island in the background. The ice edge marks the northern boundary of the fast ice covering McMurdo Sound. South of here, the ice is a nearly solid sheet all the way to the permanent Ross Ice Shelf. To the north lies loose pack ice and open water.

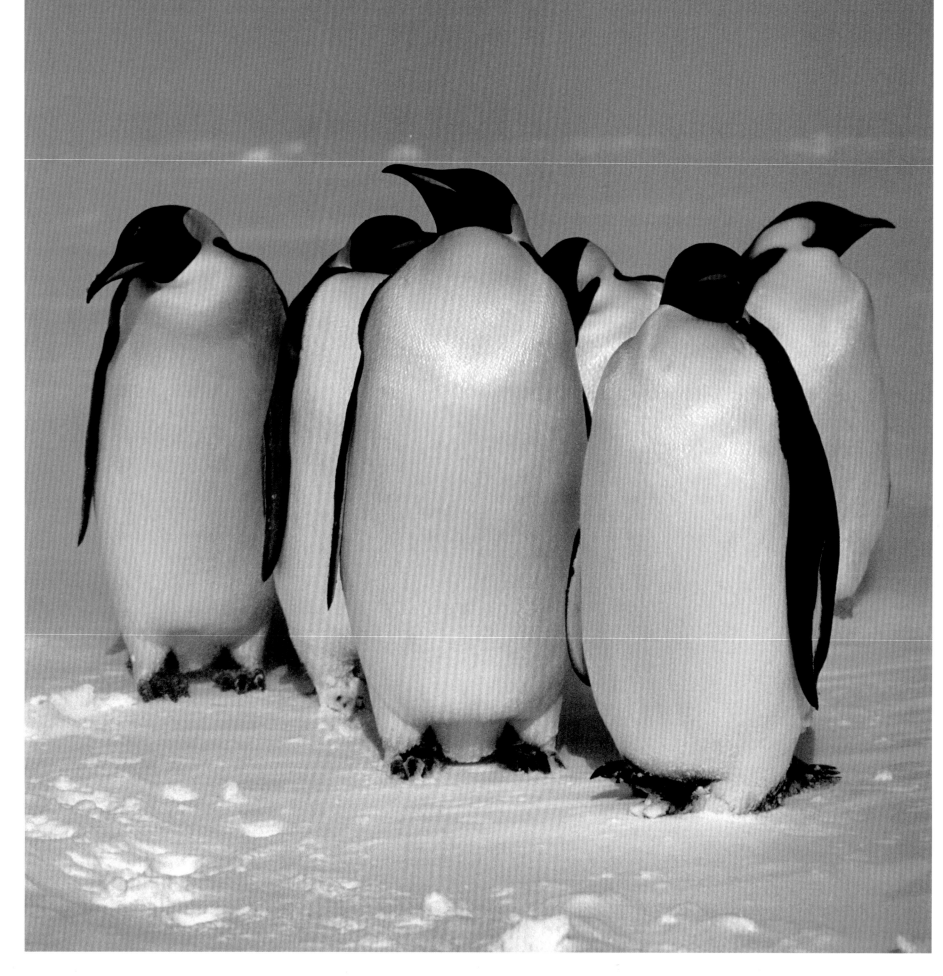

The whales were slicing through the smooth water in front of me now. I pulled on thick neoprene mitts, grabbed my underwater video housing, and plunged my arms into the water. Through the viewfinder I could see whales gliding by beneath me. One came up to within a few feet of the camera, vertical in the water, and looked at me through first one eye, then the other. They're fish eaters, I said to myself, *fish* eaters. More whales collected, drawn to something they'd never seen, the big, bulbous eye of a camera invading their privacy. I told myself that, if necessary, I could yank the camera and my arms out of the way in an instant, and part of me almost believed it.

Fish eaters.

It became a mantra. My heart ricocheted against my ribs from a mixture of excitement and fear. If I were walking near a lake and saw a tiny pair of arms holding a camera out of the water, using it to follow my every movement, would I reach in and pull out the curious camera-being, just for a closer look?

The killer whale eyeing me released a burst of bubbles from its blowhole and veered off. The rest followed, more interested in procuring some real food. I could see them slanting downward, slipping beneath the ice. Had a luckless group of cod ventured too close to the edge? Could they tell, at their depth, the difference in light, if any, that marks where the ice ends and free ocean begins? Could they see the faint shadows of their doom descending from above?

I saw something else in the viewfinder that made me think again. The penguins were diving, too. Side by side with the killer whales, they were darting beneath the ice edge and into the darkness. I looked up and saw the ocean boiling with spouting whales, upturned flukes, and bobbing penguin heads. A feeding frenzy had developed right in front of me. Hundreds of killer whales and hundreds of emperor penguins — and even a few Adélie penguins, looking lost amid the giants — churned the water. Clouds of spray and the rush of exhalations filled the air, and I could even detect that old fermented-fish smell that passes for cetacean bad breath.

I knew the penguins weren't going after Antarctic cod. They might dream, on a good day, of gorging on the rich flesh of one of these beasts, of socking one away for the winter, but they're just as likely to fly to Miami as eat a cod. They eat squid, though. It's one of the mainstays of their diet. Killer whales eat squid, too, and there are squid that live in McMurdo Sound. Perhaps there was a swarm below me at that moment, a cloud of writhing cephalopods, locked in the blind madness of breeding. I imagined the killer whales swooping into the swarm, gobbling up mouthfuls of the squid, while emperor penguins picked them off one by one. I stared into the frigid water and wished there was some way I could join these animals in the depths, to see what they were seeing.

McMurdo Sound is a vast, dark mystery. I knew strange beasts had been accidentally dragged up from the bottom in fish traps and nets: giant octopuses weighing over a hundred pounds, hard pink

Opposite: Gang of emperor penguins at Cape Washington. **Above:** Emperor penguin chicks and adults at Cape Washington. The Cape Washington rookery, located about 225 miles north of McMurdo Station, is one of the largest emperor penguin rookeries in the world. Each year, thousands of mated pairs use the sea ice there as a place to raise their chicks.

coral (and hard coral isn't supposed to exist in cold water!), and bizarre crustaceans. The first person to take a deep submersible into the Sound's depths will likely see wonders I couldn't even imagine.

For the moment, though, all I could do was watch from above as whales and penguins roiled the water in their mutual excitement. By a stroke of fortune, I was in the right place at the right time to witness this incredible behavior: penguins and whales hunting and feeding together!

Too soon it was over. The whales moved on to other hunting grounds, and the penguins, no longer so curious about me, disappeared as quietly and mysteriously as they had arrived. Before long I was standing alone on the silent ice. To the east, a long plume of volcanic smoke rose lazily into the sky from the summit of Mount Erebus. To the west, the Royal Societies were a line of blue and white peaks. Behind me, a nearly featureless plain of sea ice stretched to the south, punctuated by a single red helicopter, its blades drooping. Before me, the sea was as flat and motionless as it had been when I had arrived.

<center>❈ ❈ ❈</center>

As we moved through November, the constant summer sun warmed the dark volcanic earth and melted the ice and snow around McMurdo. Little streams flowed through town, and mud puddles formed everywhere. McMurdo became McMudhole. Gritty basaltic mud ended up everywhere, and floors were impossible to keep clean.

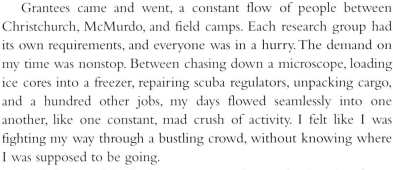

Grantees came and went, a constant flow of people between Christchurch, McMurdo, and field camps. Each research group had its own requirements, and everyone was in a hurry. The demand on my time was nonstop. Between chasing down a microscope, loading ice cores into a freezer, repairing scuba regulators, unpacking cargo, and a hundred other jobs, my days flowed seamlessly into one another, like one constant, mad crush of activity. I felt like I was fighting my way through a bustling crowd, without knowing where I was supposed to be going.

And the people! I had never seen such an eclectic mix of personalities. McMurdo was a cross-cultural melting pot like nowhere else. Government bureaucrats, sailors, naval officers, graduate students, college professors, research scientists, mountaineers, snowmobile mechanics, forklift drivers, electricians, egalitarians, ivory tower prima donnas, alcoholics, teetotalers, loners, socializers, whiners — the list was endless. They came from all over the States and all over the globe. Katsu Kaminuma, a personable Japanese vulcanologist who was smiling every time I saw him, cajoled me into teaching him American slang in return for Japanese lessons. Right on, dude! *Domo arigato!*

Women were still vastly outnumbered, so the social dynamic remained strangely skewed. It seemed to me that a lot of guys didn't even bother trying to compete for the women's attention, but instead treated McMurdo like a boys' summer camp. They worked hard, played hard, and drank hard.

Above: I often used this vehicle, a diesel-powered Nodwell, to pull portable laboratories and sleeping quarters (all of them called, generically, "fish huts") across the sea ice to study sites. The plywood buildings were warmed by oil heaters called Preways that sometimes blew out in high winds.

Other guys made it their mission to court women. One helicopter pilot, completely smitten with the beautiful daughter of a longtime Antarctic geologist, made a special flight out to her campsite to deliver a bottle of champagne. Of course, the whole town knew about it, because there were no secrets in McMurdo.

Except one, maybe. I was madly attracted to Wendy, a beautiful New Zealand girl who worked for the Navy's Morale, Welfare, and Recreation Department, but I was beaten to the punch by some naval officer who moved more quickly. So I kept my feelings to myself. But then, I hardly had time for social pursuits anyway.

When December came, I found myself on the sea ice again, this time to retrieve the fish huts I'd only a couple of months earlier taken out for the scientists to use. I was using a Nodwell again, a larger, diesel-powered version of a Spryte. Unfortunately, the sea ice was no longer the rock-solid surface it had once been, and I no longer felt so confident being on it. Twenty-four-hour sun and relatively warm temperatures had caused it to degrade. Melt pools had formed just below a thin crust of surface ice. Many times, my vehicle suddenly plunged downward for a couple of feet, sending my heart into my throat and me halfway through the roof hatch. I couldn't help thinking again of that biologist who had been trapped in his vehicle as it plummeted to the bottom, and I kept the roof hatch open to allow myself a quick escape. It sometimes made for cold driving, but the alternative was worse.

Most of the time, though, it was pleasant to be on the ice. It provided me with a respite from the crowds and the hectic pace of McMurdo, and some days when the air was still and the sun high, it was actually warm. On those days I took my shirt off and basked in the feel of sun on my shoulders, after so many months of being bundled up.

Before long, it was Christmas. The galley staff and a lot of volunteers from the community went out of their way to create a splendid meal, probably the best one I'd had all season, apart from Thanksgiving. Afterward, we had a quiet party, and a choir sang carols. The mood was subdued. Like me, everyone was a little sad to be away from home and family at this time of year. On the other hand, it seemed to me that Christmas in McMurdo was a purer celebration of the holiday than any

I could have had back home. There were no commercials to endure, no pressure to buy gifts. We celebrated Christmas just to celebrate Christmas, not as an excuse to consume. I found it refreshing and liberating.

Christmas also marked a turning point in the season. By the third week of December, the sea ice had degraded too much and travel on it was prohibited. The ice runway was closed and all flight operations shifted back to Willy Field. This essentially marked the end of the season for many of the biologists. Most had packed up and left McMurdo in order to be home for Christmas, and the population had dropped as a result. There were still plenty of geologists and glaciologists around, but all they wanted was camping gear from the BFC and boxes to fill with rocks and ice cores. I rarely saw them. Water hours were lifted (until the evaporators broke again), and my life began to slow down a bit. For the first time, I sensed that the end of the season was coming. More important, things had slowed enough for John, my boss, to allow me a "boondoggle." It was McMurdo's equivalent of an E-ticket ride.

Only 2 percent of Antarctica is ice-free, and a large part of that 2 percent is found in the Antarctic Dry Valleys. These valleys lie across McMurdo Sound, nestled into the Transantarctic Mountains about fifty miles from McMurdo Station. Though they are largely free of the ice that covers the rest of the continent, a few glaciers flow into them from the mountains and the Polar Plateau. During the summer, intense sun warms the dark earth in the valleys and causes the glacier ice to melt. Over the millennia, this melting has formed several freshwater lakes. Though each is permanently covered with several feet of ice, the depths remain liquid and the edges melt in the summer to form a moat. Each lake exhibits its own particular chemistry and biology. The bottom of Lake Vanda, in the Wright Valley, is a toxic soup of corrosive hydrogen sulfide. In Lake Hoare, in Taylor Valley, mats of ancient algae coat the gloomy bottom, living on almost immeasurable light and surviving long months of total darkness.

The rocks of the valleys and nearby mountain peaks contain their own mysteries. In some sandstone formations, communities of algae, bacteria, and fungi actually live within the rock itself. By doing so, they manage to survive winter's darkness, desiccation, hurricane-force winds, and temperatures down to minus 70° F. These simple organisms offer hope that similar life forms might be found on Mars.

Because of their uniqueness, these Dry Valleys are of considerable interest to scientists. During the summer, geologists and biologists travel by helicopter from McMurdo Station to field camps in the valleys. Some of these scientists spend most of their season in the field, returning to McMurdo only when absolutely necessary.

Below: Grounded iceberg in the Bay of Sails, near the Dry Valleys.
Opposite: Standing on the fractured freshwater ice of Lake Vanda, in Wright Valley.

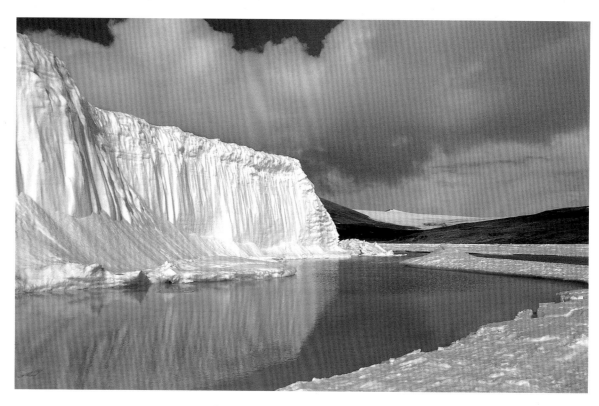

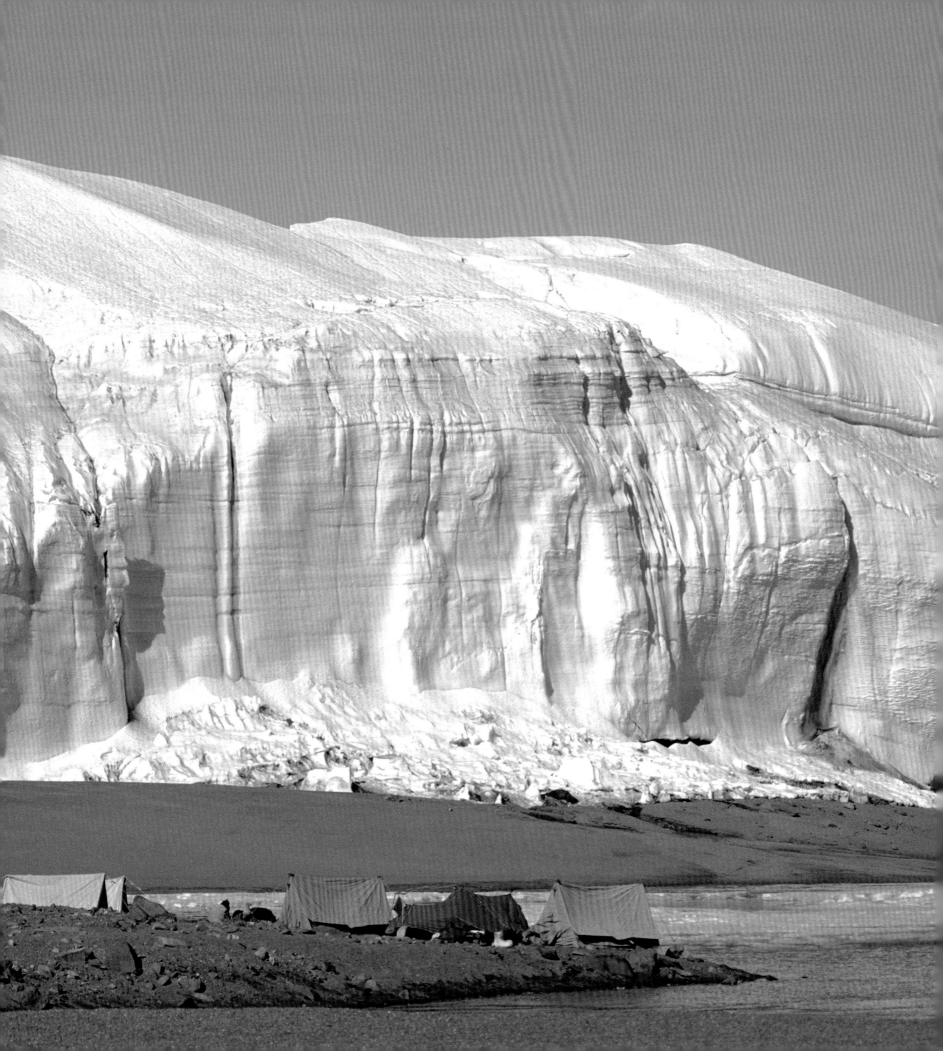

TAYLOR VALLEY

Bunny boots were never intended for hiking, especially over rocks and uneven terrain. They offered no ankle support and had a tendency to collapse to the side when I stepped on a rock at a bad angle. Worse, my feet felt like they were swimming inside the rubber boots. I was sweating in thick wool socks, and the sweat had nowhere to go. But I hardly cared. For the first time in four months, I was alone!

I was hiking up Taylor Valley, along the shore of Lake Hoare. On my right were the Asgards, a rugged and nearly vertical range of mountains that separated Taylor Valley from Wright Valley to the north. Ahead of me, I could see the fractured face of the Suess Glacier, a wall of ice across the valley. The only sounds were my labored breathing and the scuffle and scrape of my boots on loose rock.

I felt like my sanity was returning. The summer season in McMurdo had been exciting, but also exhausting and emotionally draining. Even worse than the hectic pace was the complete lack of privacy. I've always had a need for solitude on occasion, but for the past four months that had been utterly impossible. McMurdo Station during the summer was one of the most densely packed settlements in the world. There was literally nowhere I could go to be alone. Even my room wasn't completely mine, and it always seemed like the times I most needed privacy were the times my roommate was there.

When I'd thought I was about to go nuts, Bill Green, a geo-chemist, had asked for my assistance at Lake Hoare. Bill was measuring the trace minerals that flowed from the Canada Glacier into the lake, and he needed manpower to build a small weir. Requests like this were generally turned down, since the scientists were expected to bring with them to Antarctica all the people they needed to do their proposed work. But there were exceptions. I sweated bullets until I heard that the NSF representative had approved my trip. Two and a half days in Taylor Valley!

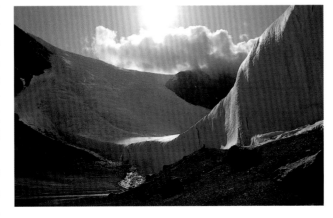

I spent most of the first day helping Bill and his team build the weir. Taylor Valley's climate was an incredible change from McMurdo's. Here, on the west side of the massive Canada Glacier, we were protected from the prevailing wind, making Taylor Valley seem positively warm. I got so hot while shoveling sand that I had to take my shirt off. Later that afternoon, four of us strapped on crampons, roped up, and climbed the Canada Glacier. We hiked past an icescape of melt pools, running streams, and ice tunnels to the apex of the glacier. From there, we could look over most of the valley and see all the way back to Mount Erebus. The air was calm, the late-afternoon sun warm, and the madness of McMurdo seemed a million miles away.

The next day, Bill said I could do as I pleased. It took me all of three nanoseconds to throw water, snacks, and spare clothes into a backpack and head out of camp. I told Bill I would be gone about eight hours. No radio, no survival gear, just me, alone, hiking up the valley.

Opposite: Bill Green's field camp, next to the Canada Glacier and Lake Hoare in Taylor Valley. **Above:** The western side of the Suess Glacier, next to Mummy Pond.

At first, I just wanted to get as far from other human beings as I could, as fast as I could, so I moved quickly along the northern shore of the lake. My first goal was the Suess Glacier, draping the valley floor ahead of me like a carelessly tossed blanket.

As is so often the case in the crystal clear Antarctic air, the glacier seemed closer than it actually was. After I'd hiked for a couple of hours, the glacier hardly seemed any closer. I paused to look at my surroundings. The warm summer sun had melted the edge of permanently frozen Lake Hoare, forming a moat too wide to cross. Beneath the clear, shallow water was a bottom of fine sand. I looked across the moat to the ice. It was jagged and uneven, the result of wind ablation, melting, and refreezing. The rocks along the shore that had made hiking difficult looked as though they had been tossed there by someone getting rid of a collection. They were all different colors and shapes — red, green, black, gray speckled, jagged and rounded, rough and smooth. I saw granite and basalt, and others I didn't recognize. It was not at all consistent. It was a rock collector's paradise, but my pack was heavy enough. I picked up a couple of especially interesting stones but let the rest be. I looked up at the imposing Asgards, which seemed to rise almost vertically from the shore of the lake. Across the lake and across the valley, the rounded Kukri Hills were in marked contrast to the steep, jagged Asgards.

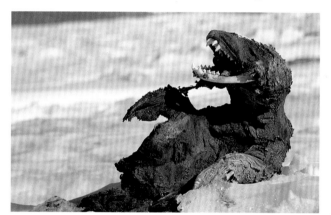

The further I got from camp, the better I felt. It was as though I'd suddenly been liberated from a prison. The nearest people were those at camp, and they were busy with their own tasks and wouldn't be bothering me. As far as I was concerned, I was alone in the world. I felt like a great weight had been lifted from my shoulders.

When I reached Lake Chad, I paused. Chad, a considerably smaller lake, lay at a slightly higher elevation than Hoare. Like Hoare, Chad was also permanently frozen, but the ice in the center was bluer and smoother. I saw that several small streams flowed from Chad's moat into Hoare's.

I could have crossed these streams between the lakes to reach the other side of the valley, which I'd have to do to get past the Suess, but I opted to continue up the north shore of Chad. Moments later I topped a small hill and came face to face with a mummified seal. It lay on its stomach, its back arched as though its last spasm before dying had been frozen in place. Most of the skin, though desiccated, was intact, except for the skull. There the incessant wind had peeled off the skin to reveal the white of sun-bleached bone and toothy grimace. It looked like a macabre sentinel, guarding the upper reaches of Taylor Valley.

I'd heard various theories of why these seals were found many miles up the valley, far from the sea. The prevailing one was that they had become disoriented and mistook the dark horizon of a valley for the dark of open water reflected in low clouds. Thinking they were heading toward safety, they headed instead farther and farther away from the ocean, until they finally died of hunger.

Above: Mummified Weddell seal on the Commonwealth Glacier, one of many such mummies in Taylor Valley. The reason why these seals crawl miles inland to die is not entirely clear. **Opposite:** While flying over the Taylor Glacier, two helicopter pilots discovered this giant ice tunnel. How it formed is a complete mystery to me.

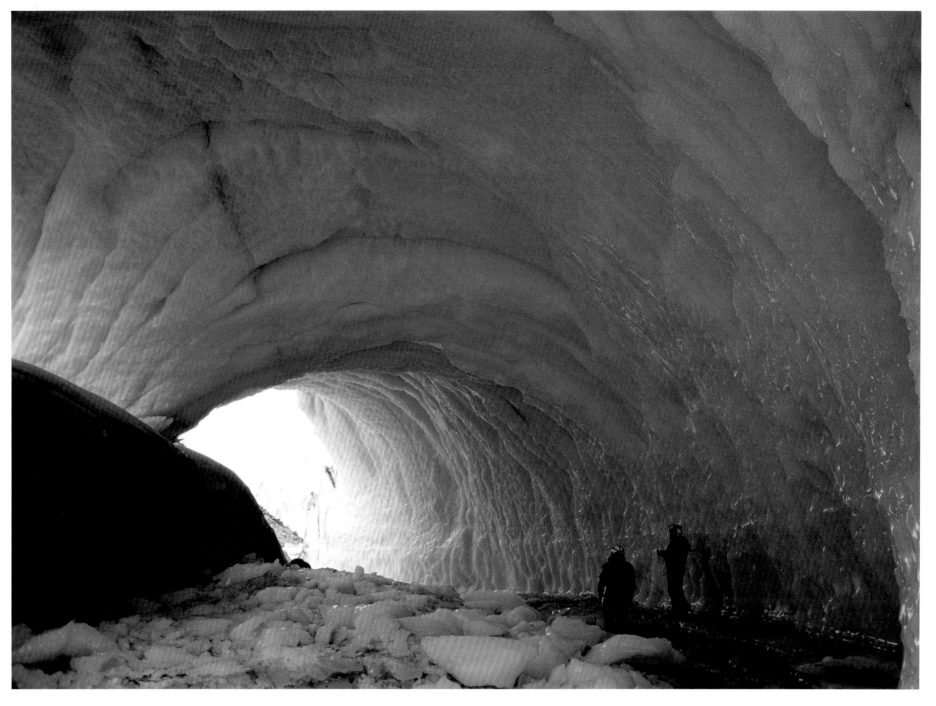

Supposedly, some of the mummies are thousands of years old, their carcasses freeze-dried by Antarctica's climate. I took a picture and moved on.

Finally, I was getting close to the Suess. Unlike the smooth western side of the Canada Glacier, the eastern side of the Suess was ragged and uneven. The strong summer sun and up-valley winds had degraded the ice, leaving vertical rifts and channels. I crossed the melt streams that flowed from the glacier into Lake Chad and stood next to the jagged wall. The earth below my feet was composed of tiny multicolored pebbles shining in the glacier's meltwater.

My next step was to squeeze through the defile, a narrow passage between the advancing front of the glacier and the steeply sloped hill it had run up against on the south side of the valley. I climbed up from the valley floor, toward that passage. At the entrance, I turned around and looked back the way I had come. Taylor Valley stretched out below me, with the stunning Asgards towering

like Norse gods over the valley floor. In the distance, I could see the Canada Glacier and the reflection of the sun off Lake Hoare's moat. Beyond that lay the rest of the valley, and then the frozen sea. I could see no sign of our camp; it was too far away. A few wispy clouds dotted the sky. The air was clean and clear and the sun warm on my face. It seemed as if the whole world lay at my feet.

Antarctica a frozen wasteland? This was heaven! This whole, vast, pristine, gloriously beautiful valley, untouched by time or human beings. A virgin land, a spectacular Shangri-la at the end of the earth. I had never felt more alive or more ecstatic. I raised my arms over my head and let out a whoop of joy.

I'd heard many people say that standing in the midst of Antarctica's vastness made them feel small and insignificant, but that wasn't what I was feeling at that moment. I felt myself not as a tiny and helpless interloper in an impersonal landscape, but rather as an integral part of the land itself. It was as though I perceived the moment from a much wider perspective, in which this magnificent, starkly barren valley and I were somehow two sides of the same coin. I knew this was exactly where I was supposed to be.

I could have stood there for hours, staring at that grand vista and feeling myself melt into the land, but I wanted to see more, and time was running out. I turned and entered the defile.

The Suess Glacier had spilled over the top of the Asgards and flowed into Taylor Valley like a river. The valley was narrow here, so the glacier had spanned the entire width of the valley floor and run up against the steep hills on the other side. The space between the face of the glacier and the side of the hill was just wide enough for a man to walk through. About halfway, I stopped to investigate a boulder embedded in the ice. Somehow that glacier had picked up a rock nearly as big as I was and transported it to this point. Now it jutted out of the face like a stone whisker. I wondered where it had come from, and how long it had rested in the ice before ablation from the wind exposed it. I laid my hand against the face of the glacier, wondering if I could somehow sense the unstoppable force of billions of tons of ice, pressing irrevocably forward. But the ice was merely cold. I'd need the perspective of hundreds of years to see the fluid motion I knew existed.

I continued through the defile until it opened up on the other side of the glacier. Below me was another small lake, a shallow body of water called Mummy Pond. On the other side of the lake, the valley sides pressed in until there was only a narrow pass. I started downhill toward the pond's shore. On the floor of the valley, the loose, rocky earth of the hill changed to a fine, soft silt. The slope leading to the pond was so gentle I almost couldn't tell where the sediment gave way to water. I tried walking to the edge of the water, but the silt became softer and softer, until I worried I might be trudging into Antarctica's version of quicksand. I turned and walked back to firmer ground.

On this side, the Suess Glacier was much higher, and instead of presenting a scalloped and jagged face, it was almost perfectly smooth. It towered above me, gleaming, backlit by the sun, like an unscalable monolith. I could hear the sound of running water and saw several small streams cascading down the face of the ice and splashing onto the broken bits of ice that litter the ground around every glacier. I dropped my pack and pulled out my water bottle. Making sure I wouldn't be the target of one of those bits of ice as it broke off and fell from the top, I maneuvered into a position where I could hold the bottle in the falling stream. Frigid water splashed onto my hand and arm, numbing my fingers.

Previous pages: Out on the sea ice on a calm, warm day during the summer, our Spryte broke down. After waiting hours for a rescue, three members of the group became fed up and decided to walk the eight miles or so back to McMurdo Station. Towering over the ice is the perfect cone of Mount Discovery, forty miles away.

When the bottle was full, I found a rock to sit on and pulled some beef jerky and a chocolate bar out of my pack. There, in the warm sun, at the base of the Suess Glacier, I ate the best lunch of my life. I quenched my thirst with the cleanest, purest water in the world, water that had been frozen for thousands, perhaps hundreds of thousands of years. Water that had fallen as snow on Antarctica when mastodons roamed North America.

It tasted better than any water I'd ever had.

Afterward, I contemplated hiking further up the valley. I felt like I was walking on ground that might never have felt the tread of human feet. Undoubtedly, a few people had come this way before me, but had anyone sat on this rock? Had anyone placed his feet precisely where mine had gone? At that moment, I understood what drove people like James Clark Ross, Robert Scott, and Ernest Shackleton. It was an incredible rush to explore the unknown, to go where no others have gone, to see the absolutely new.

The sky was beginning to look less friendly, however. A few clouds had started to build farther up the valley, and it appeared they might be moving my way. The wind had also picked up a bit. I was wearing only long underwear and a wool shirt, and had just a light windbreaker in my pack. I had wanted to travel light, but as a result couldn't take any chances with the weather. If a storm rolled in and caught me, I'd be in trouble.

So I spent a few minutes strolling around the edge of the pond, avoiding the soft sediment. I found only one mummied seal, which made me wonder about the name given to this mysterious little body of water. Then I reluctantly packed my water bottle, after filling it one more time, and shouldered the backpack. I took one last look up the valley and at the imposing face of the glacier, then began the long trudge back to camp. It was getting late, and I'd have to hurry to make it before my eight hours were up. The last thing I wanted was to be too long overdue and have a search-and-rescue called out. Very embarrassing, and big trouble if it's unnecessary.

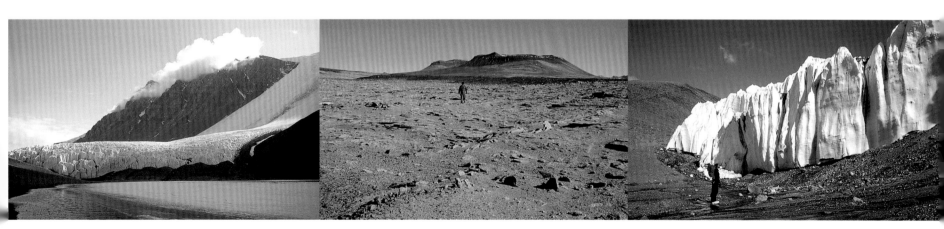

Above left: Lake Chad and the Suess Glacier in Taylor Valley. **Above middle:** Marsscape. The wind-scoured, barren earth near Lake Vida in Victoria Valley bears an uncanny resemblance to the terrain of the Red Planet. **Above right:** The fractured eastern face of the Suess Glacier. I used a tripod to snap this self-portrait just before entering the defile, the narrow passage between the advancing face of the glacier and the hillside it is pressing up against.

On the other side of the defile, I paused to collect a few water samples from the stream flowing from Chad into Hoare. Bill had requested them for an analysis he wanted to perform. Then I picked up the pace, for the sun was getting lower in the sky and the air was turning colder. The return trip over the loose rocks along Hoare's shoreline was harder going. The bunny boots were taking their toll. My feet were beginning to get sore from fighting those big rubber clodhoppers. A few hours later, I trudged into camp, my body exhausted, but my soul exhilarated. That night, I slept in my tent with a greater sense of peace than I had ever known.

<div align="center">❄ ❄ ❄</div>

At the end of December, on a clear, calm day, I wandered down to Hut Point, so called because it is the site of Robert Scott's 1902 hut. A dirt road led out of McMurdo, down past Winter Quarters Bay, where workers were preparing the ice wharf for the arrival of the resupply vessels, and finally to a bluff of volcanic rock overlooking McMurdo Sound. Just behind the bluff sat the hut, a low-slung wooden structure, looking just as it had when Scott abandoned it shortly after the turn of the century. On the bluff itself was a cross erected to commemorate George Vince, a member of Scott's crew who had slipped during a storm and plummeted to his death down a steep, icy slope into the sea.

I climbed a gravelly path, with loose stones shifting beneath my bunny boots, paused at the cross to

read the faded inscription, then moved to the end of the point. Sunlight gleamed off the sea ice and reflected from the many melt pools below me. To the north I could make out the dark shapes of Tent and Inaccessible Islands — and something else. I saw a dark line that had to mean open water. The ice edge had moved closer as the sea ice fell apart in the summer sun and winds blew it away. Below me, on the pitted, slushy ice near the point, a small group of Adélie penguins preened their feathers and waggled their hard, stubby wings.

This was the real Antarctica, I thought, the deep-south, covered-with-ice Antarctica, but the penguins and the approaching open water reminded me that the whole of Antarctica encompasses much more than that. The continent itself is ringed with tiny islands, crags of rock pounded by the stormy Southern Ocean. The area that encompasses those islands is called the subantarctic, a name that implies something less than Antarctica. Perhaps in a way it is, because the subantarctic is not as cold, not as icy, not as brutal as the barren expanse of ice that covers most of the continent. But in another way, the subantarctic is much more, because it is far richer in life. The islands of the subantarctic swarm with vast populations of seals and sea birds. I'd been to one of these islands, and I was struck now by the contrast between the lonely Adélies on the ice below me and the millions of birds on the grass-covered slopes of Bird Island.

Above: A U.S. Coast Guard icebreaker sitting in front of McMurdo Station. After cutting a channel into McMurdo from the ice edge, the breaker turned circles through the ice in front of town, churning it up and trying to create an area of open water for the incoming tanker and cargo ships to maneuver. **Opposite:** Upper Taylor Valley, looking west toward the Polar Plateau. In the left foreground is a giant ventifact, a boulder sculpted by the incessant wind. On the right, on the floor of the valley, is the permanently frozen surface of Lake Bonney.

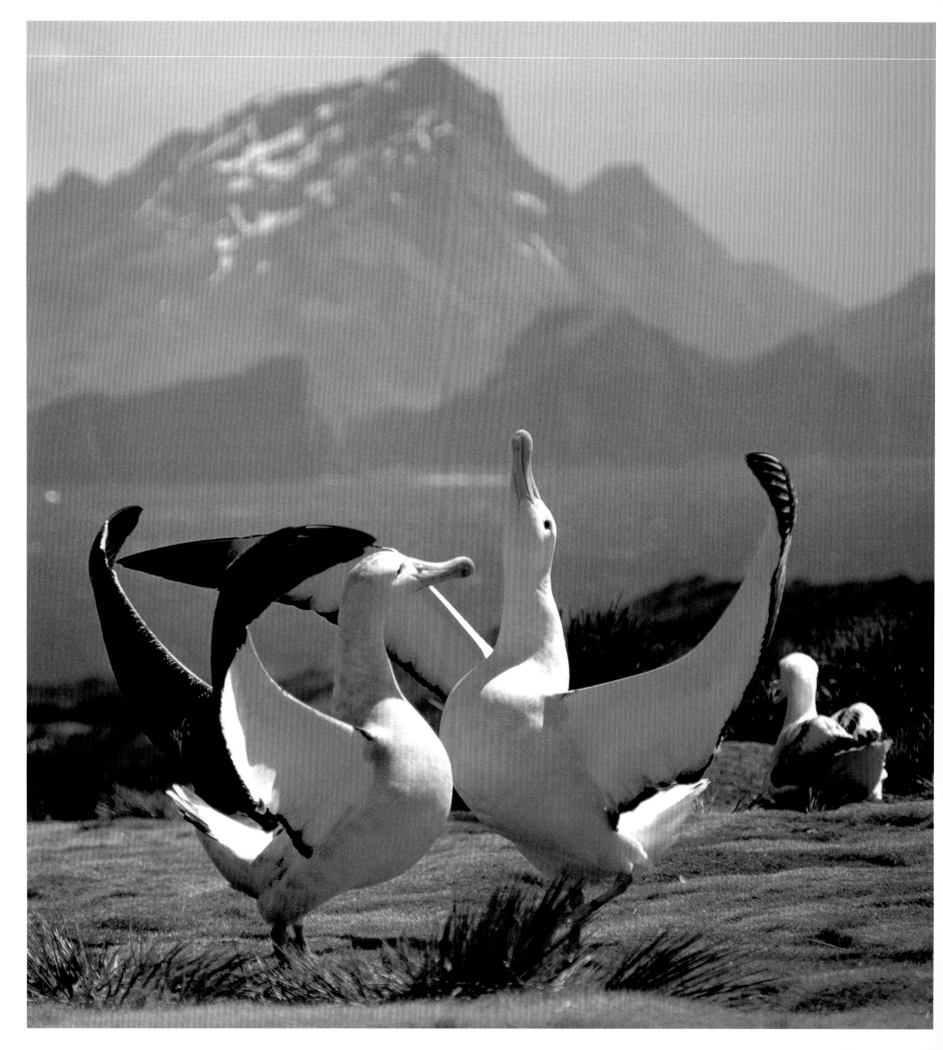

BIRD ISLAND

Bird Island sits like a biological jewel smack in the middle of the subantarctic South Atlantic. It's a tiny place, a tussock-grass-covered rock about a mile wide and two miles long, sitting just to the west of South Georgia Island. In fact, only a few hundred yards of cold, stormy sea separates the two, but they are very different chunks of rock. Where introduced deer and rats have played havoc with South Georgia's original ecology, Bird Island is uninfested and therefore nearly pristine.

I say nearly, because tiny Bird Island has not entirely escaped the ravages humans have brought to this part of the world. While the Antarctic continent is still relatively untouched, the islands of the sub-Antarctic bore the brunt of humanity's nineteenth- and twentieth-century exploitations. Seal hunters very nearly exterminated the southern elephant seal and the Antarctic fur seal (among others), and they were followed by whalers who did the same with all the giant species of great whales. The ecosystem is still seeking a new equilibrium, and fur seals, which breed much faster than whales, are in the lead.

This was made abundantly clear to me as I watched the seals clamber over the mounds of tussock grass behind Bird Island Base Camp. They were going higher and higher into the hills (for reasons I may never understand — after all, why would a seal want to climb through the hills when its appendages are clearly made for swimming?), and they were destroying the tussock. In the process,

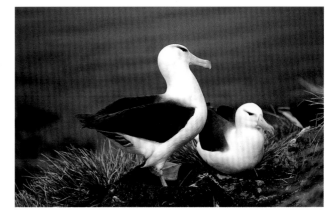

they were also destroying prime bird-breeding habitat. There were more Antarctic fur seals at that moment than at any time in the past, a consequence perhaps of the fact they no longer had to compete with whales for the krill that serves as the primary summer food source for both.

I was on Bird Island for a few weeks to help a friend and colleague, Dan Costa, study the seals' feeding biology. At the same time, another friend, Randall Davis, was doing similar work with two species of penguin. How much krill did these animals need to breed successfully? With a little scientific ingenuity, Dan and Randy intended to find out. It sounded easy to me at first. The reality was that it involved a lot of hard, dirty, and dangerous work.

We hit Bird Island at the height of the austral summer, when the seal and penguin breeding seasons were in full swing. As guests of the British Antarctic Survey (BAS), we stayed with five BAS scientists in the single hut that served as base camp. It was a comfortable enough building, with a bunkroom, kitchen, dining alcove, and laboratory. There was one minor inconvenience: it lacked a toilet. Faced with limited space, the British builders had opted to include a shower rather than a restroom. The reasoning was that, given two unpleasant alternatives, defecating outdoors in the cold was preferable to showering there.

Opposite: Two wandering albatrosses engaged in a courtship dance, with the Willis Islands forming a backdrop. The birds prance around each other, clacking their bills and spreading their wings, in one of the most elegant mating rituals in the avian world. **Above:** Mated pair of black-browed albatross (*Diomedea melanophris*) on their nest of packed mud, Bird Island. Because Bird Island has never had a terrestrial predator, the albatrosses and other birds do not fear the approach of a human, even one carrying a camera.

I probably would have made the same decision. In fact, the former wasn't all that bad, though admittedly a little uncomfortable on cold, windy, snowy days (of which there were many). Rather more disconcerting was, while in the midst of doing one's business, to feel the tickle of inquisitive fur seal whiskers against one's indelicately bare bottom. The first time this happened I nearly fell on my face when I tried to jump away with my trousers wrapped around my ankles. The problem wasn't modesty but rather the fact that fur seals have incredibly sharp teeth, and they're not afraid to use them.

That had been made abundantly clear during the daily radio communications all isolated Antarctic bases maintain with each other. Word came one day that some unfortunate fellow at another British base was in dire need of medical attention because a fur seal pup had managed to clamp down on the guy's privates. After all the "What was *he* trying to do?" jokes had made the rounds, we were left to contemplate our next foray to the "bathroom."

The bite of a seal is very serious, even beyond the initial tissue damage it might inflict. Seals have some of the dirtiest mouths in the animal kingdom, filled with nasty bacteria that can cause very unpleasant infections. Curing them often requires the latest, strongest antibiotics, something not always available in Antarctic field camps. I decided the better part of wisdom was avoiding bites, which wasn't always possible in the work we were doing. I'd already been nipped by a pup, and I had allowed my arm to stray too near the mouth of a female we had captured and restrained so we could take a blood sample. The result was that she took her own blood sample from me.

Apart from the work we were doing, just walking around was risky. The base had been constructed on a small floodplain at the confluence of two streams, near the shore of a tiny cove. One of these streams had been designated as the base's water supply, while the other served as our "bathroom." (The fur seals, unfortunately, made no such distinction.) The flood plain was the fur seal rookery, filled at the height of the season with hundreds of fighting, territorial bulls, nursing females, and squalling pups. My work required me to wade into the thick of things to capture mothers and pups for measurements. Most paid little attention to me, with the exception of territorial bulls and juvenile delinquents. The bulls, though big and powerful, were actually easy to handle.

Each of us was issued a "bodger," which was a stick about six feet long with the thickness and heft of a broom handle. These bodgers were not used to hit the seals, but rather to tickle their whiskers. The much smaller females had evolved a technique to calm the large, sexually aggressive bulls. They'd rub their own whiskers against those of the bull, and for some reason this would cause the much more powerful male to back off. I have no idea why this worked, but we used it to our own benefit. Placing the end of a bodger near the nose of a charging or aggressive bull would cause him to stop immediately. It was like magic when it worked, which was most of the time.

While the bulls were predictable, though, the delinquents were not.

We had a name for these young, brash, sexually frustrated males. We called them BEMs, or bug-eyed males. Instead of keeping to themselves, or even moving out of the way of an approaching human, the BEMs would suddenly widen their eyes until they seemed to bulge out of their heads. In a moment of apparent insanity, they'd charge, roaring, with their toothy jaws gaping and slaver-

Previous pages: Macaroni Point, Bird Island. A penguin megalopolis. Hundreds of thousands of braying birds. A raucous, deafening sea of breeding penguins on a little island in a far-off corner of the earth. **Opposite:** Macaroni penguin (*Eudyptes chrysolophus*) mated pair guarding their egg on a nest at Macaroni Point, Bird Island.

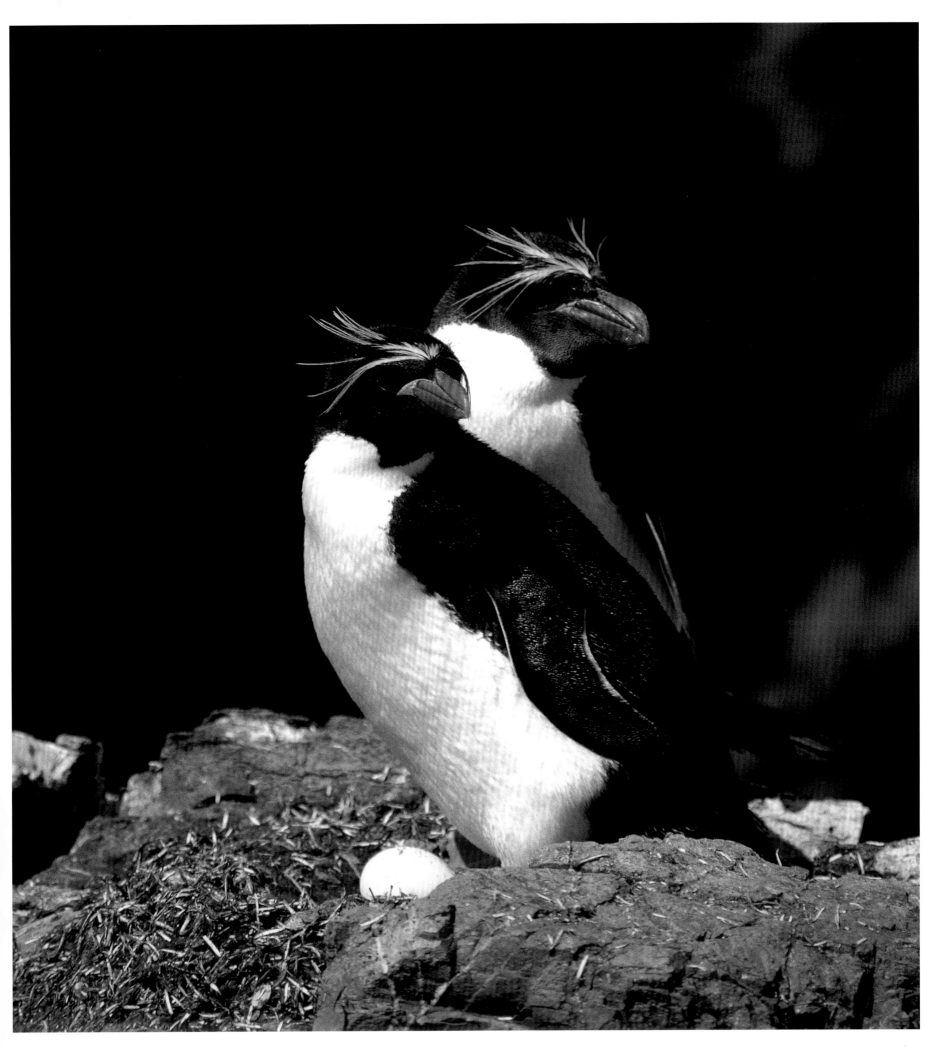

ing. There was no way to predict which young male would become a BEM, or when it would happen, nor was there an effective defense, except to run in the other direction. Bodgers were generally useless.

This made working in the rookery a bit of a challenge. I had to constantly monitor my peripheral vision and keep an eye out for seals that were paying more attention to me than to the business of mating. Fortunately, most of the subadults, including potential BEMs, were excluded from the rookery by the territorial bulls. Unfortunately, however, that meant they hung out around the edges and in the tussock-covered hills. They made each of our trips out of camp, either to the "bathroom" or to other areas of the island, a potential adventure. Sometimes it was downright hazardous.

One rare sunny day, Dan and I were caught up on our work, so I decided to make it a photo opportunity. I grabbed my bodger, my camera, and a light backpack with food, water, and a windbreaker and headed into the hills. There was a light breeze and a few puffy clouds in an otherwise clear sky. The constant din of hundreds of baying, growling, huffing, mewling fur seals faded behind me as I climbed the hills behind the base. Although I'd grown used to the incessant cacophony of the seals, and even to the banging and shuffling of young pups playing under the hut at night, the relative quiet was a relief. Distant, melancholy whistles caught my attention and I looked to my left. Black-browed albatrosses were nesting on a cliff that overlooked the camp, and the breeze carried their calls to me. I could see them as white dots against a green and brown wall.

Every inch of this island was covered with wildlife. The beaches were writhing masses of fur seals, elephant seals, and penguins. The hills, whether rocky or covered with tussock, held more penguins, wandering albatrosses, skuas, and innumerable petrels and other seabirds. Even the sheer cliffs were home to black-browed, gray-headed, and light-mantled sooty albatrosses. The tussock where I stood was probably honeycombed with the burrows of nesting fairy prions, white-chinned petrels, and South Georgia pipits. Bird Island was a bird-watcher's paradise.

I continued up the hill toward the skua pond. Hiking across tussock grass was always a challenge. This odd grass grew in giant mounds, sometimes four or five feet high. Between the mounds but hidden by the waving grass were deep, muddy pits. The trick was to walk on the tops of the mounds, but they were often slick with rain or sea mist. More than once I'd found myself suddenly up to my chest in the tussock, with one foot buried in muck. To make matters worse, sleeping fur seals looked exactly like brown, denuded tussock mounds, and there were a lot of both. After stepping on a seal during one of my treks across the island, I took to beating the tussock ahead of me with my bodger to roust any seals that might be in my path.

At the top of the hill was a pond frequently used by skuas to bathe. There were several splashing their wings as I walked by. One of them took off and dived, screeching, at my head. I figured a nest

Opposite: Bird Island Base Camp in the blue gloaming of a subantarctic summer night. **Above:** This single pair of chinstrap penguins (*Pygoscelis antarctica*) had established their nest in the middle of the gentoo penguin rookery at Johnson Cove, Bird Island. They seemed somewhat lost and a little confused.

was nearby and, after a few minutes of searching, spotted a little gray blob of fuzz hunkered near the path. Holding my bodger over my head to keep the parent from ripping at my scalp, I bent down and picked up the skua chick. It was just big enough to fit in my palm, and seemed perfectly content to do so. It fluttered its down-covered stubs of wings and cocked its head to look at me. Amazing, I thought. Who would imagine this cute little ball of fuzz would grow up to be one of the most vicious avian predators in the world? Skuas were merciless. I had seen them pecking the eyes out of dying seals that were too weak to defend themselves. Anyone who fell and knocked himself unconscious on this island would certainly wake up blind. Even taking a nap outside, if it were ever warm enough to do so, would be a mistake. Between the skuas and the giant petrels, a bigger and even more voracious bird, a person wouldn't have a chance. I'd seen a feeding frenzy of the two birds reduce a freshly dead 200-pound seal to a pile of bones in just a few hours.

I put the skua chick back where I'd found it and continued on. After a while, the parent stopped buzzing my head.

I crossed over a rise and into the upper meadow. It was a green field of scrub grass, dotted here and there with bright white wandering albatrosses sitting on nests of packed grass and mud. In the far distance, rising steeply out of an unsettled sea, were the Willis Islands.

On my way across the meadow, I stopped next to a wanderer nesting near the path. It was almost pure white, which meant it was probably forty or fifty years old, maybe more. (Whether it was male or female was impossible to tell, and both sexes share the chore of incubating the egg.) Like all the birds on this island, it merely cocked its head and looked at me. There have never been any land predators on Bird Island, so the nesting birds showed no fear of humans. I had already hiked through black-browed and gray-headed albatross nesting colonies and stood close enough to touch them (though I usually resisted the urge). To someone accustomed to birds flitting away at even the hint of a human's approach, it was a magical feeling to stand on a cliff overlooking the ocean, surrounded by large, beautiful albatrosses who merely stared back in curiosity.

But of them all, the wanderers were the most magnificent. They are enormous birds, standing almost three feet tall. They also have the widest wingspan of any bird in the world, up to twelve feet from tip to tip. The one next to me was sitting on its nest like a king on his throne, calmly regarding me with one eye. It was incredibly beautiful. I had to touch it. I knew its beak was razor-sharp, though, and it wouldn't hesitate to nip at my hand. So I used a trick I'd learned from one of the British researchers. I reached over slowly and began stroking the nape of the bird's neck.

It's too easy at times like that to ascribe human emotions to an animal, but I swear I saw the bird's look change from curious wariness to complete ecstasy. Apparently, the nape of the neck is an albatross erogenous zone. With the bird now completely calm, I ran my hand gently down its back and across its folded wings. Incredible. Unbelievable. Kneeling in the meadow grass on an island in the middle of the Southern Ocean, stroking the largest flying bird in the world. It almost didn't seem real.

Reluctantly, I stood and continued down the path. The albatross cocked its head to watch me go but otherwise remained sitting on its nest. It was probably awaiting the arrival of its mate. Like many birds, wanderers mate for life. Ahead of me, two mates had found each other again after a year spent apart. Most of their lives are spent in the air and at sea, circling Antarctica in search of food. Together again at last, they spread their wings and danced around each other, bills clacking and snapping. It was an ecstatic and elegant display of affection. I took several photos, then moved on. My plan was to reach Macaroni Point, then head across the island to Farewell Point for a look at South Georgia. Even though the sun didn't set until about ten P.M., I had to keep moving.

A few minutes later I stood on the rise above Macaroni Point. Below me, stretching away for at least a quarter of a mile, was the largest penguin rookery on the island. Hundreds of thousands of obstreperous macaroni penguins dotted the steep, rocky hillside. The noise of their combined braying was deafening, and the air was filled with that uniquely pungent odor that only penguin guano can produce. At the bottom of the hill, huge waves slammed into the shore, each one either sweeping off or depositing groups of penguins on their way to and from the sea. It was hard to see how they could survive the pounding they must have received, but they scrambled up and down the slope without any apparent discomfort.

I was at the periphery of the rookery, at the top of the hill. The penguins that had established nests here had the farthest to scramble, but they seemed perfectly healthy. Each mating pair had claimed a small section of the rocky ground and had arranged a few loose stones to make a nest. Some pairs had even pushed into the tussock grass to find room. I knelt down next to a penguin incubating an egg and patted its sturdy back. It felt like a solid mass of muscle. A penguin nearby,

perhaps annoyed at my invasion of its territory, spread its tiny wings and brayed at me. Then it calmly waddled over and pecked at my leg.

I was careful to keep my fingers out of reach. Their beaks are amazingly powerful, as I had learned a few days ago. I had been helping Randy with his penguin work, which required that I capture a study bird and bring it into the tent he was using as a field laboratory. Holding the bird's feet in one hand and its beak in the other, I started crawling on my stomach through the tent's small opening. In the process, I lost hold of the penguin's beak. It immediately swung around and took a jab at my left eye. I saw stars and then blackness. I dropped the penguin and clapped my hand over my eye. I was certain I had lost it. Blind in one eye! A horrible emptiness filled my chest. But when I removed my hand, I could still see. The bird's beak had hit my cheekbone and simply glanced into the eye itself. I was left with a deep gash on my face and a deep respect for penguins who didn't want to be bothered by scientists.

So here in the middle of all these birds, I made sure I kept damageable parts out of reach. Like all the birds on this island, these penguins were utterly fearless of me, though I towered over them. When I walked past their nests, they protested loudly and pecked at my legs. But the moment I stopped moving, they completely ignored me. I walked a few feet into the rookery and stood still, surrounded on all sides by thousands of the comical, yellow-tufted birds, a huge mass of avian fauna, a bird megalopolis, with all of them going about their business of making more penguins. I looked up to see gray-headed albatrosses gliding overhead, coasting effortlessly on their oversize wings. At that moment, Bird Island itself seemed like a living thing.

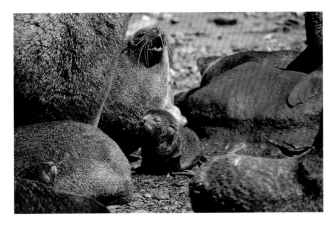

I was tempted to continue on toward Johnson Cove, where I knew I'd find a colony of gentoo penguins, but I decided to stick with the original plan. One of the other researchers was at Johnson Cove, and I felt like being alone. As at McMurdo station, living quarters here were close and privacy was hard to come by. This was my day to interact with no one except the wildlife. I turned and headed in the direction of South Georgia.

The path ran along a sheer cliff, a several-hundred-foot drop straight down to the turbulent sea. Perched precariously on the face of the cliff, in any available nook or on any small rocky shelf, were nests belonging to either black-browed, gray-headed, or light-mantled sooty albatrosses. Members of all three species and even the occasional wanderer glided along the face of the cliff, riding the updraft. Every once in a while one would rise above the cliff and soar with a *whoosh* over me. The air rushing through their feathers was surprisingly loud. Once I ducked, thinking an albatross was about to run into me, but the bird was fifty feet over my head.

Above: Born into a world of giants. The life of an Antarctic fur seal pup (*Arctocephalus gazella*) is a dangerous one. They are ignored by the territorial bulls into whose domains they have been born. In the bulls' haste to mate with a female or repulse a challenger, they often run right over the hapless pups. Sometimes they come to rest sitting on one. The pups have evolved a behavior to get them out of these sticky situations, though. They violently twitch every muscle in their body at once, becoming such an irritant that, hopefully, the bull will move and set them free.

Climbing up out of the tussock, I skirted the scree- and moss-covered base of the island's central peak, then descended into tussock again on the other side. Even here I found fur seals, at the very top of the island, hundreds of feet above the sea. I nearly stepped on one as I was jumping from one tussock mound to another. Startled, the seal barked briefly and shuffled off. I resolved to move more slowly and watch even more carefully where I was going. I managed to skirt around one or two others in my path, until finally I came out again onto bare rock.

I found myself standing on a rocky outcrop that sloped toward a cliff. Far below was the narrow, treacherous channel that separated Bird Island from South Georgia. The water was a deep and agitated blue, and giant waves exploded into white spray against the rocks and shorelines of both islands. South Georgia jutted steeply out of this unsettled sea, a line of jagged, snow-capped peaks. They stood starkly against the cloudless sky, almost close enough to touch.

Since our arrival on Bird Island, the weather had been typical for the Southern Ocean, that unhindered stretch of storm-tossed sea that surrounds Antarctica. Almost every day had been overcast, with plenty of rain and snow. We'd even had to work through hurricane-force winds once or twice. So to sit with my shirt off, with the sun on my back and the splendor of South Georgia spread out before me, was paradise. Best of all, I was completely alone, and no one knew where I was. I felt like I was on top of the world.

A couple of hours later, I reluctantly had to admit it was time to head back. The sun was sinking and the air had begun to chill. I'd already put my shirt back on, along with the windbreaker I had in the backpack. I had also long ago consumed my meager lunch and was getting hungry, and I knew it would take me several hours to hike back to camp. I stowed my camera, shouldered the backpack, and grabbed my bodger. I took a last look at South Georgia, trying to lock the postcard scene in my memory, then turned and headed west, back into the tussock.

There was no set path, but I was still near the top of the island where the tussock wasn't as high as farther down the slope, so the going was not particularly difficult. I wove my way around the higher mounds, stumbling into mud only on occasion. It was getting dark fast, though, and the way was harder to see. It was also getting cold, and I hadn't brought along any other clothes. I stepped up the pace. I needed to get back to familiar territory before nightfall.

Coming around a small rise, I startled two subadult male fur seals that were sleeping in the tussock. Both charged. I tapped one on the side of his mouth with the bodger and he immediately turned and ran off. The other seal became a bug-eyed male. The whites of his bulging eyes stood out sharply against his brown fur. He bared his yellowed, needle-sharp teeth and snarled and snorted like a monster in some grade-B horror movie. I stuck the bodger in his face and whiskers, but he kept coming. I started backing up, trying to keep the length of my bodger between us. The seal ignored the stick as if it weren't there. His bulging eyes were focused on me, and he wanted blood. I tried tapping him on the side of the head with the bodger, but that only seemed to infuriate him further. Still retreating, I swung harder. Out of desperation, I hoped a good sound smack on the head would snap him out of his temporary insanity, but before I could deliver it, my foot struck something behind me and I fell over backward. The bodger flew from my hand.

In the next instant the seal was towering over me, glaring down with one distended eye, his gaping, slobbering mouth ready to rip off my kneecap.

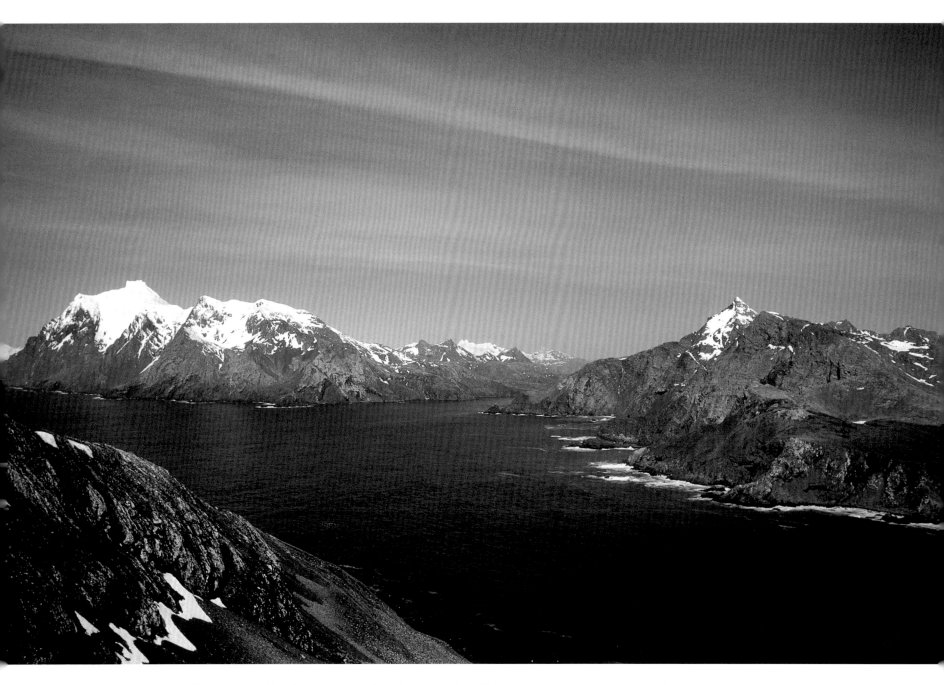

Above: The view toward South Georgia Island from the eastern tip of Bird Island. Only a narrow and very treacherous channel separates the two, but it has been enough to keep Bird Island free of the introduced rats that infest South Georgia and are decimating its burrowing bird populations.

For one horrible moment, the consequences of that ran through my mind. I was far from base, with no radio, and no one knew where I was. It was getting dark and cold. Hiking over tussock was difficult enough with two good legs. There was no way I could make it with one leg torn up, especially with the loss of blood that I would surely suffer. Even if I survived the night out in the cold, the delay in treatment would certainly mean a virulent infection that would probably cost me my leg.

Out of fear and desperation, I planted both of my booted feet into the seal's chest and shoved back with all the strength I could muster.

The show of strength seemed to shock him out of his trance. He stood for a minute, looking confused, then turned and ran off in the direction the other seal had taken. If he had charged again, he would have had me.

I lay in the tussock for a moment, staring blankly at the darkening sky, breathing rapidly. My heart hammered in my chest. Blood pounded in my ears.

Finally I rose, still shaken, gathered my bodger, and struck out again for camp. I moved more cautiously and made as much noise as I could to alert any other seals that might be in my path, but no others appeared.

I arrived at Bird Island Base after dark, utterly exhausted.

Not long afterward, our work finished, a ship arrived to take Dan, Randy, and me away. It was a drizzly, overcast day. The fur seal bulls, exhausted by fighting and mating, had stopped defending their territorial boundaries, and subadults now ran rampant through the rookery. Pups were everywhere, little growling balls of black fur. Mist wafted across the island, obscuring the hills, but I could still hear the doleful cries of those black-browed albatrosses nesting above the camp.

As I watched Bird Island fade into the mist astern, I tried to lock those images into my memory. Despite the foul weather, and despite the danger and the close calls, this was a magical place. It was a small reminder of what the world once was, and what it should be, unsullied and untainted, rich in mystery and vibrant with life.

❄ ❄ ❄

Just as they did at Bird Island and most other Antarctic bases, ships came into McMurdo Station to transfer people and supplies, though I never could have guessed that when I first arrived. The sea ice had looked so solid then. But no sooner had the calendar turned to January than I was greeted by the unlikely sight of a U.S. Coast Guard icebreaker shoving its way through what was left of McMurdo Sound's sea ice. Even more shocking, the ship was plowing right along — and sometimes through — the very roads I had been driving Sprytes and Nodwells on not three weeks earlier.

The icebreaker's job was to clear a channel through the ice so a fuel tanker and a cargo ship could get through. McMurdo and South Pole Stations burned through hundreds of thousands of gallons of diesel oil every year, as well as tons of food and supplies, and the only practical way to

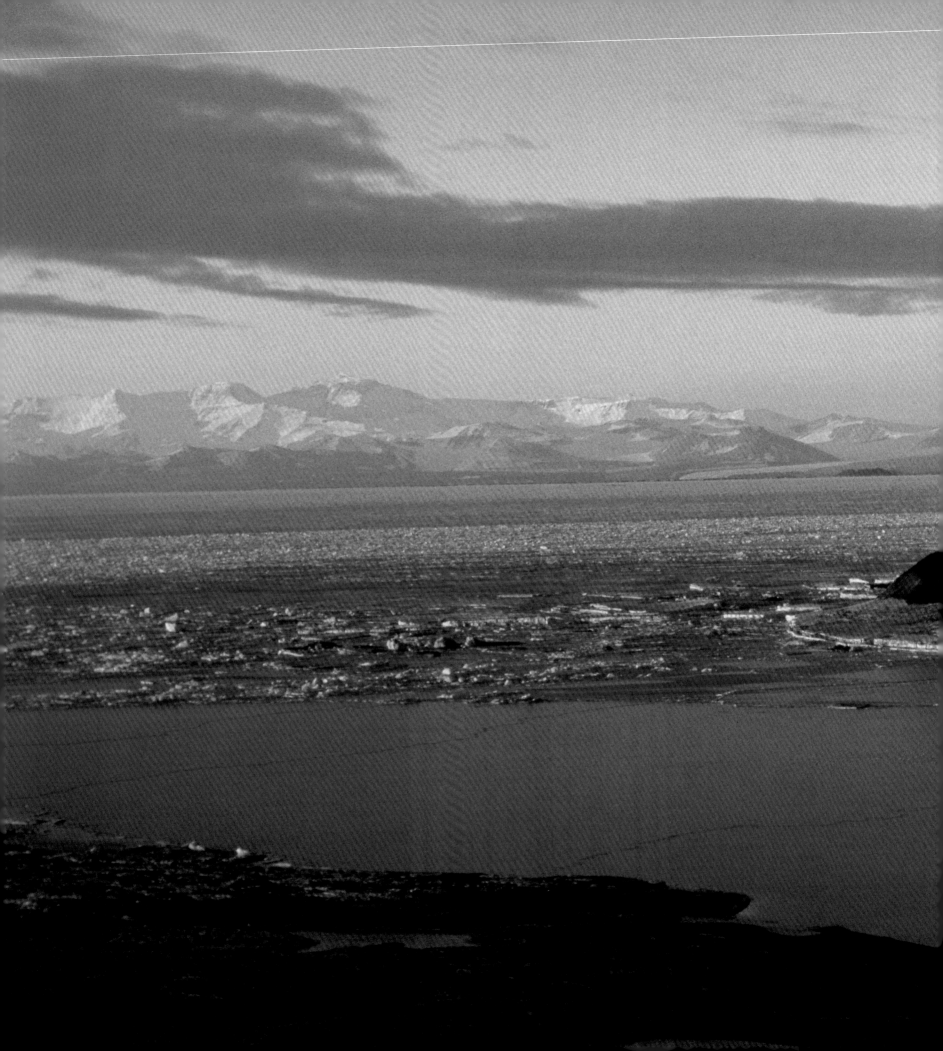

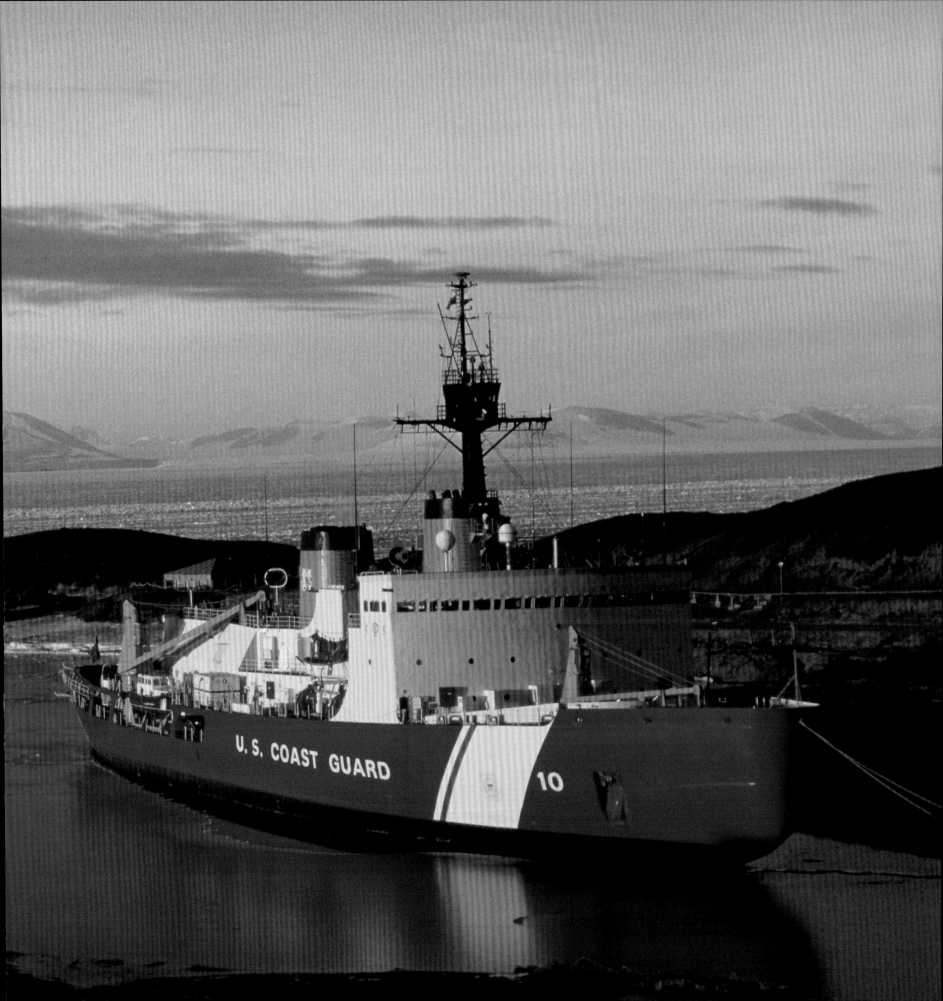

replenish these things was by ship. Over the next couple of weeks, the breaker churned circles in front of McMurdo and ran back and forth to the ice edge, trying to get the remaining ice to break up and blow away. Since the prevailing wind came from the south, loose ice was usually blown north and away from McMurdo. After a while, the combination of warmer temperatures and ice-breaker action resulted in open water in front of the station. It was a very weird thing to see after all those months of ice.

It was strange, too, to realize that all those places I'd been driving so blithely to during the spring and summer were now utterly inaccessible. For all intents and purposes, I was confined to a small corner of Ross Island until winter's cold formed new sea ice and it thickened enough to support a vehicle, which probably wouldn't be until next August or September.

A tanker arrived in late January and spent several days unloading thousands of gallons of diesel fuel and gasoline. In early February, a cargo ship arrived with its deck stacked with containers. In them was most of the food, construction materials, and other supplies McMurdo and South Pole would need for the next year. Ship offload was another hectic time. People worked twelve-hour shifts, and the work went on twenty-four hours a day. Trucks and forklifts roared through town with loads from the ship, beeped as they backed up to loading docks, then roared back to the ice wharf for more. Since all the puddles had disappeared by now, McMudhole had become McDustbowl. The increased activity covered everything with gritty volcanic dust.

Early February also marked a sudden and significant drop in temperature. It had taken months to finally get warm, and now it turned cold and nasty and windy just a few weeks later. It didn't seem fair. Winter was fast approaching.

Summer workers and the few remaining grantees had begun to head north for the winter. Shorthanded because half their staff had shipped out, the cooks closed the O side of the galley. Once again there were long lines for meals. Winter-overs started complaining, only half-jokingly, about the summer "tourists," encouraging them to go home. I agreed. Those tourists had been demanding my time and attention for months, and I was burned out. I just wanted to move on to the next phase. These final days of summer seemed to be stretching on indefinitely.

When the end came, though, it came quickly. The two weeks preceding the last flight were a mad scramble as people rushed to finish last-minute projects before they left. Friends disappeared daily, often without a word, as flights arrived from Christchurch to take them north. The Hercs had redeployed two weeks ago and were now doing turnarounds — flying south to McMurdo, boarding departing passengers, and leaving immediately. Jobs were left undone and boxes unpacked as those departing suddenly found themselves out of time.

On one hand, I envied them. They were returning to the land of warmth and sun, of beaches and trees and flowers and songbirds, of green smells and good food. On the other hand, I couldn't wait for them to leave. I wanted the madness of summer to be over. I wanted the quiet of winter to begin. Above all, I needed a rest, something I'd never get as long as demanding summer people were still around.

Before I knew it, it was February 23 and the last of the summer support people were boarding vans for Willy Field. A few hours later, I stood in front of the Biolab and watched the last flight climb into the sky and head north, silhouetted by the setting sun.

We were alone.

Above: The last plane of the summer winging north in front of a setting sun. I stood outside the Biolab and watched it go with a mixture of relief and trepidation. I was glad for the respite from summer's crazy pace, but I wondered what the winter would bring. From that moment on, we were alone at the bottom of the world.

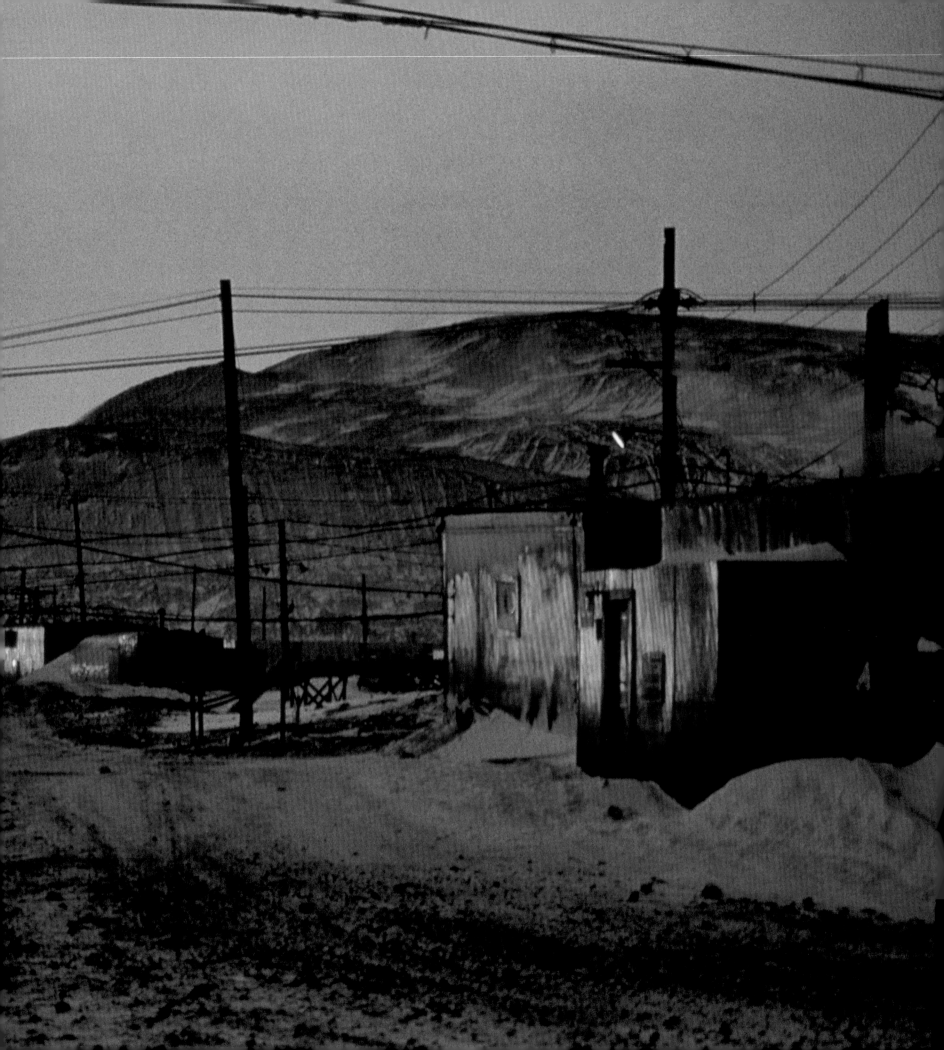

Winter

McMurdo was instantly a ghost town.

I stood outside the Biolab and looked around. Except for the wind, nothing moved. It was eerie, after the nonstop hustle of the summer, to see McMurdo's streets empty and most of the buildings shuttered. The sky was heavily overcast and everything was gray — the snow, the ground, even the stormy waters of McMurdo Sound. Pushed by the wind, a torn piece of cardboard flipped and skidded past my feet. I turned and headed to the galley for dinner.

Most of the other winter-overs were there when I arrived. There were eighty-three of us, eighty-two men and one woman, Kerry, the winter manager of the Berg Field Center. (There was actually another woman around, a reclusive and somewhat sociopathic grantee who stayed at her tiny lab on the outskirts of town and slept furtively at Scott Base. People rarely saw her — and some people never did — to the point where it was as though she wasn't there at all.) Dinner was subdued. I sat pensively over my metal tray, pondering my new isolation and sizing up the people with whom I'd

Previous pages: Icehenge. While working on a rock jetty for the water intake pipe, the construction crew had cut out large blocks of ice and left them on the snow. That part of the sea ice didn't break away at the end of summer, so in the dark of winter I set up my tripod, opened the camera shutter, and ran around to each of the blocks. It took me two minutes to press my strobe against each one and fire it off, then run back to my camera and close the shutter. **Opposite:** In one of its final appearances, the setting sun painted McMurdo's buildings with splashes of color, the last natural color we would see for nearly four months. **Above:** Steve contemplating Vince's Cross at the tip of Hut Point, on a gray early-winter day. George Vince was a member of Robert Scott's *Discovery* expedition who slipped to his death down an icy slope during a storm.

be spending the next six months. What would the winter bring? Judging from the looks on the other faces, they were wondering the same thing.

I threw myself into my work, and into my personal projects. The days rolled on, growing shorter and shorter. One day in March, Kerry called from the BFC and told me to look outside. I cracked open the front door of the Biolab and my jaw dropped. A fine glaze of new ice had formed over the sea. The full moon hung just above the twilight-purple peak of Mount Discovery, and its reflection was a streak of color across the blue Sound. In a frenzy, I grabbed my camera and tripod and stood in the cold, snapping photos until I could no longer feel my fingers.

On days that weren't stormy or overcast, the sinking sun filled the sky with brilliant colors. The sun had circled the sky during the summer, dipping low in the west and rising higher in the east. Now sunsets lasted for hours as the sun dropped at an oblique angle, sliding along the horizon before finally dipping below the edge of the world. Bright yellows and oranges morphed into pinks and deep reds, then finally to purple and indigo and violet. Colors splashed across the heavens and reflected from the glassy surface of the sea. Sometimes the Sound was covered with a mist of ice fog, its edges shimmering with fire from the setting sun.

On April 22, the sun dropped below the horizon for the last time. By the middle of May, it was dark all the time. The Royal Society Mountains were gone. McMurdo Sound was gone. Really, the whole world was gone. It had shrunk to a small, lonely group of buildings huddled in the cold and darkness. Winter's night was upon us.

<div align="center">※ ※ ※</div>

I could not wake up.

The alarm had gone off at 7:00 A.M., as usual. I reached over to turn it off and immediately dropped back into a deep sleep. An hour later, I became semiconscious for a moment, long enough to realize that I was late for work and absolutely had to get out of bed, then my eyes slammed shut again. An hour later, the same thing. I struggled to stay awake, but it was like fighting my way out of a drug-induced coma. When I forced my eyes open, the room swam in front of me. My brain felt thick, as though I were trying to think through molasses. Turning my head to look at my clock took an enormous effort. My body felt like it weighed five hundred pounds. It was too much to fight. I fell back into dream-filled slumber.

At eleven, after several unsuccessful attempts to just sit up, much less pull myself out of bed, I forced my sluggish body to roll onto the floor. I lay there on the cold, thin carpet, naked and half-conscious, until the utter discomfort of the position goaded my foggy mind to alertness. Struggling to my feet, I resisted the almost overwhelming desire to fall back into bed and, instead, stumbled to the bureau to dress for work.

Opposite: I hadn't seen the moon since the previous Winfly, and back then I had been so wrapped up in the newness of McMurdo and Antarctica that I hadn't paid it much attention. So when it reappeared in March and I stopped to take a good look at it, I noticed something was wrong. After a few minutes of turning my head this way and that, I figured it out. It was upside down! I realized that, because I was standing at the bottom of the earth, I was seeing the moon the way I would if I stood on my head in the States.

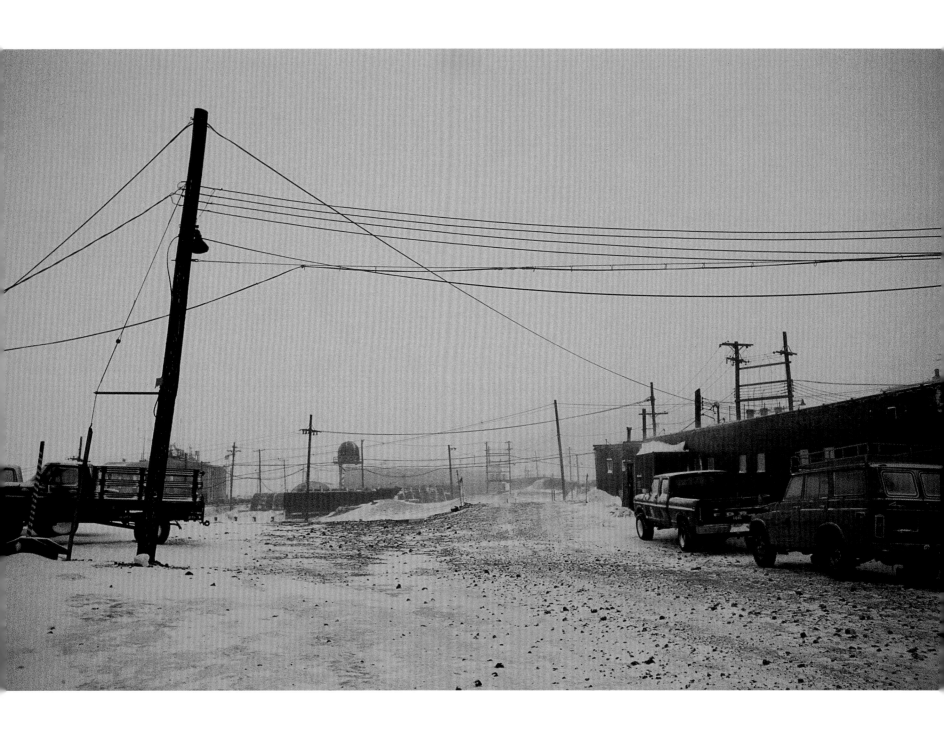

The twenty-four-hour darkness was wreaking havoc with my internal clock. Some nights, I couldn't sleep at all but would lie there, tossing and turning and staring at the ceiling for hours. This was called the Big Eye, the curse of the Antarctic winter. Other times, I couldn't wake up. There was no recognizable pattern to it. My sleep/wake rhythm was free-cycling. Periods of alertness and periods of extreme drowsiness would strike at any time, and the forced rhythm of work and meals had no noticeable effect. There was no day/night cycle to act as a cue, and my brain was improvising.

I began having wild dreams. Wild, tactile, exciting dreams. Bizarre dreams, filled with vibrant colors and fantastic characters. I had never experienced anything like them before. Some dreams were so compelling, I'd wake up in the middle of the night, anxious to write them down. Or, in the morning after I'd awakened, I'd grab a notebook and transcribe as many as I could remember. There were times when I didn't want to get out of bed, simply because every time I closed my eyes, new visions would fill my consciousness. It was like a never-ending fantasyland.

I realized it was sensory deprivation doing this to me. Not only was my visual field severely restricted by the lack of sun, but my other senses were also being starved. The increased cold of winter had diminished what few smells were available. There was only diesel, ubiquitous diesel, galley food, and the all-too-familiar odors of each building and room — the same smells we had in the summer. Nothing had changed. There was no variety, no surprises. As with any constant, unvarying stimulus, I had habituated to these smells to the point where I didn't even detect them anymore. In the galley, the stultifying parade of same dishes, same flavors, same menu had rendered all the food utterly tasteless. I ate only to survive, not because it was enjoyable.

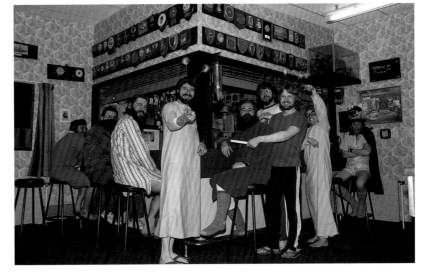

The same held true for sound. The noises of generators, vehicles, and the relentless wind were all the same, unvarying, unchanging. Nothing new. It was as though I lived in a world without sight, sound, or smell. McMurdo had become one big isolation chamber, and my mind was making up for the lack of sensory input by inventing its own.

The lack of fresh fruits and vegetables was the hardest to bear. Sometimes a few of us would sit in the galley and torture ourselves. With the remains of a leathery steak and powdered mashed potatoes on our trays, we'd talk about what fresh foods we missed the most. I'd imagine myself with a whole watermelon, scooping out spoonful after spoonful of the sweet, juicy meat. Or I'd

Opposite: As winter closes in on McMurdo, sunlight is replaced by several hours of twilight. The sky and the ice turn a somber blue-gray, which very soon gives way to total darkness. **Above:** Big Eye Meeting, 3:00 A.M., Scott Base. The constant dark played havoc with our sleep cycles. Big Eye was the name given to that particular winter malady of lying in bed all night, staring at the ceiling, unable to sleep. The Kiwis, in their playful way, decided to embrace the Big Eye. If we can't sleep, they said, well, then . . . let's party! Unfortunately for me, after five months I had finally acclimated to the dark and had established a functional sleep pattern. The Big Eye Meeting destroyed that pattern for the rest of the winter.

describe the sensation of biting into a plump ripe peach and having the juice run down my chin. Others lusted after crisp apples or massive green salads. The day when we would actually have those things seemed very far away.

A MOMENT ON THE RIDGE

Kerry and I began to spend a lot of time together, talking about the winter, about Antarctica, and about our lives. I had left a girlfriend in California but was pretty sure the relationship wouldn't survive the separation. A year and a half was just too long to spend apart. Would we even be the same people after that amount of time? Kerry was madly in love with someone she'd met during the summer in McMurdo and he was constantly on her mind. We spent long evenings in the BFC, marveling over the convoluted paths we take through life.

The two of us also found ourselves becoming close friends with three of the Kiwis at Scott Base, Andrew, Gary, and Doug. These were the "labbies," as they called themselves, since they were in charge of seismic, meteorological, and astronomical data collection in the Scott Base laboratory for the winter.

The five of us made a practice of visiting each other as much as possible. One windless night, after a pleasant dinner with our New Zealander friends, Kerry and I trudged up the hill behind Scott Base, on our way back to McMurdo. Though we had walked the same road in near total darkness, often tripping over loose stones, that night a bright full moon made the going easy. Our boots crunched over stones and ice, and the legs of our nylon-covered thermal suits swished together as we stepped. As usual, we talked about the evening, friends, and relationships. At the top of the hill, just before the entrance to the pass, we glanced back at the way we had come and fell suddenly silent.

The whole of the Ross Ice Shelf lay spread out before us, ghostly pale but gloriously visible in the moon's harsh light. Neither of us had seen the shelf since the sun had disappeared. Now, in the moon's glow, the ice seemed to stretch to infinity. Mile upon mile of dim gray emptiness, thousands of miles of ice and snow and half-buried mountains, and not a single human being, not a single living thing at all. All of it absolutely still, utterly unmoving, utterly cold.

The immensity of Antarctica hit me at that moment, with more force than ever before. I felt overwhelmed by the sheer scale of the place. I held my breath, listening for any sound, but I heard only the roar of blood in my ears and the pounding of my heart.

I looked at Kerry and could tell she was seeing and feeling the same things. I turned and looked at the hill rising behind me, which led up the peninsula and finally to Mount Erebus, quietly smoldering in the polar night. Antarctica seemed suddenly infused with enormous power, like some great beast locked in hibernation and breathing so slowly as to be undetectable. I could almost feel a deep thrumming beneath my feet, the massive energy of this continent coursing through the rocks and ice. It seemed as though the buried land was quietly conscious, that this vast continent was merely biding its time, waiting for the moment when it would rise once again. Antarctica had long ago been a vibrant and bustling place, full of animals

Opposite: Early winter moonset. The moon was moving to the left, sinking slowly as it went. McMurdo Sound is covered by a thin sheen of new ice.

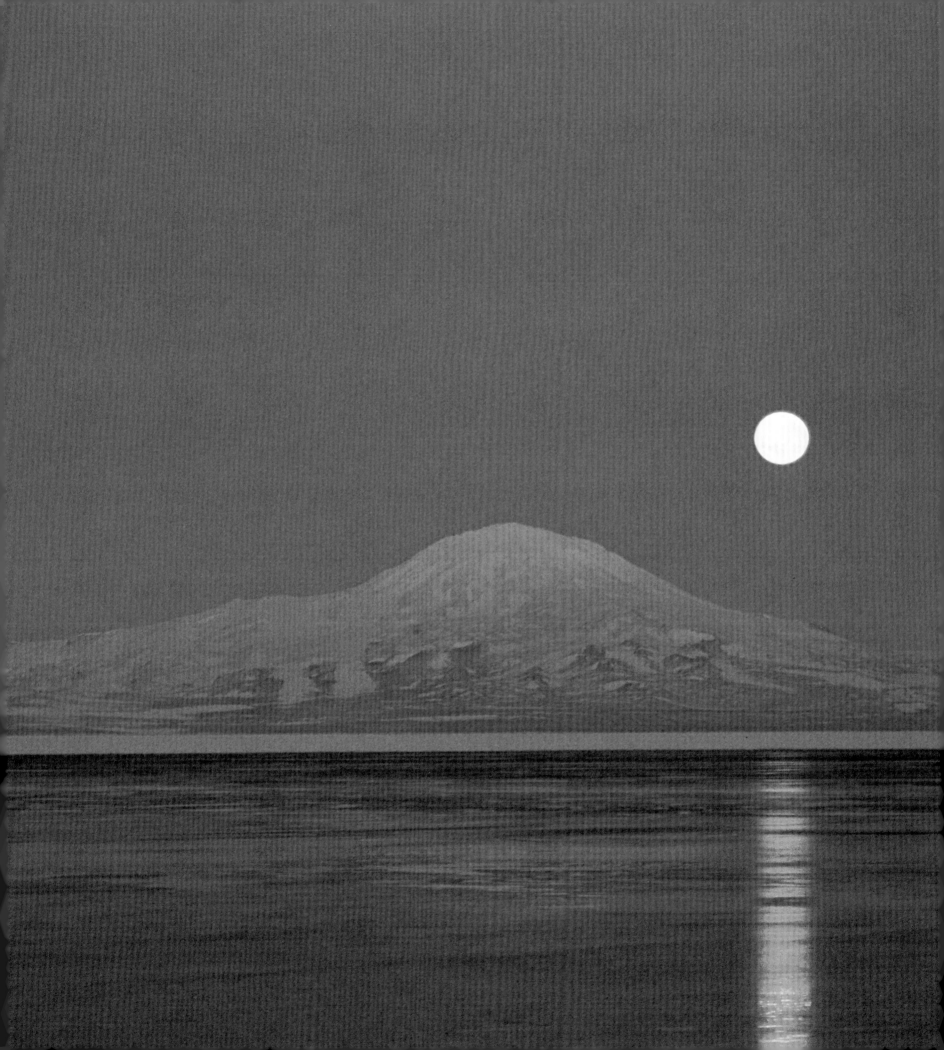

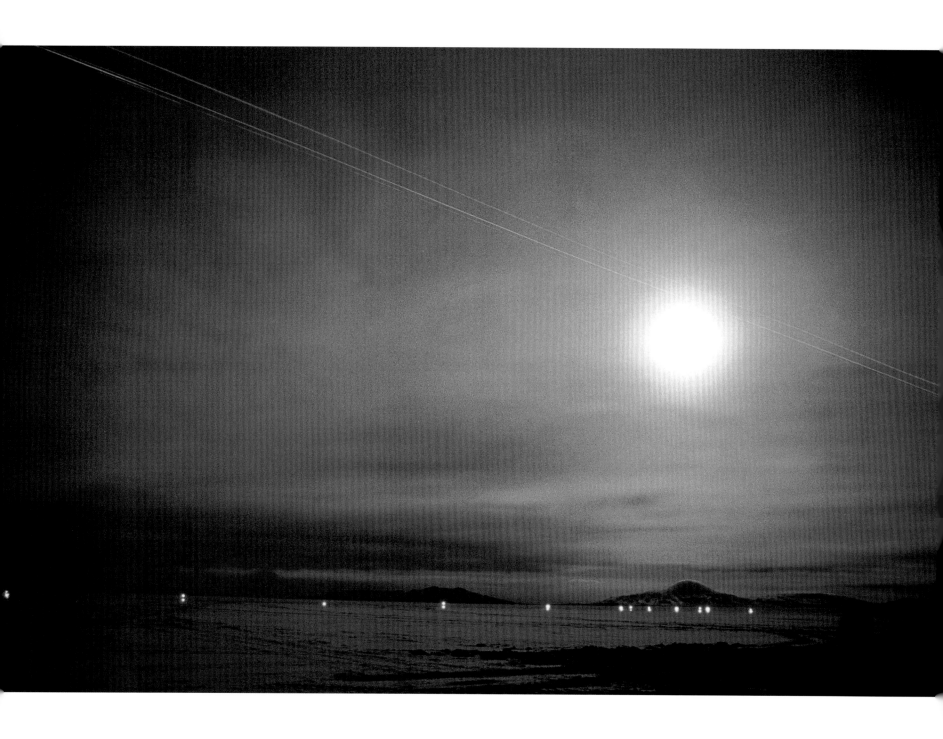

and plants, bursting with life. I knew it would be that way again, that its patience was infinite, and that this time of frozen stillness and emptiness was a mere moment on the vast time scale of the earth.

Kerry and I resumed walking in silence, but the moment had changed me. We had shared something utterly ineffable, and it made the world an entirely different place.

AIRDROP

June 21 was the day Tony Bufford began to lose his mind.

June 21 was also the day of Airdrop, and the two events were inextricably connected.

I arrived at Willy Field with the Airdrop recovery crew. Tom, the Navy's winter-over officer-in-charge, had asked me to document the event on film. It was minus 25° F, but thankfully the air was relatively still. Only a slight and sporadic breeze ruffled the fur around my parka hood. A full moon shining through a high cloud cover illuminated the field and gave the snow a steel-gray cast. I could see White Island outlined in the dim light. Several vehicles had collected in the staging area — Sprytes, large flatbed trucks to transport the packages, forklifts and bulldozers to

dig them out of the snow and load them on the trucks, and crash vehicles, in case the Airdrop plane was forced down for some reason. Headlights splayed across the snow, creating glaring white cones in the relative dimness of the moon's light.

The recovery team began lighting the oil lamps that would mark the drop zone. Their faces were illuminated by the lamp's glow, and I could see anticipation in their eyes. We had been anxiously awaiting this annual event. Many expected important letters and packages from home, signs that they were still loved by those back in the real world.

The loneliness and isolation of the Antarctic winter was painted all over their faces. I think a lot of us had tried to ignore the feelings, or perhaps had managed to pretend they didn't exist. Perhaps some, like me, had been so busy it never occurred to them that they were feeling lonely or isolated at all. Airdrop made everyone acutely aware of their separation from the world. I knew many of the guys hadn't heard from loved ones in weeks or months, and their anticipation — perhaps dread — of what would soon fall from the sky made them all a little anxious. In some ways, we were like a group of kids on Christmas morning. In other ways, we were like taxpayers waiting for a response from the IRS.

Opposite: Airdrop. The lights of the C-141 Starlifter streak over the lanterns marking the drop zone, in front of a full moon masked by high, hazy clouds. At the moment the jet was in front of the moon, crew members shoved the payload out the back cargo door. A hundred cardboard crates attached to small drogue parachutes dropped out of the sky onto the snow. In them was mail, fresh fruits and vegetables, and vital equipment. Moments later, the jet rose up into the sky and disappeared.
Above: Eager winter-overs light the lamps used to mark the drop zone, the area where crew members of the Airdrop C-141 will attempt to place their cargo.

I had another reason for being anxious. I had requested a special delivery from a friend in Christchurch, but there was an entire gauntlet of obstacles it had to survive before I received it. I was not even certain the item had been delivered to the packagers or, if it had been delivered, whether it had been included. It was an unusual item, one that the packagers might consider frivolous or nonessential. If it had made it past those faceless bureaucrats, and if it survived the drop, there was a real risk it might disappear at the warehouse before I could get my hands on it. People here at McMurdo would covet it more than silver.

After the lamps were lit, teams took them out to the drop zone with Nodwells and Sprytes. The vehicles looked like something out of a science fiction movie, bouncing along over the uneven snow, their beds glowing, the faces of crew members framed in the vehicles' windows and reflecting an unearthly radiance. Before long, the lamps had been laid out in a giant oval, hundreds of feet long and a couple of hundred feet wide. The crew on the incoming Air Force Starlifter would attempt to drop all the boxes within that oval. Small drogue parachutes would slow the boxes' descent, and collapsible cardboard pads, as well as the snow, would break their fall. In theory.

The lamp teams returned to the staging area. The word went out to kill all the headlights and they were extinguished, one by one. We were left standing in the eerie radiance of the haze-covered moon. Yellow points of light from the lamps marked the drop zone in the distance. The low rumble of diesel engines masked the conversations going on around me, but I could catch words here and there, and occasionally a sharp laugh. Many of the guys seemed subdued, standing off by themselves, as I was. Every once in a while I'd see the small flash of a match, followed by the red glow of a cigarette as it brightened with inhalation.

We waited.

I looked toward the northwest, into the dark sky. I checked and rechecked my camera and tripod. I glanced at my watch. I heard murmurs from men nearby. The plane was late.

Then someone shouted in the dark. "There it is!"

I looked to see a small group of lights — one white, one red, one green — moving against the black sky. A moment later I heard a low, throaty roar, and my heart jumped. Somehow, I needed to see and hear the proof that there really were other people in the world. Somehow, without realizing it before this moment, I needed to know that we weren't forgotten. I felt like I was witnessing the arrival of the first spaceship from Earth.

The jet drew closer, the roar of the engines louder. For one brief, glorious moment, I saw it outlined as it passed in front of the moon. A heartbeat later, I saw the silhouettes of the packages as they were shoved out the back of the plane. I saw the chutes snap open to slow their descent, and I saw two or three plummet to the snow like rocks when the chutes failed to open.

"Freshies in those boxes," I said to no one in particular. "For sure."

The roar of the jet diminished as it moved away to the south. I saw its lights arc to the right as it swung around and began climbing. I wanted to watch it as it climbed back into the sky and dis-

Opposite: Aurora australis, the southern lights. Some days the aurora was a green sheet on the horizon. Some days it was an undulating curtain overhead, flickering red and green, moving as though ruffled by some interstellar wind. Other times it danced across the heavens like a dervish, first here, then there, then directly overhead, raining down on me like a shimmering waterfall of light. Even in the depths of winter night, Antarctica found ways to dazzle me.

appeared to the north. I wanted to savor every minute of its presence, but everyone was anxious to retrieve the packages before the contents froze. And everyone wanted their mail. The headlights had all come back on with a snap, diesel engines were growling, and vehicles were moving toward the drop zone. I gathered up my camera and jumped into a Spryte.

Strobe lights had been attached to each bundle to make them easier to find, but the cold had killed the batteries and most of the strobes had stopped working almost immediately after landing. We were forced to comb the drop zone by headlight, looking for cardboard bundles and deflated chutes. The first bundle we came upon had survived the fall and was sitting upright in the snow, its chute draped over the snow nearby. We collected the number from the side of the box, then directed a forklift to it and moved on to look for another.

Several bundles later, we discovered one where the chute had failed. The package had been driven into the hard-packed snow and busted open by the force of its fall. As I had suspected, the bundle had contained freshies. Oranges lay scattered over the snow, along with pieces of broken watermelon. While I documented the carnage, others began scooping up the oranges before they could freeze. Freshies were precious commodities, more valuable than money. If there had been five-dollar bills scattered over the snow with the oranges, I'm convinced the guys would still have gone for the fruit. I would have.

The watermelons were a total loss.

Within a couple of hours, all the packages had been accounted for, collected, and hauled off to McMurdo for unpacking. My fingers and feet were freezing from being outside for so long, so I was happy to jump back in a Spryte for the ride back to town. Like everyone else, I was bursting with excitement and curiosity over what we would find. It was Christmas in the middle of June.

I ripped into the boxes I received. Friends who had been to Antarctica knew to send things impossible to come by here, things that brought a little hint of normal life to the long, dark night. Things like tortilla chips (crushed into powder, of course) and flower-scented soaps. I pulled open one box and was greeted with the smell of lilacs. I reached in, pulled out a bar of soap, and held it to my nose, savoring the fragrance. A smell that wasn't diesel! Not only was it not diesel, it was beautiful! I hadn't smelled a flower in almost a year, and even though this was only lilac-scented soap, it was still heavenly. Another friend had sent a cassette tape of jazz he'd recorded for me. New music was almost as valuable as fresh food. I put it immediately into my tape deck and played it over and over, relishing the sounds. I thought of my friend, and I knew that for the rest of my life these melodies would conjure memories of winter in Antarctica.

Those who didn't understand McMurdo sent things like candy and chocolate, which we already had in abundance. It didn't matter. It was an incredible boost to just hold things that friends and family members had held and know they were thinking of me. A few friends sent things specifically designed to torture me, like copies of *Surfer* magazine, with pictures of beautiful beaches, perfect waves, and gorgeous women. Most important were the letters. I tore into them, reading each one several times, squeezing as much memory and meaning as I could out of every word.

As the final bundles were being unpacked, I received a call to come up to cargo. When I arrived, the four guys working there stopped what they were doing and gave me a look almost impossible to describe: part admiration at my audacity, part humor, part envy, part hunger. Don called me over to a particular bundle and pulled back the lid. Everyone gathered around.

Miraculously, my special delivery items had arrived intact. There they were, right on top, with my name plastered in bold all over them: six fresh pizzas from Spagalimi's Pizza Parlour in Christchurch, the best pizza in the South Pacific. This was real food, not the tedious, tasteless, repetitive McMurdo fare we'd grown to loathe. This was food with flavor. This was gold. I could almost hear the guys salivating.

What could I do? I grabbed the top pizza and handed it to Don. "This is for you guys. Just keep word of this under your hat, okay?" The last thing I wanted was half the town descending on me for a piece of the action.

"You bet!" he said, taking it eagerly. The four of them looked like starving men who'd just been given a ticket to a lavish buffet. I grabbed the remaining five pizzas and split. For dinner that night, I invited Tom over and we gorged ourselves on two pizzas. The rest, I'm not ashamed to say, I kept for myself.

The first post-Airdrop meal in the galley was almost as good as the pizza. Bananas, apples, and oranges! Tomatoes! Salad! It was manna from heaven. The rest of the food was the same as always, but no one cared. We stuffed ourselves with the freshies, relishing every bite and laughing out loud at the sheer joy of it. One of the guys found a small spider in his salad. He carefully extracted it and guarded

it like a precious gem while we all took turns staring at it in wonder. I couldn't help chuckling to myself. Anywhere else in the world, a diner would be horrified to find a bug in his food. Here, where there were no insects or spiders, where none of us had seen a familiar animal for months, and where the windswept winter snow and rocks were devoid of life, this bug was being treated like an honored guest. The spider reminded us of the things we once took for granted, and of the living world we had all left behind.

Between the fresh food and the mail, the mood of the town was nearly euphoric for a couple of days. That euphoria turned quickly to depression. Being reminded of loved ones and of the world of sun and warmth was wonderful, until it made us miss them all that much more. It didn't help that these were the darkest days of winter, coal-black days with no hint of sun and no respite from the cold. I sometimes felt the sun was only a legend, that it never existed and never would return. The world was, and would only ever be, darkness and ice.

Then, of course, there were the inevitable Airdrop foul-ups, which did nothing to improve our mood. Mail had been placed under the fruit in the exploded bundle we'd found. Some people had to peel watermelon seeds off their letters. It was idiotic, and it made people furious. Even though my mail escaped unscathed, I felt myself succumbing to Antarctic Anger.

Above: Strange things happen during the winter, and even at Winfly. For some reason it became terribly important to exactly re-create the Last Supper in the McMurdo galley. The director, Neal Terry, spent several days choosing the appropriate people, developing costumes, and designing the layout. When the designated day arrived, everyone gathered in the galley and got into position. The director, using a photocopied encyclopedia photo, carefully adjusted arms and heads until he was satisfied. I took the official photos, then the whole episode was promptly forgotten.

The psychologists had warned us about how easily minor irritations could acquire an importance far beyond their true insignificance during the winter, how people often could get bent out of shape over the most ridiculous things. So I understood intellectually what was happening, but that did nothing whatsoever to mitigate my feelings. I felt appalled and enraged that some fool in Christchurch wouldn't have the sense to realize what could happen when a several-hundred-pound bundle was flung out of a jet at almost 200 miles per hour, a thousand feet above the snow. Packing heavy fruit on top of mail! Unbelievable!

There was another, even worse foul-up. McMurdo had two pumps to drive large volumes of seawater up the 200-foot hill from the bay to the water plant. One of them had failed early in the winter and the second was showing signs of wear. Tom had requested a replacement, but the pump they had dropped on us was too small and underpowered to do the job. If the last remaining pump died, we'd be without water for weeks, maybe months. Just as bad, when Tom sent a message informing them about the error, they wrote back that he was wrong, and that he really didn't know what he was talking about.

Such abysmal stupidity! Such hubris! No showers for months! No laundry! Being forced to hump clean ice from miles away for cooking and drinking! I stewed in my anger.

Others had bigger problems. A few guys had received the Letter.

It was bound to happen. We had been away at the end of the world for months, after all. Some rela-tionships were bound to disintegrate. I'd actually expected such a letter myself from my girlfriend, after our disastrous MARS patches. The tone of her letter was subdued. For the time being, she said, she was keep-ing open the possibility of resuming our relationship when I returned.

The guys who received the Letter kept to themselves for a few days, depressed perhaps, but still functioning. All except for Tony Bufford.

I had first met Tony back in early February, when he burst into my room. "I'm your new roommate!" he boomed, throwing his bags on the empty bunk.

Great, I thought. Bob had headed home a couple of weeks ago. The last thing I wanted this close to winter was another roommate, espe-cially one as loud and obnoxious as this guy appeared to be. But I shook his hand and tried to look happy. I tossed a few questions at him as he unpacked, trying to learn a little about this new addition to the winter crew. He seemed friendly enough, but full of himself and unin-terested in anyone else. After the careful psychological scrutiny I'd undergone before being allowed to winter, I was a little annoyed that, faced with a last-minute open position, the system had apparently scooted this guy through with minimal attention. He didn't seem like winter-over material to me.

"So," I asked, "are you married?" I'd seen a ring on his finger.

"Oh, yeah," he replied, suddenly excited. "And my wife just posed for *Penthouse*. She's the latest Pet of the Month."

Opposite: People walking across the snow compressed it beneath their boots. When the wind came up, loose snow around the now denser footprints was scoured away, leaving a raised and somewhat ghostly record of their passage. **Above:** When a Weddell seal hauls out on the ice, the warmth of his body melts the snow and ice under him. When he slips back into the water, the water refreezes, leaving a seal version of a snow angel that's called a "seal shadow."

One day a week I ran the Antarctic MARS network from McMurdo. MARS stands for Military Auxiliary Radio Service, a network of ham radio operators in the States who set aside time to relay teletype messages and phone–radio patches between U.S. military personnel overseas and their families and friends. It was a vital and invaluable service, even though our location so far south made the connection sporadic and unreliable. Since we had no phones, and e-mail hadn't even been invented, the MARS network was our only link to home.

During my first shift it became clear to me that, despite its importance, the service had serious limitations. Most notably, nothing was private. MARSgrams had to be transcribed by an operator, sent over public airwaves as teletype, scanned by the receiving operator to confirm receipt and legibility, and then delivered to the final recipient. At the very least, two other people saw the message. Potentially, hundreds did.

MARS patches — phone calls transmitted over the radio — were worse. I had to listen to the incoming dialogue, wait for the word "over" to indicate the person on the other end was finished speaking, press the transmit switch on my end, listen to the outgoing dialogue and wait for the word "over," then immediately let go of the transmit switch so the person on the other end could reply. The stateside MARS operator would be doing the same thing on his or her end, and both of us (and anyone else with a radio who wanted to listen in) would be hearing the most intimate details of people's lives.

Most people simply didn't know how to communicate effectively over the radio, and many were obviously uncomfortable with the need to verbally punctuate their end of the dialogue with an "over." As a result, conversations would often sound something like this:

McMurdo Person: I'm fine, I'm fine. We're all working hard and looking forward to winter being over. How are you doing? Over.

Stateside Person: I'm fine. We're all fine. We miss you. How are you doing?

[Pause.]

Stateside MARS Operator: Over.

SP: Oh, yeah. Over.

MP: Heh heh. Yeah, you have to remember to say "over" when you're done talking. Uh, I'm fine, like I said. I sure miss you, too. How's Johnny? Over.

SP: He's fine, he's fine. He misses you. [Pause.] Over.

MP: Oh, that's good. That's good. Over.

SP: [Pause.] We sure wish you could be here now. Over.

MP: Me, too. Me, too. Yes, I wish I could be there. Over.

And so on. I'd sit, obediently pressing and releasing the transmit button as needed, sometimes feeling slightly embarrassed at being privy to people's intimate details and sometimes gritting my teeth at the banalities. It was even more excruciating on days when communications were bad:

Stateside Person: Static scratch screech squeak hiss garble garble garble. Garble.

McMurdo Person: I did not copy that. Please repeat. Please repeat. Over.

SP: Static scratch screech squeak hiss garble garble garble.

MP: I did not copy. Please repeat. Over.

Stateside MARS Operator: She said she loves you and misses you. Over.

MP: Oh! Tell her I love her and miss her, too. Over.

SMO [garbled and masked by increasing static]: Roger, roger. Stand by. [A moment passes, then:] She says she loves you, too. Over.

MP: I couldn't hear what he said.

Me (to MP): She says she loves you.

MP: Okay, okay. Tell him to tell her I love her.

And so on. Some days were more grueling than others, but none so bad as after Tony received the Letter.

"You're kidding," I said.

"No, I mean it. Want to see a picture?"

Well, I had to admit, I was curious. I anticipated that she would be a reasonably attractive woman. Tony took his wallet from his pocket, opened it, and pulled out a piece of paper. I expected a wallet-size portrait. Instead, he unfolded the paper and shoved it in my face. It was the *Penthouse* centerfold, and thus little more than an anatomical study of female genitalia.

"That's your wife," I said, dumbfounded.

"Yup!"

I handed the picture back. "I can't tell what she looks like from this. Her face is out of focus. Don't you have another picture?"

"Nope," he replied, folding the photo and returning it to his wallet. The absurdity of the moment seemed completely lost on him.

So it came as no surprise to me that Tony had received the Letter. In it, his wife was not merely content to say that she was leaving him. She also told him she had sold all their furniture, and she had emptied their bank account and was taking all the money with her, including Tony's salary for the past several months. Finally, she was thorough enough to inform him that she was moving south with a photographer, and that he shouldn't come looking for her when he got back.

At first, his response seemed within reason for someone hit with that kind of news; he began writing long and pleading MARSgrams and making long and pleading MARS patches. All the operators, including myself, tried to be as accommodating as possible under the circumstances, and that included relaxing the 200-word limit to allow his anguished, threatening, rambling, repetitive,

Left: Sunset reflecting on newly forming ice. The moment the air was still, McMurdo Sound would immediately begin to freeze. Then a wind would come up from the south and blow all the new ice away. It wasn't until June that the ice became thick enough to stay.

nearly incomprehensible thousand-word MARSgrams. At least I didn't have to read them to transmit them. The MARS patches were torture. Listening to him ramble on, begging, cajoling, threatening, crying, I knew I was listening to a mind that was coming apart.

Stories about him began circulating. Even in the summer, McMurdo was a rumor mill. In the winter, nothing was secret.

A few days after Airdrop, Tony was working with other members of the maintenance crew at Willy Field. He was inside an unpowered, unheated building when the wind blew the door shut, somehow trapping him inside. He started screaming. There was a problem with the latch, and the other guys had to work at it to get the door open. They called to him to let him know they were going to get him out, but he was in a complete state of panic. He used a chainsaw to cut a gaping hole in the roof of the building and was halfway out when his coworkers got the door open. They were flabbergasted. During a few minutes of panic, Tony had essentially destroyed the building.

He blabbered incessantly about his wife and his predicament to anyone who would listen, saying the same things over and over, whipping himself into a frenzy, until no one could stand to be around him. The resulting social isolation made things worse. He became incapable of meaningful work. Tom and Jorge, the doctor, began watching him closely, thinking he might be a threat to himself or others. Finally, a few weeks before Winfly, Tony was carefully escorted to the medical building, where he was sedated.

No one saw him much after that, and Jorge wouldn't say much. Tony didn't have any friends, as far as I could tell, so I don't think anyone ever went to visit him. I asked Jorge once what was going on, but he just shrugged. All I could gather, second and third hand, was that Tony seemed happy now. He didn't ramble on about his wife much anymore, mostly because no one on the medical staff would listen. He played solitaire, watched TV, and slept a lot. And when he wasn't doing those things, he'd wander the darkened halls of the medical building, talking to himself, like a lost soul in pajamas and slippers. When the first plane of Winfly landed, Tony was quietly spirited aboard and sent north.

❊ ❊ ❊

July was the hardest month. A Fourth of July party had given everyone a chance to break out of the funk left over from Airdrop, but now it was over and there were no more holidays. Winfly was still six weeks away. The night seemed interminable. July dragged on and on: cold, dark, changeless.

Some days I felt like the earth I had known wasn't quite real anymore. Or maybe it was just in suspended animation. If there was news, if anything was happening anywhere else, I didn't hear about it, and I didn't care. McMurdo was my world, quiet and safe, like a cocoon. Other times, I felt just the opposite. Up north in the sun, things *were* happening! There were people to meet, places to go, things to do! Life was passing me by, and I was stuck. I stared at scenes of tropical beaches and palm trees on the posters in my room, and I gritted my teeth at the sound of the wind gusting against my window. I was frustrated by the endless darkness, the storms, and the deprivation. How much longer could this go on?

I was also having another attack of Antarctic Anger, more virulent than before.

Opposite: With the returning sun and the bitterly cold temperatures of late winter, nacreous clouds reappeared in the sky. Formed by condensing ice and nitric acid crystals in the stratosphere, nacreous clouds refracted the sun's light in a way that made them seem to glow with their own inner light.

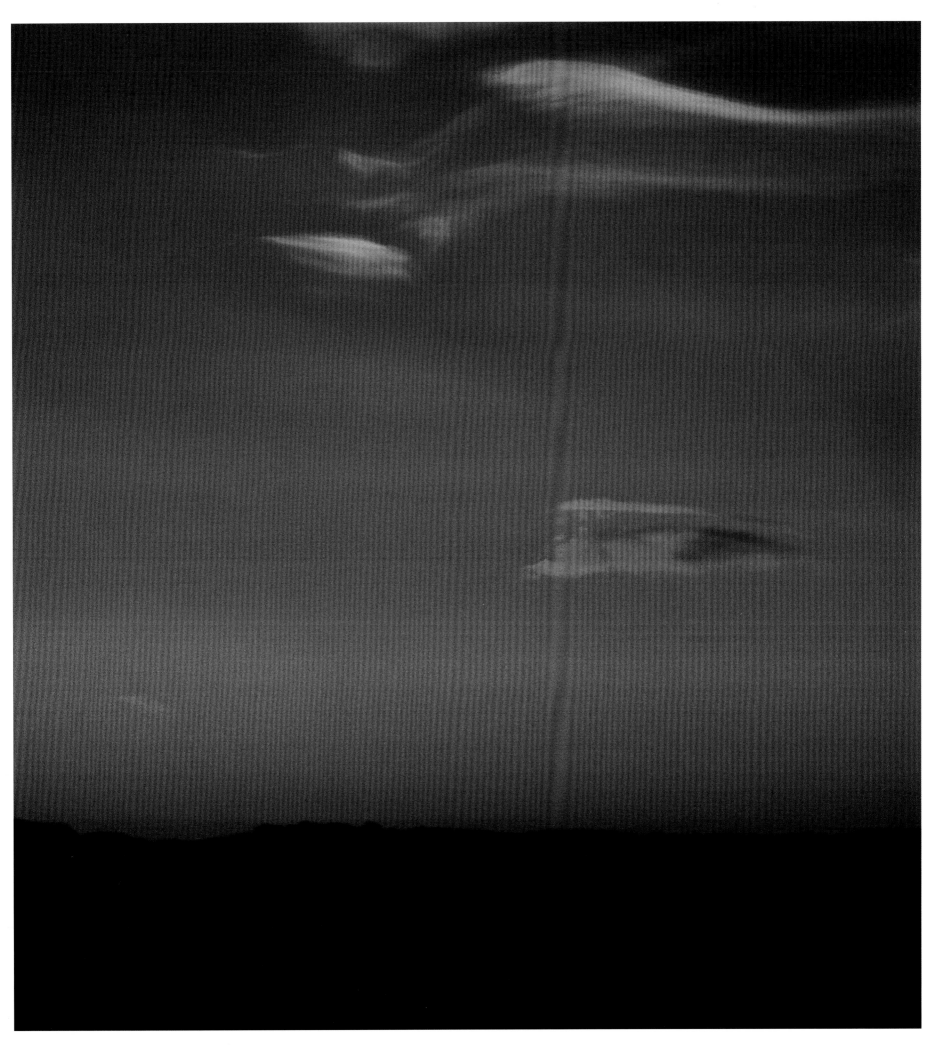

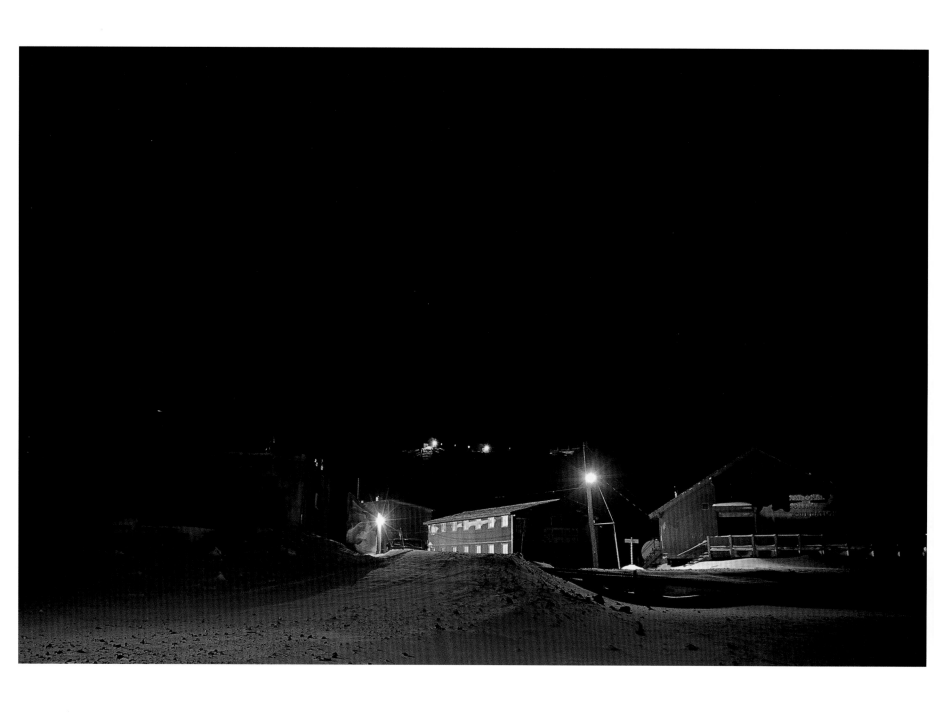

ANTARCTICA

I was harboring a simmering, smoldering fury that occupied my thoughts day and night, sometimes to the total exclusion of everything else. I could be organizing flasks in the Biolab stockroom, walking to the galley for a meal, or just sitting in my room reading, when a wave of wrath would boil up inside me and everything else would go by the wayside.

"What a jerk," I'd say aloud. "What an *asshole!*"

I was talking about Jack, the science technician in charge of monitoring and maintaining the Cosmic Ray Laboratory, a T-5 located on the other side of the pass, near the Ham Shack. Shortly after the beginning of July, Jack had stopped doing House Mouse, and I was furious at him because of it.

Everyone had been assigned a room in Building 155 for the winter. Since there were no janitors, each of us was expected to pitch in and clean the living areas. No one was excluded. Even the officer-in-charge and the civilian station manager had their days as House Mouse. The three-hour duty came about once every sixth Saturday, and it involved scrubbing the bathroom and sweeping and mopping the floors. It was hardly onerous, though most of us would certainly have rather spent the time doing other things. But we understood that we were a close-knit community and everyone had to do his part.

Well, except Jack, apparently. Because he spent a large part of his time at CosRay, I had to assume he simply didn't feel responsible for cleaning living areas that he rarely used. But that didn't assuage my anger. If anything, it intensified it. What arrogance! What selfishness! Whenever I'd see Jack, I'd feel the anger well up. I'd glare at him with undisguised fury. At those moments, I utterly despised him. Oddly, I had no desire to harm him; I just wanted to hate him. If I were to hit Jack, the anger might have dissipated, and I didn't want that. I wanted it to last. I savored the fury, nurturing it, reveling in it.

Finally, after two weeks of seething, the anger subsided. When my head cleared, I felt like I had experienced a form of temporary insanity. Normally, I don't stay angry for more than a few minutes. What the hell had this been about?

After a little reflection, I thought I understood.

Most people understand the sensory deprivation that winter-overs endure. What no one realized, though, was that we were also experiencing a subtle and insidious emotional deprivation. We had not seen anyone other than each other for almost five months. By now, almost all social encounters had become standardized. We saw the same people, day in and day out, and we said the same things to these same people, day in and day out. Even most of the friends I had made offered few surprises. Interpersonal interactions had taken on the same "sameness" as interactions with the environment. There was no opportunity to feel different emotions, or even any emotions at all. Everything was gray.

So it was easy to see why I had unconsciously nurtured my anger. Not only was a broader perspective lost as my world shrank to the size of McMurdo, but the constant flood of emotional response I had become accustomed to as a natural consequence of normal human contact had completely dried up, leaving a yawning chasm. It was a vacuum aching to be filled, and the stronger the emotion the better. Anger was perfect. It felt genuinely good to feel that anger toward Jack, and I milked it for all it was worth.

Opposite: A dark, quiet McMurdo street in the dead of winter.

THE HAUNTED LABORATORY

The incessant dark played other games with my mind. Rob and Sandra had told me during the summer that the Thiel Earth Sciences Laboratory was haunted. Of course I didn't believe them. I figured this was something they told all the winter-over lab managers, just to mess with their heads.

"Yeah, right," I said.

"It is," Sandra said. "Honest. It is."

I gave Rob a skeptical look. He just nodded and shifted the toothpick he was nursing from one side of his mouth to the other.

"Okay," I said. "How do you know?" Not that I was even thinking of believing them, but I wanted to at least hear some evidence. I wanted to see how creative they were going to be.

"You can just feel it," Sandra said. "You know? You can just tell when you walk in. Haven't you felt weird up there?"

I had to admit, there was something unusual about TESL. The basic T-5 structure had been partitioned into a small library and several tiny offices connected by a narrow hallway. The hallway led to the back, where there was a grimy rock-cutting laboratory and a ladder to a dark attic. Freezers for storing ice cores from South Pole Station were located in a poorly lit addition attached to the library. It seemed like TESL had more than its share of dark corners. During the summer, I had felt uncomfortable walking back to the rock-cutting room, or into the freezer room. I always felt like someone or something was going to jump out at me. The rock-cutting room was especially spooky. The dark hatch to the attic was right over the only entrance. I hated walking under it, and I absolutely never wanted to climb the ladder and look in, even though the hatch was always open. I couldn't explain why.

I was reluctant to admit this to Sandra. "Well, I suppose there *is* something a little different about it," I said. "But that hardly means it's haunted."

Rob finally spoke. "It's the lights," he said.

"What about the lights?"

"They go out," Rob said. "Even when the power is still on."

"And then they come on again, for no reason," Sandra chipped in.

A pair of lights had been mounted in the main window overlooking town to let everyone know whether the power was on in TESL and, consequently, whether the building was warm. A rock X-ray machine had been installed in one of the offices some years earlier, and the machine had to stay warm or certain components would be destroyed. Since localized power outages were a fact of life in McMurdo, a glance up at the lights would indicate if there was a problem so it could be fixed before the X-ray machine was damaged.

Opposite: In late May, I drove up to the water distillation plant on Observation Hill, set up my tripod, and aimed my camera at Mount Erebus. The mountain was dimly outlined in the light of a full moon. A Japanese vulcanologist, Katsu Kaminuma, had told me that Erebus was one of only three active volcanoes in the world with a permanently molten lava lake. If I was lucky, he said, during the winter I might be able to capture the glow from that lake on film. It would be a rare and unusual photograph. I stood in the cold with the camera shutter open, holding a cable release and counting off the seconds for a series of images, while my fingers froze. And I got lucky.

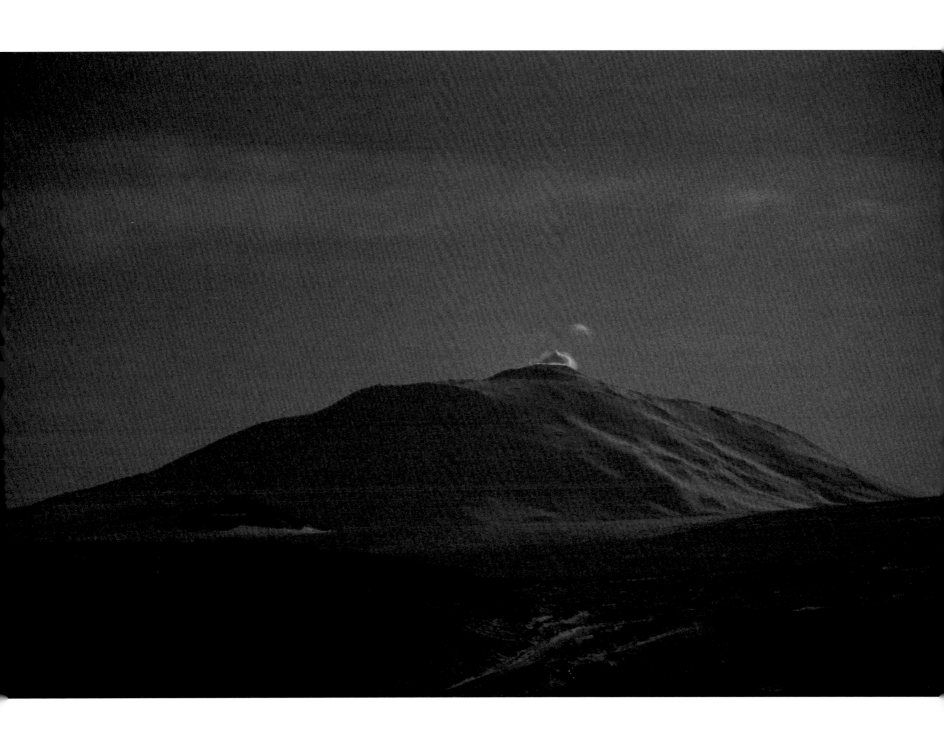

"A short in the wiring," I said. "Or the wind."

Sandra shook her head. "It happens on calm days, too, and the wiring's been checked."

I looked at Rob. "C'mon! You guys are putting me on. You don't really believe this!"

Rob shrugged. "TESL is haunted," he said with finality.

Now here I was, in the middle of winter, and I didn't want to go near the place. It *looked* haunted, a darkened hulk sitting alone up at the top of the hill above McMurdo, with those two lights in the window resembling nothing so much as a pair of malevolent eyes. But one day when they went out, I had to go up and check the building. I grabbed a flashlight and the key, bundled into my parka and wind pants, and headed up the hill into the wind. It blew directly down into my face. Even when I turned my head sideways, it managed to swirl into my hood and cut into my flesh. It was hard to breathe. I fought my way up the hill, slipping on patches of ice. My eyes watered from the wind, and the tears froze on my face.

When I reached the lab, I fumbled with the key, trying to open the lock without taking off my mitten. Rob and Sandra had taken to locking TESL during their winter because they had at first thought someone was playing games with the lights and monkeying with the building. Locking hadn't changed anything, but the procedure persisted. Finally, I undid the lock and pushed open the door to the vestibule. The floor was coated with the fine, powdery snow that the wind always managed to drive through every tiny crack, and it was undisturbed. It was clear no one had been in here recently.

I passed through the vestibule and opened the interior door to the library. The room was warm, so the power had not gone out. Just to be certain, I flipped on the light switch, and the room was illuminated. I dropped my mittens on a counter, then walked around a high bookshelf to check the lightbulbs in the window. The switch that controlled them was on, but the bulbs were not. I considered it unlikely that both had burned out at the same time, but I replaced them both anyway. No change. Fine, I thought. A short in the system. I'd call a utility technician on it when I got back to the Biolab.

I walked over to the hallway that led back toward the rock-cutting room. Since I was here, I thought I should check on the X-ray machine, located in the second office on the left. Looking down the dark hallway, though, gave me the creeps. I reached into the first office on the left and switched on a light, but it did little to make me feel better. The rock-cutting room in the back remained forbiddingly black. I shined my flashlight down the hall, then into the furnace room on the right. Nothing out of the ordinary. So why were the hairs standing up on my neck? "Well, everything looks okay here," I said aloud. Still talking to fill the eerie silence, I moved down to the X-ray room. Backup electric heaters inside kept the room warm in case the main furnace went out in a high wind. I cracked the door and shined my flashlight in, then reached in to switch on the light.

The old, silver X-ray machine sat on one side of the room, next to a metal cabinet. On the wall, an electric heater whirred. In a corner of the room, behind the machine, I saw a pile of fine wood shavings. "Looks like termites!" I said. I studied the wall and looked up at the ceiling, but I couldn't see an obvious source. Nonetheless, the room was always warm. If termites had come in on a shipment of building materials, they'd still be here.

Satisfied that the X-ray machine was all right, I turned out the light and shut the door. I glanced back toward the rock-cutting room and hesitated. I felt like I should do a complete inspection of the building, but I shuddered when I thought of going back there. In fact, I suddenly had a very strong desire to get out. I backed up, shining the flashlight beam up and down the hallway and into each office doorway. When I reached the first office, I flipped off the light, then moved quickly through the library to the front door. Keeping the flashlight illuminated, I slid my mittens back on, then switched off the library light. Another quick sweep of the room with the flashlight, and I shut the interior door behind me. Outside, I replaced the lock on the vestibule door and headed back down the hill to the Biolab. It was a relief to be out of that place.

Back at the lab, I gave the utility technicians a call, asking them to check the light at TESL. They'd have to stop at the Biolab for the key. A short time later, one of them came through the lab door.

"You wanted us to check the power light at Building 138?" he asked.

"Yeah. I've got the key right here."

The UT looked perplexed. "The light's on," he said.

I stared at him for a minute. "What, are you kidding?"

"No, it's on."

He followed me as I moved back through the lab, toward the receiving room and the back door. I grabbed the handle and swung the door open, giving me a perfect view up the hill to TESL.

The lights were on again.

I shut the door again and looked at the UT. "You didn't do anything?"

"Nope."

"Well, they were off a little while ago, and no one's been up there but me."

He shrugged. "Must be a short. Let me know if it happens again." And he left.

Yeah, sure, I thought. *A short.*

Rob and Sandra were right.

I stayed away from TESL after that.

LOST IN THE STORM

Even by McMurdo standards, this blizzard had been brutal. For nearly two weeks, almost nonstop hurricane-force winds had driven blinding snow across Hut Point Peninsula. Poor visibility had brought the town to a standstill, and the wind had wreaked havoc everywhere. Though the storm had kept us from taking a full accounting of the damage, at least one jamesway had been destroyed. I had passed it this morning while fighting my way from my dorm room to the lab. Half the wood frame was gone, along with the cloth that had covered it. The rest lay bare, with a few tatters of fabric whipping in the wind, like the rib cage of some large animal from which the flesh had been ripped.

I had shuddered when I walked by, and not just from the cold wind that lanced through the seams in my clothing. My sense was that the storm was not through with us yet. A few times the wind had diminished and visibility improved for a few hours, enough for people to start moving around again. But no sooner had we tried to resume normal operations than the storm kicked up again. During the summer months, the helicopter pilots had called these false respites "sucker holes." Antarctic

storms were famous for them. A patch of clear sky would appear and the storm would seem to be breaking. A pilot anxious to get somewhere would be suckered into flying into the clearing, only to have the storm close in around him.

Now I wondered if that wasn't happening again. I stood in the doorway of the Biolab and looked out. The wind had dropped in the last couple of hours to an almost reasonable twenty-five knots and, except for a few wisps scudding along the ground, the air had cleared of blowing snow. Across the dirt road that ran in front of the lab, a mercury-vapor streetlamp cast a circle of yellow light on the snow-covered ground. Nearby, the Chalet sat dark and empty. Like so many other buildings in McMurdo, it had been shuttered for the winter. I glanced up. Telephone and power lines overhead twisted in the wind. Beyond the pale light of the mercury lamp, Antarctica was a black and formless void. The sky was starless and utterly dark.

I didn't like the looks of it, but Steve had decided to take advantage of the relative calm to drive down to the aquarium. Steve was a marine biologist who had elected to stay for the winter to study the life cycle of single-celled organisms called foraminifera. His live cultures of the critters had to be kept in salt water at ambient temperature, and the aquarium was the only place to do it. It was a rectangular wooden structure situated at the water's edge, about 400 yards' driving distance from the lab. To get to it, he'd head down the hill in front of the lab, make a left turn before driving out onto the ice-covered sea, and travel along a narrow road between the sea ice on the right and the steep hillside below the helicopter pad on the left.

Like most Sprytes, Steve's didn't have much of a heater, and the windows tended to fog up quickly. But the trip was short; after telling me he needed only a few minutes, he threw his parka over the light sweats he always wore in the lab, jumped in the vehicle, and took off.

I shut the lab door and went back to work in my cramped office.

Caught up in what I was doing, I didn't look up again until some time later. A change in sound had caught my attention. The low background hum of the wind snaking around the rickety laboratory had turned once again into a loud, low rumble, punctuated by heavy thumps as gusts slammed into the back door or tore at the roof. The blizzard had kicked up again.

I went to the front door and cracked it open. The wind grabbed it and shoved me backwards. It was a good thing the door opened inward. Otherwise, it would have been ripped from both my hand and its hinges. Beyond the opening, the lab's lights illuminated a solid wall of white. Snow was streaking horizontally through the darkness. I shoved the door shut.

The phone rang. It was Steve.

"I'm coming back to the lab," he said.

"Are you nuts? Visibility is zero. You won't be able to see beyond the windshield."

He was adamant. "I can't stay here," he said.

It was true that the aquarium was not a comfortable building to be stuck in. It was colder than other buildings, in deference to the temperature needs of the marine creatures kept there. The water in the tanks was 29° F; if it got much warmer than that, the fish and other animals died. So the aquar-

Opposite: By late February, nearly all the ice had broken up and had been blown out of McMurdo Sound, leaving open, storm-tossed water where planes once landed.

ium was kept at about 55°, bearable for an hour or two but not much longer. In addition, there were no beds, no comfortable chairs, no food, no bathroom, and no water.

"If you don't see me in a few minutes," Steve said, "call Tom."

I hung up the phone and waited. It was impossible to go back to my work. The wind had increased in intensity and the entire laboratory was creaking and groaning. I heard a loud banging in the back of the lab and went to investigate. Storm winds in McMurdo come from the south. Since the lab was aligned south-to-north, the south end took the brunt of the wind as it roared off the unobstructed expanse of the Ross Ice Shelf, through the pass, and down over the station. As if to emphasize that point, the noise level increased as I entered the back room, a small workshop and cargo receiving area. The electric wall heaters were buzzing at top capacity, but the room was freezing. The back door was straining at its latch as though some large animal was trying to force its way in. The banging I had heard was coming from the plywood roof over my head. It was bucking as if it was about to be ripped off and sent flying. I remembered the jamesway I'd seen that morning and headed back to a safer part of the lab.

Ten minutes passed. Twenty. It was only a five-minute drive from the aquarium to the lab in good weather, even though the Spryte was not a vehicle meant for dirt roads and had a top speed of about five miles per hour. I knew Steve would have to stop frequently to keep his bearings, perhaps to wait for the snow to clear long enough for him to spot landmarks. I went to the door and cracked it again. Apart from a small patch of blowing snow illuminated by the naked bulb over the door, the outside was utterly black. The blizzard was so thick it was completely masking the light from the nearby streetlamp.

I mentally kicked myself—and Steve—for not getting the radio in his Spryte fixed. We'd intended to get it done, but as long as he was just using it to go back and forth from the lab to the aquarium, it didn't seem that important. But now there was no way to reach him to find out where he was.

After thirty minutes, I picked up the phone and called Tom.

He took in the news, then paused. "Give him another fifteen minutes. If you haven't seen him by then, call me back. I'll start putting together a SAR."

Initiating a search-and-rescue was no minor thing. A SAR meant someone was in serious trouble. More than that, it generally meant that whoever was about to go out and attempt a rescue would also be placed in danger.

Another fifteen minutes went by with no sign of Steve. It was clear to me now that he was lost somewhere in the storm, in a poorly insulated vehicle with an inefficient cabin heater and limited fuel. I called Tom back. He said it would be an hour before they were ready to go out. He had to gather the SAR members together, along with their gear, and get their vehicle running. I hung up knowing that they'd never be able to find Steve. Visibility in a vehicle is even worse than it is on foot. Sitting higher up off the road makes it harder to know where the road is. In addition, the Spryte's headlights reflecting off the blowing snow would blind the driver, making it impossible to see navigational landmarks, like the faint, intermittent light from streetlamps. Add to these difficulties the problem of windows fogging up from passengers' breath, and I knew it would be a near miracle if they were even able to stay on the road.

Above: To a photographer, Antarctica is a paradise of light. The light was always changing, and the symmetrical dome of Mount Discovery was the perfect canvas. It never looked the same way twice.

The only way to find Steve would be on foot. I shed my tennis shoes, pulled on a sweatshirt, then climbed into my hooded one-piece thermal suit. During the winter, I had found it to be my best protection against the cold. Next, I pulled on my bunny boots. Then I put on a thick woolen cap and pulled a woolen gaiter over the hat and down over my nose and mouth. Next came the ski goggles, after which I flipped the thermal suit's hood over my head and zipped it up. Finally, I put on woolen glove inserts and slipped my hands into leather mittens. I grabbed a powerful flashlight from my office and headed for the door.

The wind nearly knocked me over the moment I stepped outside. I held on to the door handle for support and looked around. I was in the middle of a maelstrom. In the dim light of the single bulb over the Biolab door, I saw only a swirling wall. The thick snow of the blizzard was streaming horizontally, like a sheet blowing in a hurricane. Beyond my tiny circle of white snow was only amorphous darkness. The snow was so thick it was obscuring every streetlamp, every artificial form of light, and the Antarctic was offering none of its own. On a clear day, I could navigate by starlight. But now, with the sky obscured by clouds and snow, not a single photon of natural light was getting through.

I turned on the flashlight, but turned it off immediately. All it did was illuminate the snow in the air before my face; it probably didn't penetrate five feet. I let go of the Biolab door and took several steps in what I knew was the right direction. After moving about twenty feet, I turned and looked back.

There was nothing but blowing snow. No sign of the Biolab. I was completely surrounded by impenetrable storm.

This is nuts, I told myself. *What good will it do Steve for me to get lost, too?* I retraced my steps, leaning into the wind, and with great relief found the Biolab door. I pushed it open and stumbled inside.

After removing my cold-weather clothing, I paced the Biolab lounge, trying to think of something I could do. What I needed, I decided, was a rope I could tie to the lab and use to guide myself, and presumably Steve, back to safety. After an exhaustive search of the storage room, though, all I could come up with was a roll of string wound around a hollow tube. At first I discarded it as being too thin and flimsy. But when I could find no other suitable, thicker rope, I picked up the string again. It would have to do.

I bundled into my cold-weather gear again, leaving the goggles off. The tint of the lens had obscured what little light there was and made it even harder to see. I'd have to do without them. After putting a screwdriver into the string's hollow tube so the roll could rotate freely, I stepped outside. Fighting the wind, I tied one end of the string to the lab's doorknob. Then I headed out again, holding the screwdriver and allowing the string to play out behind me. This time I didn't look back.

Immediately across from the lab there was a small empty lot with a memorial to Admiral Richard Byrd. A dirt road ran between the lab and the Byrd memorial. About fifty feet from the lab's door this road was intersected by another dirt road. This was the transition road, so called because it led down the hill that McMurdo sits on, across the land/ice transition, and directly onto the sea ice. On my right as I headed down that road would be a few shuttered buildings. On my left, below the Byrd memorial, was a road to the helicopter pad and gymnasium. Farther down, near the ocean, the transition road cut deep, as though through a gully. On the left, up a steep and rocky slope, was the hel-

icopter hangar. At the bottom of the hill, another road cut off to the left, toward the salt-water intake that fed the desalinization plant. This road was also flanked on its left by a steep, rocky slope, and on the right by the ice-covered water of McMurdo Sound. Several hundred yards down the road sat the aquarium. There would be only one streetlamp on my route. It sat on a power pole outside the hangar, at the top of the rocky slope and overlooking the bottom of the transition road.

I had walked this route more times than I could count, and I knew it as well as I knew the layout of my own room. I also knew I'd have to navigate based solely on this internal map. One thing in my favor was that maintenance crews had done their best to keep the roads relatively free of drifted snow. As long as I could see dirt and rocks beneath my feet, I would know I was on a road.

The wind at my back nearly pushed me over several times before I had even reached the transition road. Tiny rocks, whipped up by the wind, pelted the back of my suit. Even through the insulation, I could feel the cold pressing in. The wind was driving it through every minuscule crack in my clothing.

At the corner of the two roads was a green flag on a bamboo pole, placed there to guide the snow removers. I almost ran into it. I looked in what I knew was the direction of the transition road. Still nothing but darkness and swirling snow. I started working my way down the hill, keeping my eyes on the dirt below my feet. But I was facing sideways to the wind now, and wind-driven dust and small pebbles were blasting my face and getting in my eyes. I began to wish I had the goggles again, but with the tinted lenses obscuring what little light there was, I probably wouldn't be able to see the road beneath my feet. So I worked my way forward by walking sideways, keeping my hooded face away from the wind and only stealing glances now and again in the direction I was headed. The roar of the wind was deafening, a constant, low-frequency roar that seemed to consume the world. I could feel it vibrate through my body, even as it pushed at me and kept me off balance.

I continued moving slowly down the hill, hoping I'd run into Steve's Spryte. Perhaps he had made it part of the way and was waiting for a clear moment before continuing. Then I hesitated, struck by a realization. I looked in the direction I was heading. It was impossible to see more than three feet. If he was on this road and if he was moving, he'd run me over without even seeing me. I didn't much fancy getting chewed up by the steel tracks of a Spryte.

There was no other choice, though. If I left the road, I'd be hopelessly lost. I started moving again, hoping that he was not. I tried to keep my bearings by glancing up every few minutes. Occasionally, through a break in the snow, I'd get a brief glimpse of a slightly lighter spot in the sky to my left, which I knew must be the streetlamp near the helicopter hangar. Also, as long as I could feel the downward slope of the road, I knew I was on the right path. I tried not to think of the phone and power lines snaking overhead. If one broke free, it would become a vicious whip in the wind, deadly even apart from the live electricity it carried.

Flying objects, in fact, represented the greatest danger in a blinding snowstorm like this. A sheet of plywood or, worse, a sheet of plate metal driven by hurricane-force winds would be like a scythe. Either one could take off my head before I knew what had hit me. And there was no shortage of loose construction material lying around McMurdo Station, including sheets of steel, rolls of wire, wooden pallets, and innumerable heavy cardboard boxes and crates. But I took courage from the fact

that this storm had been raging for two weeks; most of the easily dislodged material must have blown away days ago. I hoped.

I concentrated on keeping my eyes on the dirt below my feet. At times, even that would disappear in the driving snow and the darkness, and I would have to bend down to make sure it was still there. It seemed to be taking me forever to get to the bottom of the hill. I glanced back the way I had come, but it was as dark and uninviting as the direction I was headed. I looked down again — and suddenly the ground disappeared. I was hanging, suspended in space, surrounded by swirling snow. I became dizzy and disoriented, unable to maintain my balance. Nausea boiled up inside me. I knew I must have walked onto a snowdrift, and I quickly forced myself to stumble backward before I fell. The vertigo disappeared as soon as I could see dark earth below my feet again.

I stood for a moment, unsure what to do. I had heard of vertigo resulting from a total whiteout condition, but had never believed it could actually occur. If this snowdrift was too big, I might not be able to get through it. *How absurd!* I thought. To go out into this wind and cold and near zero visibility and be stopped by a stupid snowdrift! If nothing else, I thought, I could crawl over it. But before I was forced to do that, I decided to try a faster approach. I took a deep breath and ran toward the drift. In several steps I was over it and onto hard road again.

I had no idea how far I had gone or how far I had left to go before I came to the bottom of the hill. I knew if I wasn't careful, I might end up out on the sea ice, where there were no landmarks. I would be completely lost, except for my string. Moments later, though, I ran into a pair of flags side by side, one orange and one green. I knew from memory that this marked the bottom of the transition road. The aquarium was to my left, directly into the wind. I headed that way, leaning into the gale.

The wind was relentless. It pushed at me like a living thing, trying to keep me from moving forward. Snow, driven at hurricane force, stung my face. Pebbles and sand flew at me and ricocheted off my suit. I kept my face down to keep from being struck in the eye. Still feeding string out behind me, I pushed into the storm.

There were large rocks in this road, and twice I nearly tripped and fell over one. Time seemed to stand still, with me stumbling forward but not seeming to make any progress. My heart sank with each step I took without running into Steve's Spryte.

Finally, I could make out a dim glow ahead. It had to be the light over the aquarium door. If I hadn't encountered Steve on the road, he surely wouldn't be at the aquarium. Moments later I confirmed that fear. I stood outside the aquarium door, and the Spryte was nowhere to be seen. I stood for several minutes, buffeted by the wind, trying to come up with another plan. But there was nothing left to do. I turned around and began heading back, spooling the string back onto the roll as I walked. The going was slightly easier, now that I had the wind at my back. It pushed me along, still pelting me with small rocks.

About halfway down the aquarium road, my string swerved right, up the steep hill of loose rocks and dirt that led to the helicopter hangar. The wind must have whipped it up the hill and wrapped it around a rock. I pulled, trying to dislodge it — and the string broke.

Opposite: McMurdo Station, noon, midwinter.

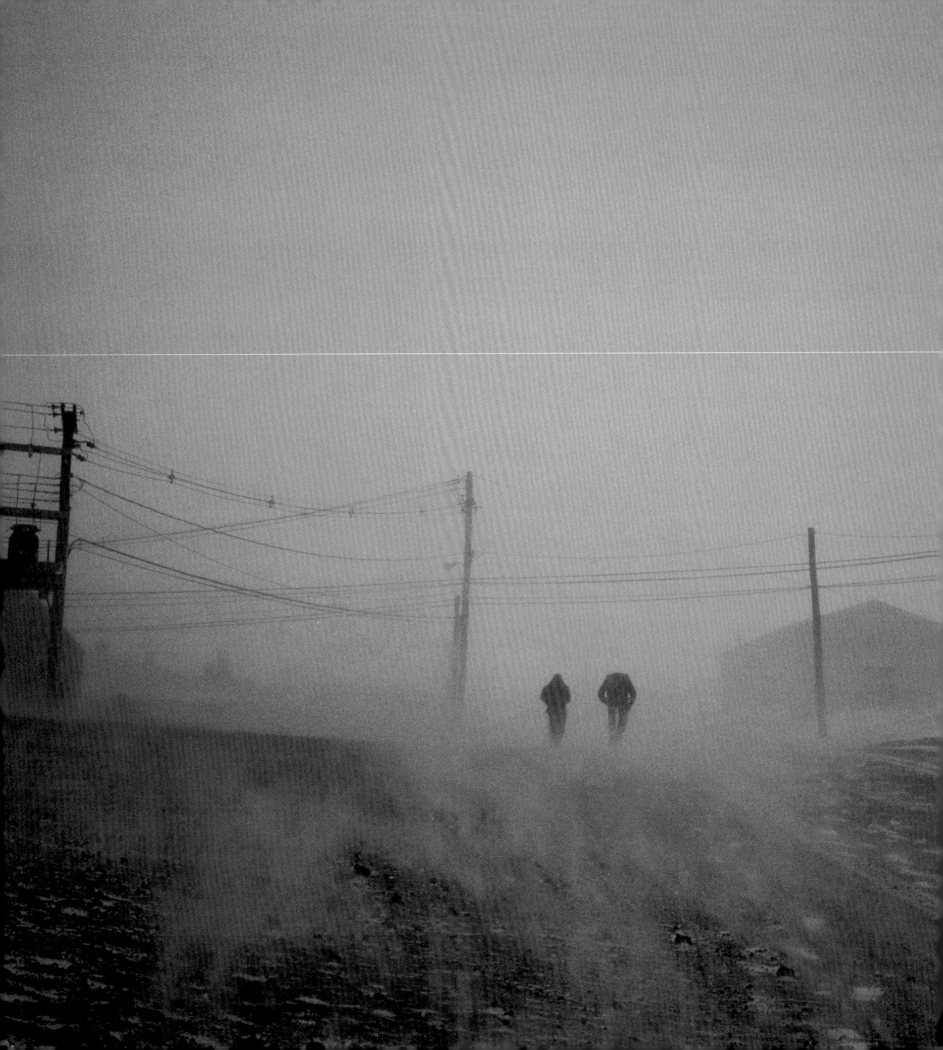

I was gripped by a fleeting twinge of panic. Flimsy as it was, the string had been a psychological comfort. Now I was absolutely on my own.

Then I mentally kicked myself. I had found my way down to the aquarium without a string, after all! Of course I could find my way back to the lab. Besides, the wind had probably wrapped my string around all nature of obstructions. It was a silly idea to start with. I stuck the remaining roll of string and the screwdriver into a pocket and continued forward. I glanced upward to catch brief glimpses of light from the streetlamp next to the helicopter hangar. I was getting close. A few minutes later I came to the orange and green flag combination.

Before heading up the transition road and back to the lab, I paused. There were only two places Steve could be: either he had made a wrong turn and ended up out on the ice, or he had missed the transition road and had continued straight along the shore. If he was out on the ice, I knew he wouldn't survive the night, and there was no way to reach him. With visibility at three feet, he could be absolutely lost less than a stone's throw away.

There was a better chance, I thought, that he had gone straight and simply missed the turn. In that case, he was somewhere ahead of me in the darkness. Snow swirled past my head in an endless stream, disappearing into a black void. I considered working my way in that direction, but hesitated. I didn't know the terrain on that side of the road, and there were no markers. The only thing I could do to keep my bearings would be to hug the side of the hill, making sure I was always on a slope. Otherwise, I could easily wander off onto the sea ice and be irrevocably lost myself. I started to move forward, then stopped. Something told me this would be a mistake. Reluctantly, I turned right and followed the dirt road up toward the Biolab. Once again, I had to keep my face averted and walk sideways to keep the bitter wind out of my face and the blowing pebbles out of my eyes. When I reached the snowdrift, I ran across it as before to avoid vertigo. At the top of the hill, I found the green flag and turned right again. A minute later, the door of the Biolab loomed out of the roaring darkness.

Inside, I pulled off my overalls and found that the wind had driven snow through every tiny hole, even through the zipper. The inside of the suit was packed. I shook it off and went to the phone. I knew Tom would be upset at what I'd done, but I could at least save him the trouble of retracing my route on the SAR. I was too late, though; he and his SAR team had already left. I found out later they had taken over an hour to get their Spryte to the bottom of the transition road, where it had stalled. After spending several minutes getting it restarted, they had turned around and headed back. Trying to search for anyone in that visibility, they had decided, was hopeless, and their unreliable vehicle made it too dangerous.

By this time, several hours had passed. Depending on how much fuel he had and whether his own Spryte had continued to run, Steve could be getting hypothermic. I was considering pulling on my gear and giving it another try when the phone rang.

It was Steve.

His voice sounded shaken, but he was all right. He was in the power plant, which was far down at the other end of the station. He had missed the turn, as I suspected, and had run up against an obstacle. Unable to go forward and afraid of going back for fear of ending up out on the ice, he had

Opposite: A windy, stormy day at McMurdo Station.

sat there for hours with the engine running, hoping either that the storm would abate or that some-one would find him. The Spryte's inefficient heater was useless. Snow began filling up the cabin around him, and he started doing pull-ups on the vehicle's ceiling handles to keep warm. When the Spryte ran out of fuel, though, he knew he had to find a way to safety or freeze to death where he was. The storm had not diminished, and it was clear no one would be coming to find him.

He had crawled out of the Spryte and discovered that the barrier that had stopped him was a set of sewage pipes that ran down to the sea. He had followed the pipes up the hill until he could make out the outline of a building, which turned out to be the power plant. The engi-neers on watch had been stunned to see him stumble through the door, wearing only sweat pants and a parka.

The next day, the storm was completely gone. After two weeks of nonstop, brutal wind and blow-ing snow, the air was clear and dead calm. I walked down the hill, retracing my route of the previ-ous night. A yellow light was flashing, illuminating the snow and the sides of the buildings. I couldn't figure out what it was, until I turned the corner at the bottom of the hill and saw Steve's Spryte rammed up against the pipes below the power plant. He had turned on the vehicle's flashing emer-gency light and had forgotten to turn it off when he left. The battery had kept it flashing all night. From the bottom of the transition road, where I had stood only a few hours before and stared into the swirling blackness, the Spryte was about 200 feet away. The strobe was bright enough to be seen for miles, and I had not had even a glimpse of it the night before.

Then I saw something that brought the hairs up on my neck.

A few feet from where I stood, the wind had scoured out a deep hollow in a snowdrift. There was a ten-foot vertical drop from the lip of the hollow to the frozen ground below. Steve was lucky enough to have missed it, but it was directly in the path I would have taken if I had gone forward. I never would have seen it; I would have simply stepped into air and tumbled head first to the hard ground below. I probably would have broken my neck.

I noticed something else. The wind had blown my string all over the station, wrapping it around buildings, telephone lines, and power poles. Later that day, and in the weeks that followed, I overheard several people wondering where it had come from. I decided not to embarrass myself by telling them. I could just hear their response: "You used string as a guideline? In hurricane-force winds?"

Three years later, when I returned to McMurdo Station, the string was still there, still wrapped around poles and dangling from power lines. People were still looking up at it and asking "Where the hell did all that string come from?"

I never said a word.

THE RADIOACTIVE LAB

In retrospect, it was probably a mean thing to do, but the opportunity was just too perfect to pass up. The five-man winter construction crew had been tearing apart the South Lab for a couple of weeks. From the very start, each of them had voiced concerns about radioactivity. Despite my assur-ances that every countertop and every drain had been checked and rechecked for residual contam-

ination, I heard constant grumbling. Pete, the general assistant, and Rick, the plumber, were the most vocal, tossing nervous gibes and half-jokes my way at every opportunity.

"I don't like the looks of this sump," Rick said.

"It's not contaminated," I replied, annoyed at having been called away from my work.

"Doesn't look like it," he responded.

I sighed.

"We're probably all getting poisoned every time we come in here," Pete said.

I could tell a good part of him believed that. Pete was the instigator. His constant griping had the entire crew on edge about the work. Their nervousness was making the job go far too slowly, and it was disrupting my schedule. Never mind that I had assured them over and over the lab was safe. Never mind that the radioactive substances used there in the past for biological research were nearly benign. One would have to ingest them in fairly large quantities for any deleterious health effects, and the quantities used in the lab were very small.

These assurances went in one ear and out the other, and the whining was beginning to irritate Steve and me both.

So I hatched a plan. I had discovered a cache of glow-sticks, fluid-filled plastic tubes with a small glass vial sealed inside. Breaking the vial releases a chemical that interacts with the fluid to produce a green glow. The chemical process is similar to that used by fireflies. The substances are completely harmless and biodegradable, but the effect looks positively eerie.

After the guys had left for lunch, Steve and I activated several sticks, then cut them open to gain access to the glowing fluid. While Steve poured a generous amount into the recently opened sump tank, I smeared a little on the ends of pipes, fixtures, and countertops. Then we put some on our hands and grasped the tools that the workers had left lying around. Finally, I turned out the lights to review our handiwork.

The effect was remarkable. The sump hadn't been cleaned or replaced in years, so it already resembled a horror-movie prop, with several evil-looking varieties of mold and algae growing on the sides and bottom. Now there were also several small pools of a bright green substance, glowing menacingly at the bottom of the tank. The same menacing glow lined plumbing fixtures in the process of being removed, and it dripped from open pipes. Both plumbing and carpentry tools bore shimmering, fluorescent green fingerprints. If I hadn't known the truth, the scene would have scared the wits out of me.

Steve returned to his work in the North Lab and I returned to my office, where we waited, barely able to contain ourselves.

When the crew returned from lunch, we stayed where we were, pretending to work. Though we couldn't see the guys, we could hear them talking. The usual construction crew banter preceded them as they filed through the back door and into the lab. Suddenly, we heard an alarmed "Hey!" and the banter died. There was a moment of absolute, stunned silence, followed by a few seconds of frantic muttering in uncharacteristically subdued voices.

"Hey, Jim!" Pete shouted. "What the hell is this?"

With Steve watching from the North Lab doorway, I left my office and sauntered into the South Lab, straining to contain a smile.

"What's what?" I asked.

"This!" He pointed toward the glowing sump.

I'm no actor, but I have to give myself credit for this performance. I walked up to the tank and looked in. My eyes widened and my jaw dropped. "Oh my God!" I said. "Gamma radiation! I didn't test for that!"

I would not have thought it possible, in the middle of an Antarctic winter and deprived of sun for months, for anyone's skin to be whiter than theirs was already. I was wrong. I watched the blood drain from five horrified faces. Pete and the four others looked as though Death had rattled his scythe right in front of them. Biting my lip, I couldn't resist one last dig. I looked meaningfully at the tools covered with glowing fingerprints and asked, "You did wash your hands before eating, didn't you?"

All five men fled from the room like panicked moviegoers from a burning theater. Pete paused at the doorway, waved his arms frantically, and shouted, "I don't want my kids to have flippers!" Then he was gone.

A few minutes later, Steve and I struggled to sitting positions and held our aching sides.

"Well, I suppose I'd better go tell them the truth," I said, wiping tears from my face, "or the lab will never be finished."

"Better you than me," Steve choked.

I grabbed a spare glow-stick, threw on my parka, and walked across the street to the Hotel California, which the guys were also renovating. I found them sitting in a circle with frightened looks their faces, discussing what now seemed to them to be an uncertain reproductive future. I told them about the joke and demonstrated with the glow-stick. It is safe to say they were not amused. Fear turned to relief and almost instantly to anger. They let me know what they thought of the prank, and me, then announced they were never entering the lab again. For the next few days, they did stay away, except for a brief incursion during which they planted in my toilet a ten-pound molded block of Spam they called the "Sacred Loaf."

Ultimately, work on the lab resumed, but things were never quite the same. For one thing, they never again moaned about radioactivity.

<center>❋ ❋ ❋</center>

In late July, as I stepped outside the Biolab on my way to lunch, I stopped short. Something was different. I looked up. The sky! It wasn't black anymore; it was deep blue. There was a hint of light coming from the northeast, from behind Erebus. My heart jumped. Though the sun was still well below the horizon, it was finally — finally! — on its way back.

A week or so later, I saw the Royal Society Mountains for the first time in months. I could just discern them in the twilight blue, faintly outlined along the western horizon. It was like seeing an old friend again. The world was returning.

Unfortunately, warmth was not.

Opposite: One day in late July, I noticed something different about the sky. It wasn't black, as usual, but deep blue. This was my first evidence that the sun was indeed coming back after the June 21 winter solstice.

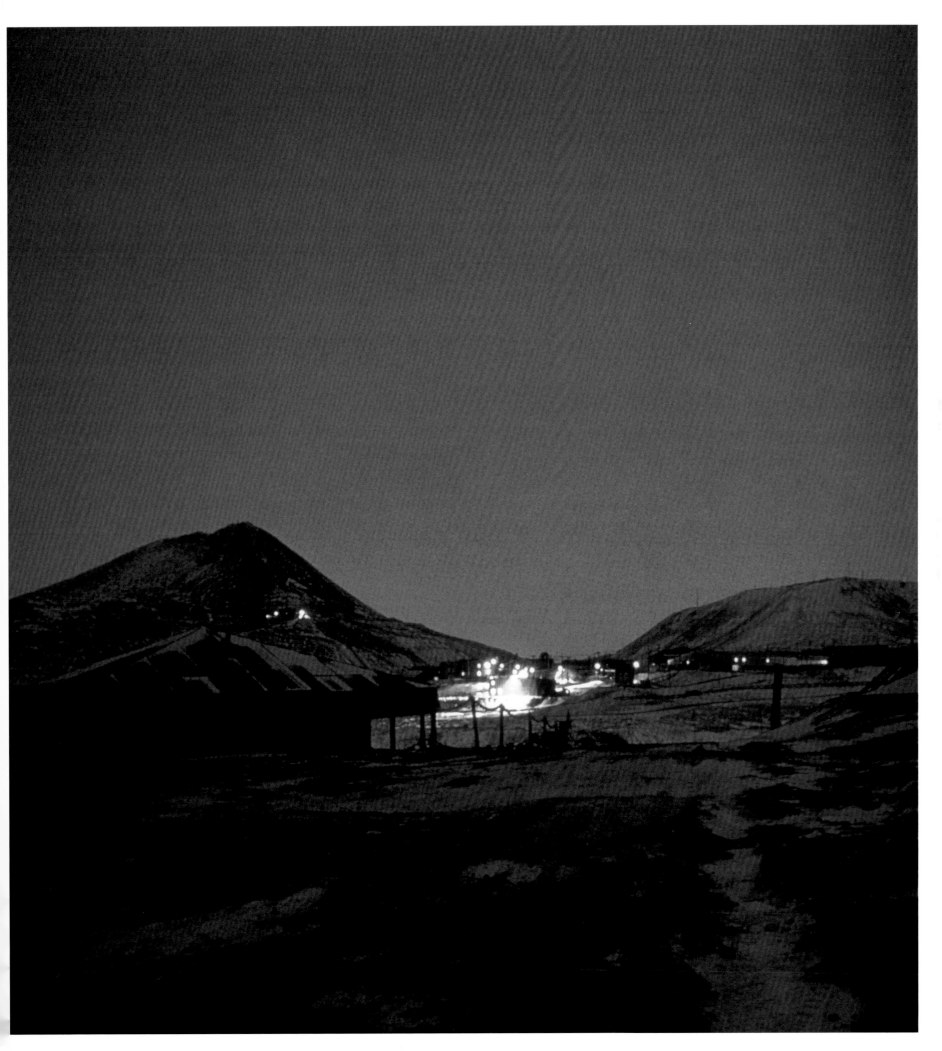

WINDLESS BIGHT

Greg, a meteorologist, had been collecting atmospheric aerosol samples all winter. Aerosols are microscopic particles held suspended in the air. Greg was trying to understand more about global air circulation, and how contaminants were transported in the atmosphere. Now, a few days before Winfly, he needed to go to a place called Windless Bight to collect snow samples, which he'd analyze for trace contaminants. Snow deposited at Windless Bight fell out of the cleanest air on Earth. Any small particles of pollution he found would tell him a lot about global aerosol transport.

Windless Bight, though, was one of the coldest places on the planet. The region had almost killed Wilson, Bowers, and Cherry-Garrard when they traveled to Cape Crozier to collect emperor penguin eggs during the winter of 1911. As a precaution, I bundled up in every bit of ECW gear I had, including the wind pant and parka liners I hadn't used all winter. Tom decided to come with us, so just as the sky was beginning to lighten, the three of us fueled up a Spryte and headed south.

We passed Scott Base on the Willy Field road. A few hundred feet farther on, the road made the transition from the volcanic rock of Ross Island to the packed snow of the Ross Ice Shelf. We continued to follow the flagged Willy Field road for a short way, then turned left, off the road and onto untracked snow. It was a clear, cold day. In McMurdo it had been minus 40° F, with only a slight breeze. Out here on the ice, the temperature began to drop. With Tom at the controls, the Spryte bumped and rattled over the uneven surface of the shelf.

The side windows of the Spryte fogged over quickly from our breath, so I couldn't see much from the back seat. Every once in a while I'd use my mitten to scrape off the ice for a quick look, but all I could see in the gloaming was a field of bluish snow and a twilight sky. The constant high-pitched roar of the Spryte's engine kept us from saying much. Lost in our thoughts, we moved deeper into the Bight.

Two and a half hours later, we pulled up near an automatic weather station that had been placed at Windless Bight to monitor conditions and radio the information back to McMurdo. The power supply had failed, though, and the station was not functioning. Tom put the Spryte in neutral and left the engine running. I swung open my door and stepped out onto the snow. It was almost noon, and the sky was as bright as it was going to get. There was a slight orange tint along the northern horizon, the first hint of any color other than blue that I had seen in the sky since last April. The sun was not yet high enough to clear the horizon, but it was getting close. To my left, the backlit bulk of Ross Island rose up, blocking most of the northern horizon. I had my best and closest view of Mount Terror, the other major peak on Ross Island. Despite the name, Terror was completely dormant, while Erebus continued to spew a plume of volcanic gas across the twilight sky. Everywhere else I looked, the ice shelf was a flat, featureless plain, tinted blue and purple by the hidden sun. There was not even a hint of wind. My exhaled breath hovered in front of my face, a personal fog that sometimes obscured my view.

It was all incredibly beautiful, but that's not what got our attention. Greg, Tom, and I looked at each other and I could see we were all thinking the same thing: It was unbelievably cold. It was cold like I had never experienced cold. The air stung my face. It hurt to breathe. This was the cold

of interstellar space, the cold that chilled atoms to stillness in the void between the stars. This was deadly cold.

"Jesus," Tom said, and we all knew what he meant.

Greg sprang to action, knowing he had to finish his job quickly so we could get out of there. He grabbed his sample bottles and moved away from the Spryte to gather up some virgin snow. I picked up my camera. Tom jumped on the bed of the Spryte and opened up the spare gas tank we'd brought. The fuel gauge in the vehicle was not working, and he didn't want to risk running out of gas out here. If the engine died, we might not be able to get it started again, and we'd be in real trouble.

I took a shot of him refueling the Spryte. Then I turned and took a photo of the glowing horizon. Finally, holding very still in the dim light, I took a photo of Greg collecting his samples. I pushed on the film advance lever for another shot and the film snapped from the cold. I stared at the camera in disbelief. That was the first and only time that had happened to me. How cold did it have to be to make film so brittle it would break?

I walked back to the Spryte where Tom was just finishing his refueling. He'd spilled the tiniest amount of gas on the fingers of one hand and they'd become frostbitten immediately. In obvious pain, he stuck his hand into his armpit, trying to warm it. I checked the thermometer we'd brought along. It read minus 65° F. Minus sixty-five!

I turned to look at Greg. He had both hands under his armpits and was stamping his feet. "Are you about done?" I called. "Let's get out of here!"

He nodded, grabbed up his sample bottles, and stomped back toward the Spryte. A few minutes later, Tom had turned the vehicle around and we were following our tracks across the snow toward McMurdo.

I couldn't get warm again. The Spryte's heater seemed to be doing nothing at all. My toes went numb in my bunny boots. I kept wiggling them to make sure they were still working. I felt a chill deep inside and folded my arms in front of my chest. I'd been cold a few times during the last several months, but there had always been a warm building to enter, or more clothes I could put on. This was different. I realized that putting on more clothes, if I even had any with me, wouldn't help. My problem wasn't lack of insulation, it was my breathing. The air was so cold that I was losing more heat in each breath than my body could replace. My life's heat was slowly and inexorably being drained from my body, and there was nothing I could do to stop it.

I looked at Tom and Greg. They were staring intently forward, their faces grim. No one was talking, but I know what we were all thinking. If the Spryte died on us, we'd be looking at severe frostbite and hypothermia. Maybe worse. I wondered if that frightened them as much as it did me.

Two and a half hours later, we rolled back onto the black dirt of Ross Island and I breathed a sigh of relief. I had become a little complacent, I realized. I thought I'd seen the worst Antarctica could do and I could handle it. I was wrong. That day at Windless Bight gave me a new respect. Antarctica hadn't even been trying; no blowing snow had obscured our vision, and no high wind drilled the cold through our clothes. It was just the cold itself, the unbelievable, metal-shattering cold, quietly and surreptitiously sucking away our life's heat.

I resolved never again to underestimate Antarctica's power.

✽ ✽ ✽

Finally, we were into August. Winfly was within reach. The winter was almost over. That realization brought conflicting emotions. With the imminent return of the outside world, this world I had come to know so well would evaporate. People I had grown close to would soon be scattered across the globe. Our community would disappear. In addition, I still had work to do and personal projects to complete. What had looked a few months ago like an almost endless stretch of time suddenly became a crunch. There was too much to do and time was running out.

On the other hand, the return of the sun couldn't come fast enough for me. I made a point of standing outside as long as I could tolerate the cold, just to look at the light in the sky. It was a glorious sight. I welcomed the end of winter for another reason. The planes of Winfly would bring both old friends and new people, and I was looking forward to seeing them. It would be good to have new faces in town. Best of all, the arrival of Winfly meant that only seven or eight weeks would stand between me and a warm tropical beach. I'd been dreaming about that all winter, and my heart jumped into my throat when I thought about how close it was.

The pace of activity increased at both McMurdo and Scott Base as we began to prepare for the planes' arrival. Vehicles were brought out of storage, shoveled free of snow, and started up. Buildings were re-opened and their furnaces started. Message traffic increased. I started spending late nights at the lab, trying to finish things up.

Near the end of the second week in August, a week before Winfly, I stepped out of the Biolab on my way to lunch and stopped short. The last time I had seen McMurdo Sound, before winter's night shut out the world, it was open water. Now it was once again a plain of ice, but that wasn't what caught my attention. Across the Sound, through the calm and absolutely transparent air, the Royal Society Mountains blazed with brilliant pink light. It was the first real color Antarctica had given me, other than blue or gray, since the sun had set nearly four months ago. The mountains glowed, pin-sharp, etched against a perfect blue sky, while the ice over the ocean, still in Erebus's shadow, was a mixture of purple and blue. I stared at the scene, speechless, unable to pull my eyes away.

A week later, on an equally calm and beautiful day, I stood with Kerry at CosRay and watched the first LC-130 of Winfly descend in twilight to land on the snow runway at Willy Field. Everything was about to change. Again.

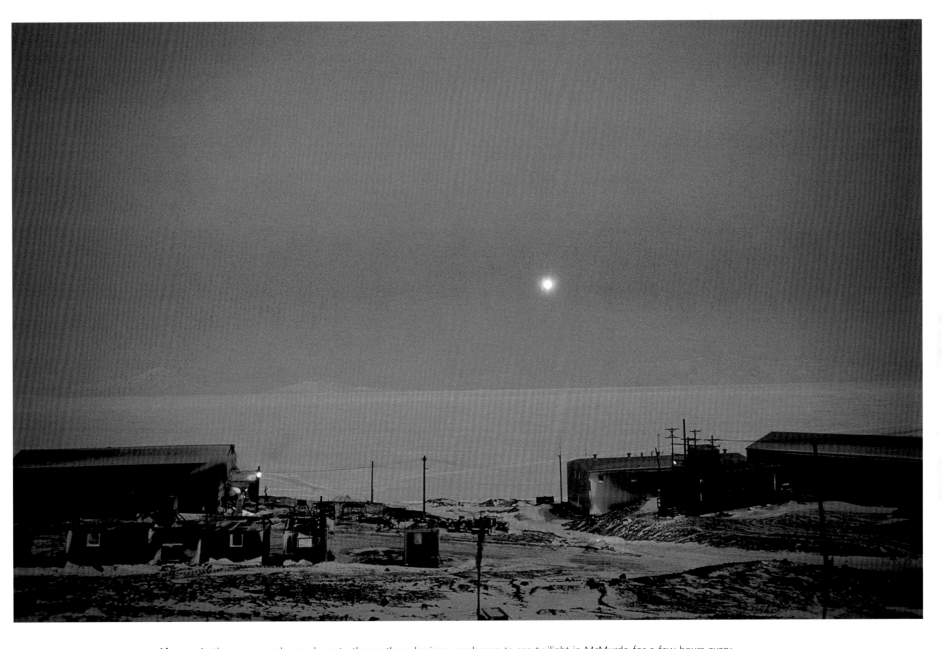

Above: As the sun moved ever closer to the northern horizon, we began to see twilight in McMurdo for a few hours every day. And, after nearly three and a half months of being hidden in the darkness, the Royal Society Mountains appeared again on the other side of a refrozen McMurdo Sound.

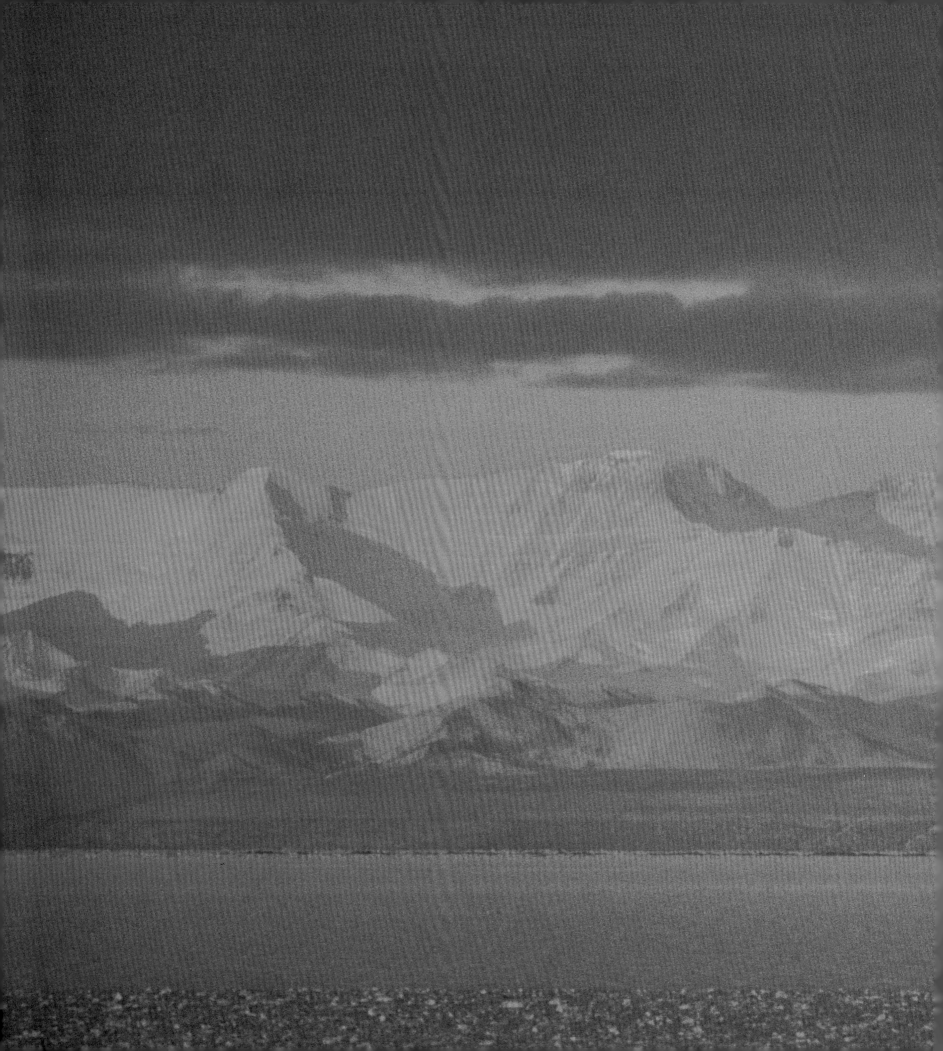

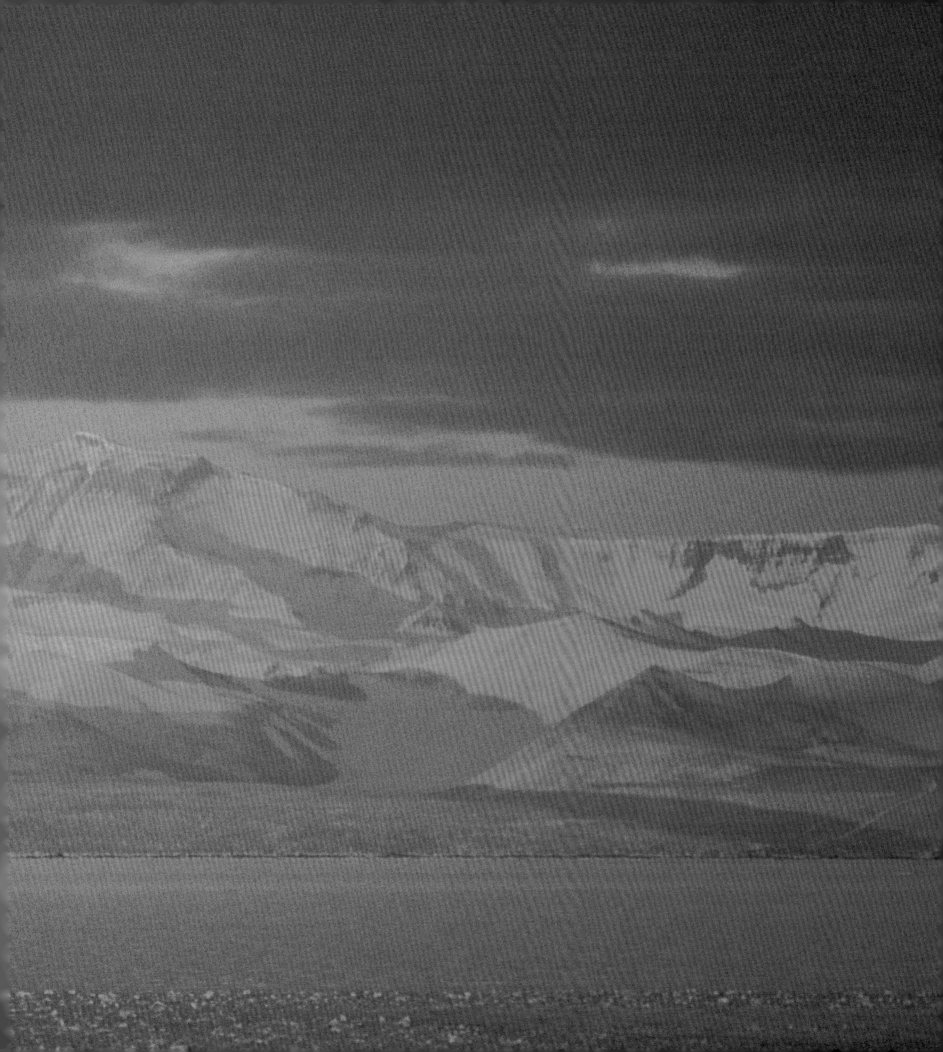

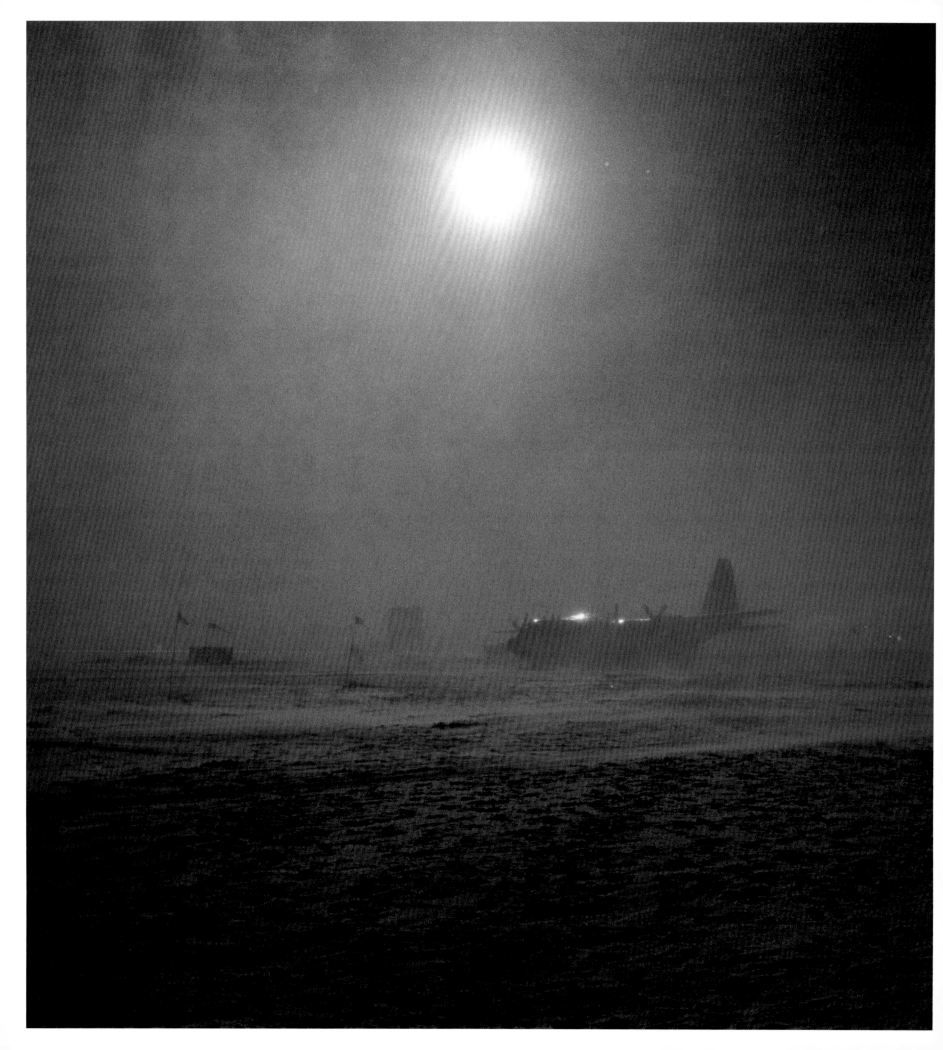

Spring

PILOT'S NIGHTMARE

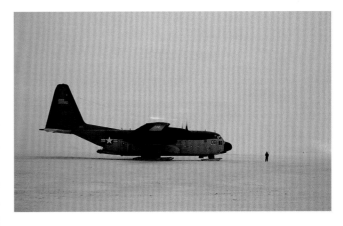

It was turning out to be a stormy August. One Herbie after another roared through, and the Winfly flights had become backed up. Over a week had passed since the first flight got in and out, and three flights were still due. So when it looked like there was going to be a reasonably clear window, the NSF dispatched all three LC-130s from Christchurch, one after another, spaced about an hour apart.

The weather was cloudy and blustery, and it was cold, but visibility was good. Kerry had moved up her departure date from October and was flying out today, on the third plane. She stopped by the Biolab to say goodbye, then boarded a van bound for Willy Field.

A few minutes later, everything went to hell.

All three Hercs had passed the point of safe return. The first was only a few minutes away from landing at Willy Field when a vicious storm blew up out of nowhere. The wind spiked almost instantly to sixty knots sustained and visibility dropped to zero. It was every Antarctic pilot's

Previous pages: Once again, the rising sun paints the Royal Society Mountains pink. **Opposite:** I had tremendous respect for the pilots who flew these Hercs through storms and blustery weather, sometimes to land on unexplored and untested ice fields. To test for crevasses, the pilots would fly over a potential landing site, dragging their skis to dislodge any hidden snow bridges. It was dangerous work, and it took enormous skill. **Above:** An LC-130 Hercules on the snow at Williams Field, packed with burned-out summer support people waiting to leave. For them, grass, trees, flowers, songbirds, and real food. For me, several months of cold, darkness, and diesel fumes. But I wouldn't have traded positions for anything.

nightmare: nowhere to land but in a whiteout. Nor was it any better for the people on the road to Willy Field. The vans came to a complete stop as the world closed in around them in the form of a blinding, furious blizzard.

I was stuck in the Biolab, helpless to do anything but listen to radio transmissions and try to piece together events as they unfolded.

The first Herc arrived to find the ground completely obscured. After a couple of aborted attempts to land, the pilots fell into a circling pattern, hoping the weather would clear before they ran out of fuel. Time was short, though. Even with auxiliary fuel tanks hung under the wings, a Herc arriving at McMurdo after the long flight from Christchurch might have only a few minutes of fuel left before the pilots were forced to land, no matter what the conditions. That was precisely the situation these pilots found themselves in.

The first plane was still circling when the second arrived. It too began circling. Friends who were on these planes told me later that, between the sharp turns, aborted landing attempts, and turbulence, it was a very rough ride. Several people lost the lunch they had devoured only a few hours before. Since everyone was crammed in, shoulder to shoulder, one person throwing up caused a chain reaction. Vomit was everywhere, and the cabin reeked. Old Antarctic hands knew there was trouble, and they were scared. New people were terrified.

Very soon, the pilots of the first plane had no choice but to land. They were out of fuel. They lined up into the wind and, following a radar beacon from the control tower, began a controlled, wing-level descent of 200 feet per minute. By adjusting their altimeters to the local barometric pressure, they had a good idea of where the ground was, give or take a few feet, but it was impossible to know exactly where they would be in relation to the airfield and its buildings. The idea was to descend until they thumped onto the ground, then throw full reverse thrust on the engines before they plowed into something. The radar operator guided them to an ungroomed stretch of snow near the runway that was supposed to be kept free of obstructions for just this kind of situation.

The plane hit the snow hard and roared into reverse, finally coming to a stop after bouncing across the rough surface. Following instructions from the radar operator, who could still see their plane on his screen, the pilots taxied to a spot near the refueling station. Then they shut off three of the Herc's four engines to conserve the meager amount of fuel they had left. One engine would keep the passengers warm and give the pilots the power they'd need to restart the others. But even this conservation measure wouldn't help for long. They were nearly on fumes when they landed.

A fuel attendant on the ground, believing he knew where the plane was, headed into the storm to make contact and immediately got lost. In a howling wind, the roar of a Herc's turboprop seems to come from everywhere, and nowhere. It's impossible to localize the sound. The fuel attendant, blinded by the blowing snow, could easily walk into a whirling propellor. All the pilots could do was watch for him, even though they couldn't even see the tips of their wings.

As the second plane was beginning its radar-assisted landing approach, the third arrived. These pilots had a bigger problem; they had to worry about hitting the other planes. Although the radar operator could try to guide them down to different areas, in reality there was considerable uncertainty. The pilots had to trust the radar operator without knowing how accurate his fixes were, or

Opposite: A surreal green sky of nacreous clouds over McMurdo Sound in early spring.

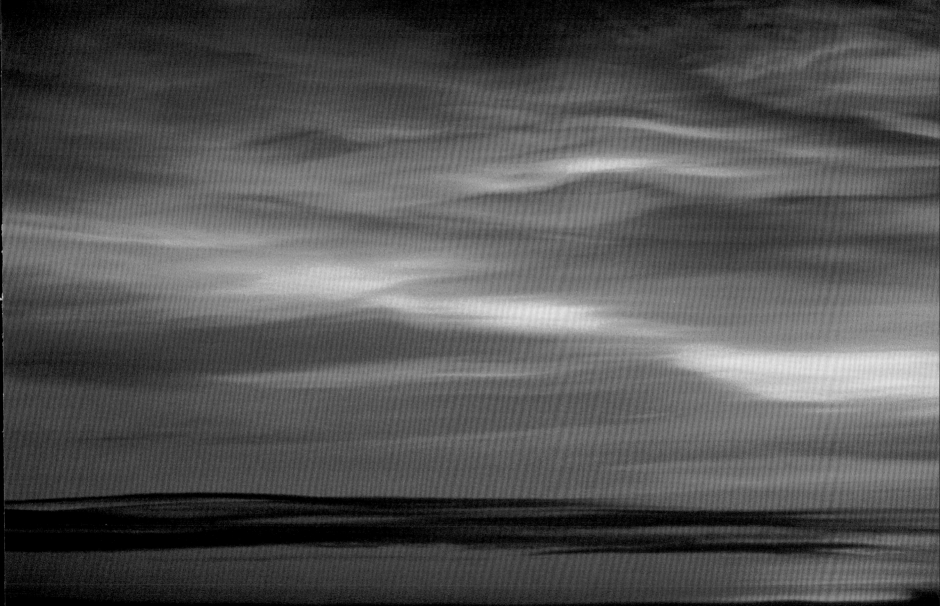

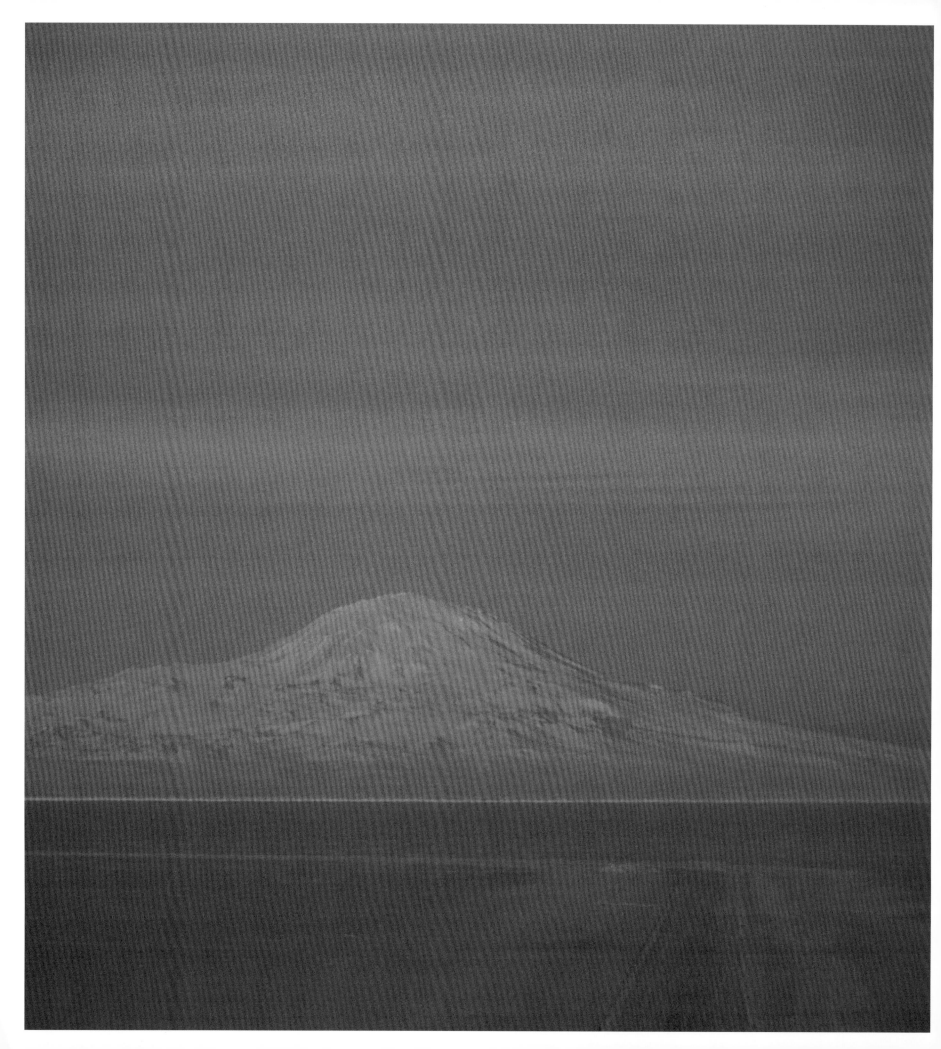

whether he had the experience to guide them in safely. They had no choice, and it felt like Russian roulette to them. At least one of them, I learned later, felt it quite possible she would die.

There was also that fuel attendant, wandering around lost in the storm. They could mow him down and never know it.

The second plane hit the rough snow like the first, then the radar operator guided the pilots to a parking spot near the first plane. By now, the third plane was low on fuel and the pilots were forced to descend blindly into the storm, waiting for the jolt that told them their skis had hit the snow.

The first plane had completely run out of fuel and the single working engine sputtered into silence. Metal enclosures like vans, Sprytes, and Herc fuselages suck away heat in a cold wind. It's often worse to stay in them than it is to be outside in a storm. The passengers on the first plane quickly began to freeze, but the second and third planes still had fuel and their engines were still producing heat. Through the swirling snow, the pilots of the first plane had gotten brief glimpses of the second Herc sitting nearby. Before hypothermia set in, they decided to try and make it to a warmer cabin. The loadmaster from each plane stepped outside, tied a line to his fuselage, then began walking through the blizzard in the direction of the other plane. They stumbled into each other somewhere in the middle and tied their lines together. Following this line, the passengers of the first plane were able to fight their way through the storm to the warmer cabin of the second, with the loadmasters watching them to make sure no one wandered into a spinning propellor. They were jammed in, standing room only, but it was better than freezing.

Things were no better for the folks who had been on their way to the airfield. Kerry told me later that they had become trapped close to Willy Field when the visibility dropped so low they couldn't even see the road flags, much less the buildings. They sat in the vans for several hours, while the drama unfolded around them, until their fuel ran out as well. At that point, workers at Willy Field who thought they had a good idea of the vans' location formed a human chain and went out into the storm to search. Incredibly, they found the vans and were able to escort all the occupants to the passenger terminal. Not long afterward, the lost fuel attendant staggered, dazed, out of the storm and back to the safety of his own building.

Miraculously, no one was killed. No one was even hurt, in what could easily have been the worst disaster in the history of the U.S. Antarctic Program.

The airplane crews and outgoing passengers were forced to spend the night at Willy Field. The next day, the planes were dug out of the snow and refueled, and their frozen engines carefully restarted. Twenty-four hours after she was originally supposed to leave, Kerry finally lifted into the air on her way to Christchurch.

❀ ❀ ❀

The Winfly folks were like an invasion force. Suddenly, the population of McMurdo had tripled.

At first, it was great to see the friends I'd made the previous summer, and it was refreshing to see all the new faces. McMurdo was no longer dull and predictable, but vibrant again, full of activity.

The excitement wore off quickly. Within a week, I was becoming irritable. Strangers were everywhere. The galley was crowded. After six months of having the place practically to myself, I

Opposite: Mount Discovery in early spring. The ice of McMurdo Sound remains locked in twilight shadow.

now had to stand in line to get a meal! I hated that. I hated the loud, frenetic pace of the galley after winter's quiet. Most of all I hated calling other work centers and having strange people answer the phone. I just wanted to tie up a few loose ends, but the new arrivals were full of "Wait. Start over. I don't follow you" or "That shouldn't have been done that way" or "I'll have to get permission first." I felt like my forward progress was grinding to a halt.

Even worse, I began to feel like a stranger in my own home. Who *were* all these people? My territory had been overrun by aliens. I realized I had come to feel a little possessive about McMurdo, and about the Biolab. Now I was suddenly being dispossessed. I didn't like it.

I found myself gravitating to other winter-overs, to familiar faces. We sat together in the galley like pioneers circling the wagons. Some of the winter-overs were feeling useless, as though their contributions no longer mattered, as though their efforts over the long dark months had been unimportant. The big boys were in town now. There was work to be done. Get out of the way.

So, I thought to myself, this is what those winter-overs were going through when I blew into town a year ago. Suddenly, their odd behavior was perfectly clear. We were doing the same things. During the winter, we had become completely comfortable in our environment. Everybody knew everybody else, and that had made us complacent. Even more important, I realized, was that in enduring the hardships and the deprivation together, we winter-overs had formed a bond. Among those of us who had become close friends, that bond was surprising in its strength. I don't think any of us realized it at the time. Now we clung to each other like the survivors of a shipwreck cling to a life raft. Time with winter-over friends was like respite from a psychological storm.

I found, too, that this situation applied even to people who had wintered in different years. All winter-overs were part of a unique fraternity that summer people could never fully understand.

After a few weeks, our feelings of invasion and territoriality began to dissipate. A new equilibrium established itself as winter-overs and Winfly people learned each other's foibles and priorities. Even more important, as the sun rose higher each day, we winter-overs saw a clear end to our time in McMurdo. All the projects and all the work were very soon to become someone else's responsibility. At some point, nothing I did would matter. At some point, I wouldn't care, and that point was coming soon. I began to count the days until I could be back in the world of trees and beaches and flowers.

But Antarctica wasn't done with me yet.

RESCUE MISSION

Another storm had been raging for days, and it showed no signs of letting up. A Winfly science team was trapped at their field camp on the sea ice. For the first few days, it hadn't much mattered, since they could conduct their work from inside their huts. I had friends out there, but I assumed they were safe and had sufficient provisions to see them through. Then Al Martin, the operations manager, stepped into the Biolab on other business and mentioned that the researchers were running low on fuel for their heaters and their generator. If the storm didn't break soon, the researchers would be without heat or power, and what was now an inconvenience would turn into a crisis. Al

was going to have to take fuel to the field camp, but I could tell he was not looking forward to it. I decided to save him the trouble.

"I'll go," I said.

He looked at me for a moment and I could tell what he was thinking. *You want to go out onto the ice in this miserable storm? You want to risk getting lost and have to sit, freezing, in your vehicle for days? Are you nuts?*

"Are you sure?" he asked.

"I'll do it," I repeated. "Just tell me when."

I knew that the mission was not as dangerous as people might think. There was a good flagged road to the study site; I'd flagged part of it myself and I knew it was solid. With a reliable vehicle and enough fuel, food, and water, I felt like I'd be perfectly safe.

What I didn't tell Al, or anyone else, was that one of those researchers was my new girlfriend. Lisa had been one of the few women to arrive at the beginning of Winfly, and I had been smitten as soon as she walked through the Biolab door. She was petite and blond, and I couldn't take my eyes off her. Without either of us trying too hard, casual conversations led to friendly backgammon games, then to swing dance lessons, and then, all of a sudden, to a relationship.

We knew we had to keep it a secret, though. With the sex ratio so off balance, McMurdo was a lurid rumor mill, and neither of us wanted the attention we would get if the word leaked out. Somehow, we managed, and no one in the room that day, not Al, and not Greg (who was very attracted to Lisa himself and frantic with worry), knew my real reason for wanting to go.

Al told me to get the fuel and other supplies together. The final word on when — and whether — to go would be up to the current NSF representative, Dave Bresnahan.

"There's only one thing," I said. "I want a Tucker." The Tucker Sno-Cats were the most modern and the most reliable vehicles at the station. More important, they were powered by diesel engines, and they had enormous fuel tanks. If I were to get stuck or lost, the Tucker would run for twenty-four hours on its own tank, and I'd have fuel on the sled I would be pulling. That fuel was meant for the field camp, of course, but I could use it if I needed to. A Spryte was out of the question; they simply weren't reliable enough, and they were powered by gasoline, which they guzzled faster than a wino putting away his Thunderbird.

Al nodded. "I'll see what I can do."

He stopped by later to tell me that I'd have my Tucker, and also that the new assistant manager of the Berg Field Center, Chuck McGrosky, would be going with me.

I shrugged. I felt like I would have been fine going it alone, but I didn't mind the company. Chuck was a friend of mine, and I knew him to be capable and levelheaded. He'd be a good man to have around.

I walked to my room, with the wind shoving at my back and the snow swirling around my head. I looked toward the sea ice but couldn't see it. Blowing snow had reduced visibility to only a couple hundred feet in town. Out on the ice, it was zero. In my room, I pulled out my ECW gear and tossed it into a survival bag. Then I filled two water bottles and threw those in the bag, along with some chocolate bars and other snacks. Slinging the bag over my shoulder, I trudged back to the lab, fighting the wind the whole way. Chuck called to tell me he had filled three drums with fuel and

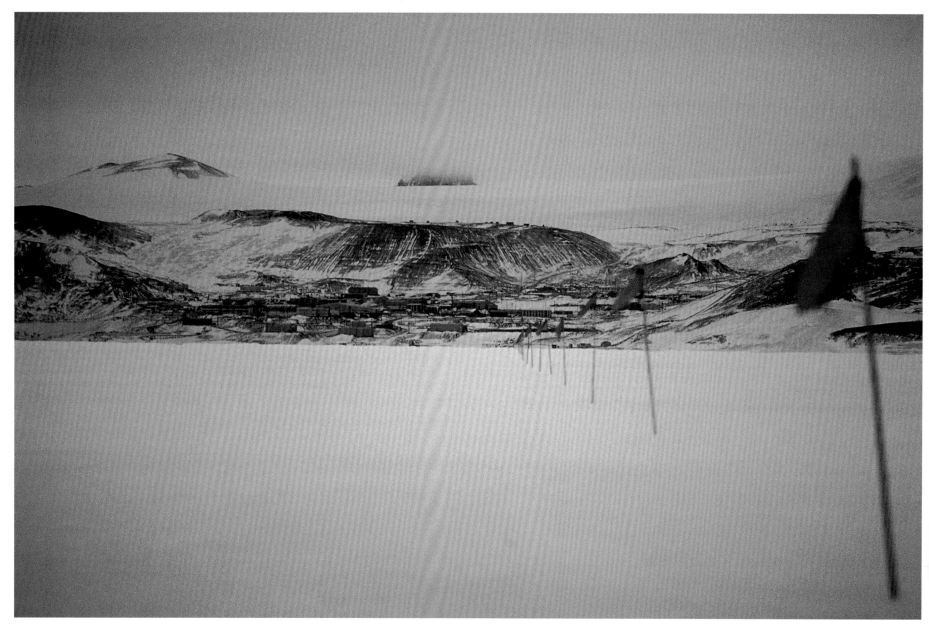

Above: A flagged road on the sea ice, leading to the safety of McMurdo Station.

strapped them onto a sled. He'd also pulled together some food and survival equipment from BFC stores, including a tent, sleeping bags, and a stove, just in case we really got stuck. I threw my parka back on and went outside to give the Tucker a thorough check.

The cold and the weather were hard on vehicles, and often the people who drove them treated them like rentals rather than the crucial pieces of equipment they were. Vehicles were a lifeline back to safety, and breakdowns could be disastrous. Too many times, people had jumped into a vehicle without checking it and headed out onto the ice, only to have their Spryte throw a track or spring an oil leak, leaving them stranded for hours. I wasn't going anywhere in this storm until I knew our vehicle was in top working condition.

With the wind fighting me every minute, I raised the hood to check the oil, coolant, and transmission fluid levels. I had to remove my mitten to get my hand into the engine and pull out the dipsticks. The cold metal sucked the heat instantly out of my fingers. I stuck my hand under my armpit to warm it, then slid my mitten back on. Getting down on my knees, I looked under the engine, checking for fluid leaks and loose parts. Then I rattled the treads, assuring myself they were securely attached. Satisfied that everything was in order, I jumped into the cab and started up the engine. All the gauges seemed to be working, so I unplugged the vehicle and drove over to the fuel pit to top off the tank.

There was no job less pleasant than fueling a vehicle in a storm. The fuel hose was heavy and awkward and the fuel inlet on the vehicle often difficult to reach. I sometimes had to remove my mitten to unscrew the lid to the fuel tank. Even with a mitten on, holding the cold metal of the nozzle became painful very quickly. Worse, the nozzle did not have an automatic cutoff, so if I wasn't careful, I'd find myself with diesel fuel suddenly gushing out of the tank, all over the vehicle and all over me. It had happened more than once. Diesel fuel has a horrible, nauseating smell, and it takes forever to get it out of clothes.

Storms made the whole fueling procedure harder because my parka hood obscured my vision and wind blew droplets of splashed fuel everywhere. Worse, the sound of the wind made it impossible for me to hear when fuel was reaching the top of the tank, and that sound was often the only way of knowing I was getting close. This time I was lucky. The tank was already nearly full and I could see the level of fuel when I looked down the spout. I managed to top it off without spilling a drop. I drove back to the lab and plugged in the Tucker.

Then I waited.

I had thought this was an emergency and assumed we would leave as soon as we were ready, but it was not to be. Several times Al called to tell me it was time to leave, then called back to tell me to stand by. Radio messages were flying back and forth between Bresnahan and the field camp. I caught only second- and third-hand hints of the nature of those messages, but it appeared that Dave was hoping for a break in the storm, and at the same time trying to determine whether this really was an emergency or whether the lead scientist was exaggerating the problem simply because he wanted to come back to McMurdo. The waiting was driving me nuts. By the end of the day, I was chomping at the bit, and then it was too dark to go. I was frustrated and beginning to get a little worried about Lisa. I stashed my gear and went back to the dorm.

If anything, the next day was worse. Visibility was still down to nothing on the ice and the wind was still blowing a steady thirty-five to forty knots. The storm showed no sign of abating, and more frantic radio messages had come in from the field camp. Still, I was told to wait. Then I was told to get ready to leave. Then hold off. Then get ready. Then wait. I was ready to pull my hair out.

Around midmorning, the phone rang. Dave Bresnahan was on the other end. He said one word. "Go."

I waited a moment, expecting more, but there was only silence. Dave was never one for idle chitchat. "Go" was all he needed to say, and all I needed to hear.

"I'm gone," I replied.

I walked to the front door of the lab and looked out. Things weren't quite as bad as they had been. I could now see the snowmobiles and other equipment that had been parked on the ice in front of the station, several hundred yards away. An hour earlier I had hardly been able to make out the next building. The wind had dropped, too. It was a respite. A window. We had to move fast.

Thirty minutes later, Chuck and I were on the ice in front of the station, hooking up the sled to the back of the Tucker. Soon we were on the flagged road, heading north, with instructions to maintain constant radio contact. The buildings of McMurdo disappeared behind us in the storm.

Visibility was not too bad, considering. I could see as many as ten flags ahead of us on the road. That was plenty good, as far as I was concerned. Piece of cake.

It didn't last. A few minutes later, the window closed. The wind kicked up and visibility diminished to almost nothing. I could now see only one flag ahead of us, and sometimes even that was obscured. I stopped the Tucker and looked at Chuck.

"Well," I said, shrugging, "one flag is all we need." I was trying to sound convincing.

Chuck just nodded.

"Okay," I said, and put the Tucker back in gear.

We rolled forward. The red flag, stretched out taut from its bamboo pole, slipped by Chuck's window. At the same moment, the next one appeared out of the blinding snow ahead of us. As I drove, both of us leaned forward intently, scouring the featureless white for each flag. There was no horizon, no sky or earth. It was impossible to tell where the ice ended and the snow-filled atmosphere began. Except for the inside of our cab, the Tucker's gauges, and each other, we saw nothing but white. After a while, even those things seemed to disappear, so focused were we on detecting the flags. Everything else was irrelevant. Our concentration was absolute. Our entire universe shrank to that next faint red speck, fluttering dimly ahead, barely visible in a swirling, formless chaos.

Often we reached a flag and stopped, unable to see the next. The wind had increased in intensity and the blowing snow had thickened, obscuring our lifeline. We sat in our rumbling vehicle, buffeted by the wind, leaning forward so that our faces were almost on the windshield, searching.

"Got it," Chuck would say, after several minutes.

"Where?"

He pointed. "There. A little to the right."

I squinted into the storm. Then I saw it, the faintest hint of color in a sea of white. I rolled the Tucker toward it.

Opposite: The sun returns to McMurdo Sound, and the cycle begins again.

A few times, we sat and stared for what seemed like an eternity and no flag ever appeared. The only one we could see was the one straining at its pole just on the other side of Chuck's door. Mac Ops had been calling every couple of hours for a progress report, and the radio crackled during one such moment.

"Progress is slow, but we are proceeding," I reported. I didn't want to tell them the truth, for fear they would order us to turn around. I found myself wishing we'd put the flags a little closer together when we made this road. But then, no one was supposed to be out on the ice in conditions like this, anyway. Twenty-five yards between flags had always seemed a reasonable compromise between visibility and having to haul and plant too many bamboo poles. It was good enough for most situations. It just wasn't good enough right now.

Finally, I couldn't wait any longer. If we didn't make it to the field camp soon, night would fall and further progress would be absolutely impossible.

"Keep an eye on that flag," I told Chuck, indicating the one outside his window. "I'm going to move up a little." I was hoping that a few more yards would make a difference. As long as we had at least one flag in view, we weren't lost.

I started to inch the vehicle forward. Now only my eyes were searching the blizzard for a faint smudge of red. I scanned slowly back and forth, knowing if I looked too quickly I might miss it.

"Can you still see the last flag?" I asked.

"Yep," Chuck replied. He was holding his door open slightly, fighting the wind that was trying to rip it from his hand.

I kept moving. Still nothing.

"I'm losing it," Chuck said.

I stopped the Tucker. If we lost that flag, we'd be stuck, unable to move at all. To do so without any reference would be suicidal. We could end up utterly and completely lost on the sea ice, in a storm that could last another week.

"Still see it?" I asked.

"Barely."

I was preparing to back up a little, to secure our link to that last flag, when I caught a hint of red out of the corner of my eye. I squinted, trying to resolve form out of formlessness. It was definitely the next flag, just at the limit of visibility.

"Got it!" I said, and pushed down on the accelerator. The next flag came into view as the one behind us disappeared.

It took almost six hours of this halting motion to travel a distance that, in normal circumstances, would have taken less than one. Several times, Chuck asked me to stop the Tucker so he could get out and check that the sled and its cargo were still secure. We had taken a few hard jolts as we moved over snow humps and sastrugi that were impossible to see and avoid. There was absolutely no definition on the ice in front of us. A three-foot ridge of built-up snow looked the same as a flat section of ice.

At one of these stops, I climbed out of the Tucker and onto the ice. I thought I had seen a crack and I wanted to check it out. I knew there were several cracks in this road, but they had been stable and unchanging until now. I wanted to be sure this long, violent storm hadn't set the

ice to moving again. The wind pummeled me from behind, pushing me forward. I stepped on a patch of bare ice and slid suddenly forward, trying to keep my balance, with my body acting like a sail, until I was stopped by a patch of snow. If there had been an open crack, I might have been blown right into it. I turned to make sure I could still see the Tucker. It was silhouetted against the blizzard, its headlights flickering as snow blew in front of them. I could just detect the rumble of the engine over the roaring wind. I moved forward cautiously, until I reached the edge of the crack. It was only about two feet wide and still solid, still frozen in the middle. Nothing had changed. It was safe to cross.

I turned and leaned into the wind, fighting my way back to the Tucker. It was the only object visible in the entire world, the only sign of solid reality in chaos. It seemed like a lone island in the middle of the ocean, or a solitary planet hanging suspended in the vastness of space.

Finally, we reached the spot where a side road split off of the main route. This side road led to the field camp. We were almost there. I radioed ahead to let them know we were near, and I could hear the relief in their voices. Moments later, the dark bulk of the camp loomed out of the blizzard. I swung the Tucker around to the generator shack, keeping a safe distance from the huts. Wind-driven snow drifted around stationary objects, creating an encircling ridge with a steep drop-off into a hollow on the other side. Since there was no surface definition, I could see neither the drifts nor the drop-off. If I accidentally drove over one, the Tucker would flip over.

People appeared suddenly out of the gloom. Grantees had come out to help us muscle the fuel drums off the sled and refuel the generator. I informed Mac Ops we had arrived. "Stay at the camp for the night," they radioed back. "It's getting too dark to make it safely back to McMurdo."

I was anxious to complete the mission, but I knew they were right. Once night fell, it would be impossible to see any flags in these conditions. I reluctantly swung the Tucker around to a vehicle outlet and plugged it in. Anticipating that we would be staying for dinner, the lead scientist had prepared a big pot of his special pepperoni spaghetti. We all gathered around in a hut that served as both kitchen and sleeping quarters and, over steaming plates of pasta, listened to stories of the storm. Chuck was subdued. I knew he was annoyed at the lead scientist for the lack of foresight that had brought us out here. All I cared about was being close to Lisa. We stood next to each other and, in the best performance of our lives, acted nonchalant while stealing surreptitious touches.

When I could bring myself to pay attention to the stories, they were harrowing. Chuck and I learned that, earlier in the storm, drifting snow had blocked off all the exits to the huts. The scientists had discovered this when one of them needed to use the bathroom outside. Had there been a fire or other emergency, everyone would have been trapped. Two of the researchers had managed to force open a roof hatch so they could crawl out and shovel the doors clear.

The next day the storm was gone. Just like in the storm Steve had gotten lost in, after several days of howling blizzard, of which the last day was the worst, the air was utterly still and clear. I was faintly disappointed. After the long wait to make the trip, and after the previous day's struggle, it would have been much more dramatic to fight our way back to McMurdo. Like true heroes in a true rescue!

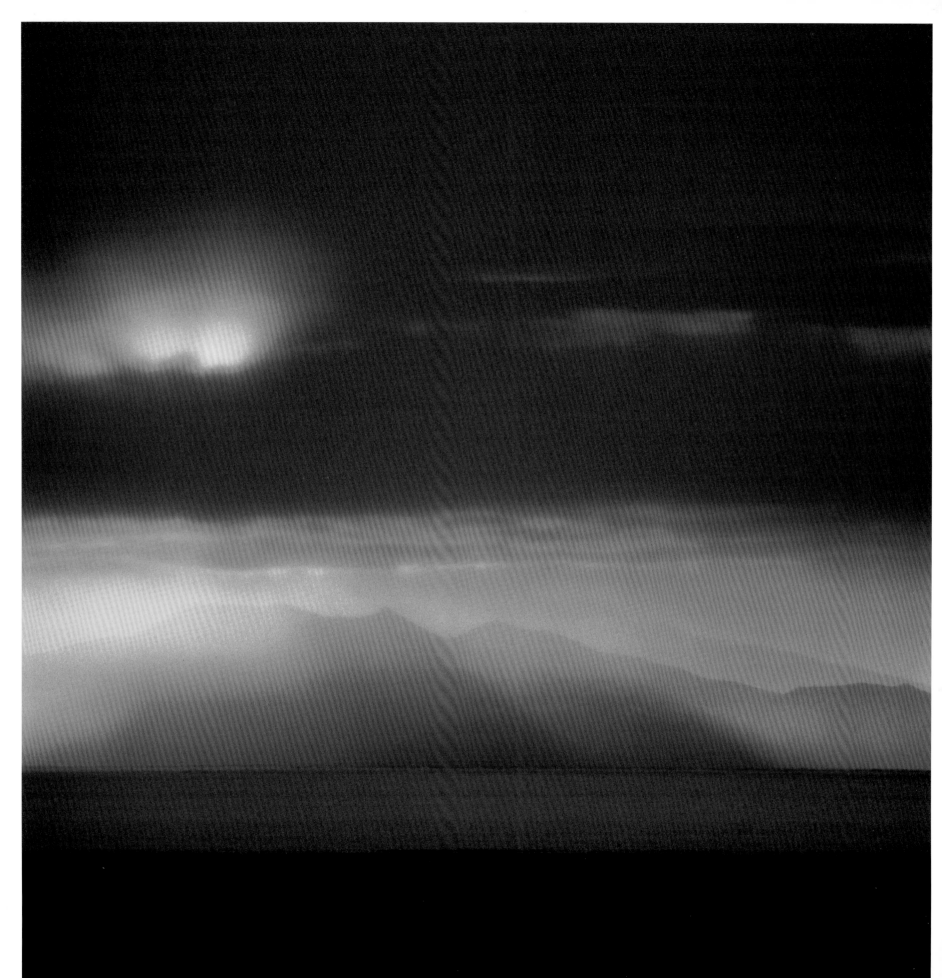

Instead, had we waited just one more day, there would have been no drama at all. We might not even have had to come.

So the trip home was anticlimactic. Visibility was unlimited. The long road of red flags stretched out on the ice in front of us, clearly marking the road. It seemed incredible to me that we had had to fight for them the day before. Now they were completely unnecessary. To our right, the Royal Society Mountains glimmered in the morning sun, and Mount Erebus stood sharply demarcated against the clear sky on our left. I could even see Ob Hill in the distance ahead of us. Chuck and I sat in front, lost in our thoughts, while Lisa and the rest of her science group were jammed together on bench seats behind us. Hardly anyone uttered a word during the journey.

<p style="text-align:center">❊ ❊ ❊</p>

I watched the first C-141 of Main Body descend through the clear, cold air to the ice runway with a feeling of complete calm. This wasn't like last October at all, when I felt the excitement and trepidation of a summer season about to begin. Then I knew I had a rough but thrilling five months ahead of me. Now, it didn't matter at all that the plane was full of people who'd scream into town in a mad rush to get things done. It wasn't my responsibility this time. I could just look forward to seeing friends again, for the few days that remained before I left, and let someone else worry about the frantic activity about to ensue.

Meanwhile, I just couldn't resist one last gag.

I knew the first van to arrive at the Chalet would be carrying Erick Chiang, an NSF representative; Art Brown, the deputy project director of the company I worked for; and a few other administrative personnel. They'd all be dressed to the hilt in their ECW gear because it was required for flying. There would be a couple of new people on that van, and for them the ECW gear was their newfound armor against the harsh and cruel realities of Antarctica. Like me a year ago, they'd think it was necessary to wear it all the time just to avoid frostbite.

Fortunately for my plan, the wind was calm. I changed into a pair of white shorts and a white T-shirt, pulled on white socks and tennis shoes, and slipped on a pair of sunglasses. Then I grabbed a racquetball racquet and a ball, and I waited for the van to arrive.

The moment it pulled up, I stepped out the front door of the Biolab and sauntered nonchalantly in the direction of the Chalet.

"Hi, guys," I said, with as much insouciance as I could muster.

Erick laughed and shook his head. Art's look said as clearly as if he'd voiced it aloud, "What will these nutty winter-overs do next?"

Opposite: Golden, late-summer sunset. As the sun began to drop toward the horizon, sinking lower each day, summer's endless white gave way to color again. **Above:** Late in the summer, the Greenpeace vessel appeared in front of McMurdo Station. Greenpeace members came ashore to hold a demonstration in front of the Chalet against Antarctic mining. Then, a few hours later, they went away. It was all very strange.

"Hi, Jim," he said, shaking my hand.

A new fellow stood aside, staring at me in complete amazement and admiration. After Erick, Art, and the others I knew had greeted me and entered the Chalet, he approached and extended his hand. "Hi! I'm Bob!" he exclaimed, pumping my hand as if he was introducing himself to a rock star. Then he looked me up and down as if he couldn't believe his eyes. I could see him wondering, Could it be that Antarctica wasn't all that bad?

"Aren't you cold?" he asked finally.

The amazing thing was, I wasn't. Winter must have thickened my blood.

<p style="text-align:center">❄ ❄ ❄</p>

The day before I was scheduled to leave, I walked down to the edge of the frozen sea. It was late afternoon and most everyone else was at dinner. I stood in front of the aquarium building and gazed out over the Sound. It was a clear day, and the sea ice shimmered in the sun. The Royal Societies looked bigger than usual, massive and imposing, as though they'd moved closer since the day before. Mirages appeared and disappeared at their base, creating ephemeral cliffs and inverted hills. A slight breeze ruffled the flag over the helicopter hangar, but the aquarium shielded me from it. It felt unseasonably warm for mid-October.

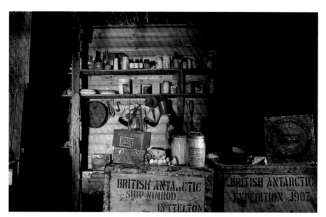

I tried to lock the scene into my memory. It was a bittersweet moment. I was looking forward to reentering the world of warmth and life, of finding a tropical beach somewhere and snorkeling over a coral reef. But I was sad to leave. Antarctica had been my home for over a year, a year full of friendship and life-changing experiences. I would miss it.

On the flight north the next day, I stood in the cockpit and watched Antarctica slide beneath our wings. From the ground, it is beautiful enough, but from the air Antarctica is almost incomprehensible. I finally saw what I had only been able to imagine on my flight south in the darkness of the previous August. A tremendous mountain range lay buried in snow and ice, its peaks sticking out of wind-scoured depressions. On one side of the mountains was the Polar Plateau, an endless plain of two-mile-thick ice. On the other side was the ice-covered ocean. I could see for hundreds of miles in the clear air, and in every direction I looked there was only ice and snow, with an occasional patch of bare rock or open water. Thousands upon thousands of square miles of total, complete emptiness, most of it utterly untouched by human feet and, except for an aerial view, unseen by human eyes. It was incalculably immense, incomprehensibly mysterious. I stared in awe.

Above: The interior of Ernest Shackleton's hut from the 1907–08 Nimrod Expedition. Shackleton made it to within ninety miles of the pole before being forced to turn around. This hut, like Scott's at Cape Evans and Hut Point, is designated as a museum and historical site. The cold and dryness make preservation relatively easy. **Opposite:** In one of the last sunsets of the year, the sun painted the sea and sky blood-red. The air was so crisply clear that, even when the sun was on the horizon, it was too bright to look at.

What does one make of such a landscape? I wondered. How does one come to grips with a land so alien and so dangerous, yet also so beautiful and so alluring? Why does this place exert such a hold on the people who have spent time here? I'd read about it, I'd seen it in others, and now I felt it in myself. Antarctica pulled at my heart, unwilling to let me go. In the days and months that followed, I think I began to understand more clearly.

We are drawn to new and unexplored lands, to wild, untouched places, and there are few of them left on this planet. Perhaps that's why we are so fascinated by stories of the "heroic" polar explorers. Almost every book on Antarctica and almost every description of the place is couched in terms that refer to those men who were the first to set foot on the great, unexplored southern continent. As humans, we establish our connection to places, both foreign and familiar, by focusing on the history of human occupation. We know a place by those who have come before us. Human history gives the land texture and substance, makes it real. The north polar region is as ice-covered as the south but seems somehow less alien because people have lived there for a very long time. We can make sense of the land through their eyes and their stories. They have languages to describe it.

Stories of the heroic explorers fail to provide that depth of meaning. There just isn't enough human history to work with in Antarctica — certainly not on the scale of the rest of the earth. Human exploration of the continent began less than two hundred years ago, barely enough time to register our presence. There are no middens, burial grounds, or ancient fire pits ringed with bones. There are only relatively recently abandoned huts, rusting implements of seal and whale harvests, and dried-out piles of unused supplies. These were left by people just like us, modern explorers of an unknown land, temporary visitors in a place not designed for human habitation. Their stories tell us of incredible human stamina, courage, and sacrifice, but almost nothing of Antarctica itself.

I wonder if it is possible to come to a new realization about a place, a realization independent of human history. Antarctica gives us little choice. Somehow, we have to make sense of the land without history to guide us, without the stored wisdom of a native peoples to provide us with explanatory myths and a pantheon of polar gods. We have to find the gods on our own.

On the plane flying north that day, I knew I would be back to look for them. Quietly, without my realizing it, the Ice had gotten into my blood.

Opposite: An LC-130 Hercules flying over the Transantarctic Mountains, on its way back to McMurdo Station from the South Pole. McMurdo Station is about 800 miles north of the Pole, a three-and-a-half-hour flight in a Herc. Between the two stations lies a vast, empty wilderness of glaciers, buried mountains, icefalls, and snow-covered ice.

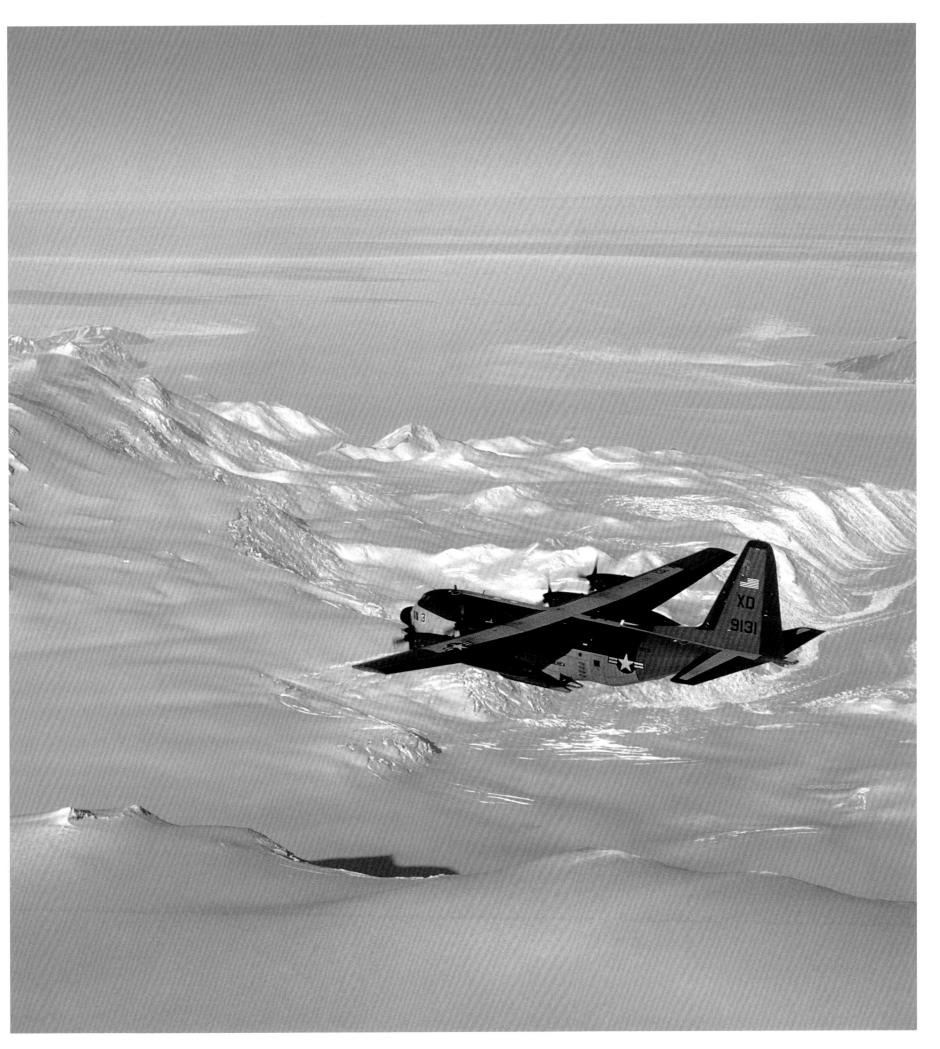

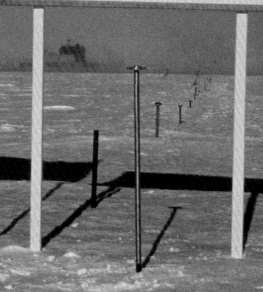

POSTSCRIPT

All things change, and the U.S. Antarctic Program is no exception. In 1998, after forty-three years of supporting research in Antarctica, and after several years of steadily diminishing involvement, the U.S. Navy packed its collective duffel bag and left. The Hercules aircraft are now flown by pilots of the New York Air National Guard, and pilots working for a civilian contractor operate the helicopters. All other support functions, from administration to medical services to air traffic control, are now provided by civilian contractors. The military-base aspect of McMurdo Station is gone.

There have been other dramatic changes to McMurdo's landscape. The level of alcohol use and abuse has diminished considerably. There are now only two bars, the Erebus and Gallagher's Pub. The old Officers' Club has been converted to a coffeehouse, and the enlisted men's Acey Deucy has been turned into a workout room, with treadmills and rowing machines. Heavy drinking is no longer tolerated. The rowdy "boys' summer camp" attitude I saw my first season has largely disappeared.

Some of these changes are probably due to the new demographics of the Antarctic Program. The number of women has steadily increased, at times approaching 40 percent. This has had a profound impact on the McMurdo social fabric. Watching the transformation happen over a period of years, I couldn't help feeling that the women were a civilizing influence. The increase in women has also brought a greater degree of normalcy to interpersonal relations. Many people now live and work in McMurdo as couples, and dating between singles is as common as anywhere else.

Communications have also improved dramatically. The days of scratchy, broken-up ham radio calls are gone. Everyone has e-mail, and every dorm room has a phone. For a modest long-distance charge, about the same as one would pay in the States, anyone can call home anytime, summer or winter. People generally feel that is better than the alternative, but I often wonder if instant communication with loved ones wouldn't make wintering-over much harder. During my winter, we had no choice but to let go of the world and immerse ourselves in the experience. We missed our friends and family, but we weren't constantly reminded of them. I think it would be more difficult to accept the winter and the darkness if loved ones in the States were always available to tell me what I was missing.

Despite all these changes, the essential aspects of Antarctica, and of wintering-over, remain the same. It is still cold. There are still violent storms. Spring sunsets still splash color across the heavens, and nacreous clouds light up the sky. Winter still means four months of almost total darkness, and Antarctica is still a vast, empty continent covered with ice. These things will never change, and these are the things that make spending a year — and especially a winter — in Antarctica a life-altering experience.

Opposite: Sign, flag, and U.S. Geological Survey disk marking the location of the southern geographical pole. Since the ice sheet over the pole is in constant motion, the exact location of the pole must be determined and a new marker placed every year. A line of disks stretching out behind the sign marks the location of the pole in previous years. The ice sheet over the pole moves approximately thirty-two feet per year. In the background, an LC-130 Hercules is taking off from Amundsen-Scott South Pole Station.

Following page: Every sunset at the Erebus Ice Tongue was unique. This time a sheer ice wall at the tip of the tongue turned gold in the light of the setting sun.

175

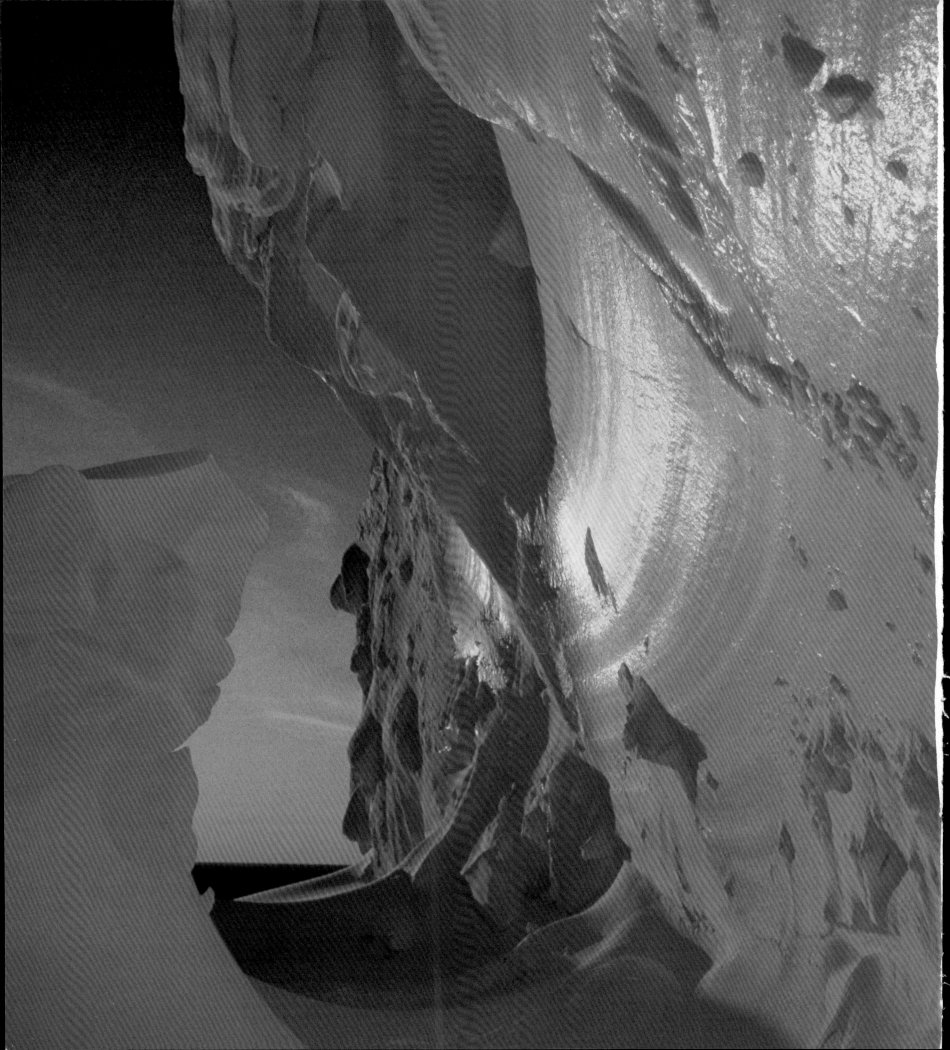